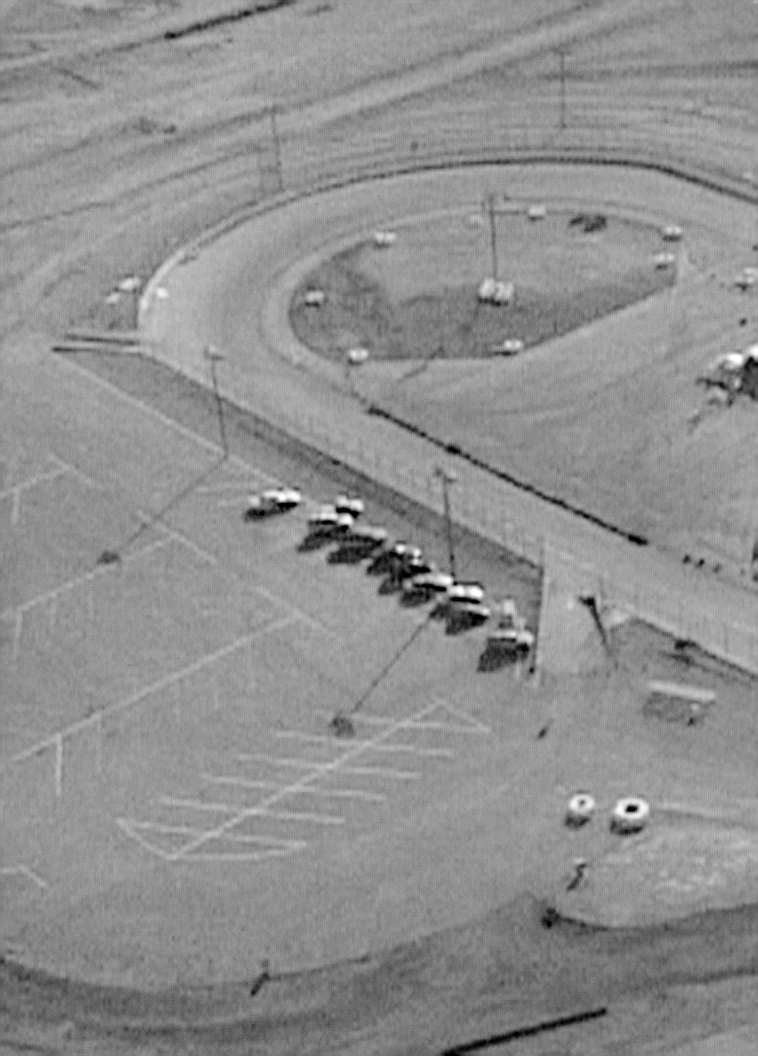

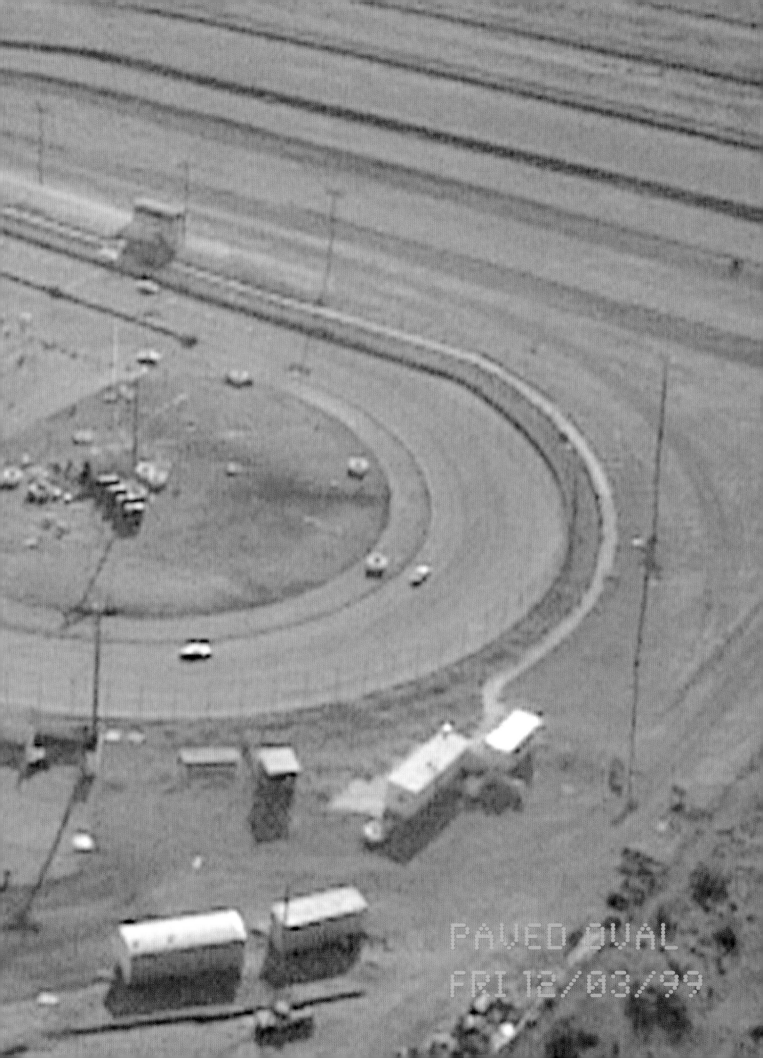

PAVED OVAL
FRI 12/03/99

THE *snowball*

T ROAD in the west

a collaborative project by
Peter Bonde & Jason Rhoades

edited by **Marianne Øckenholt & Jérôme Sans**

Hatje Cantz Publishers

contents

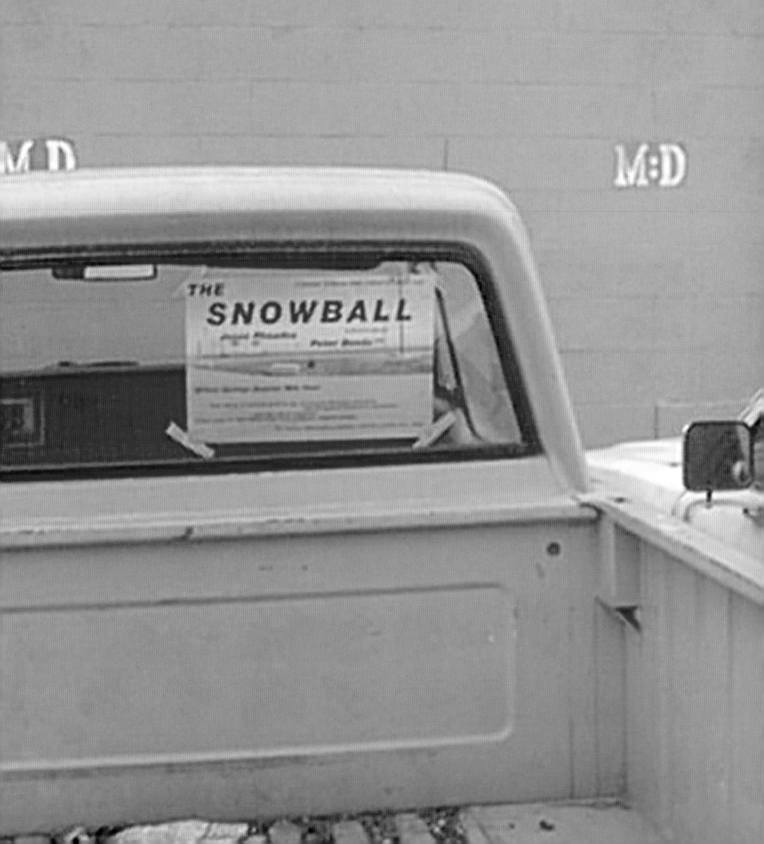

THE
SNOW

Jason Rhoades

a.s.a.p.

Willow Springs Quarter Mile

Take 405 or 5 freeway north to the 14

past the city of Lanc
Follow signs to 75th Street west main entra

For further

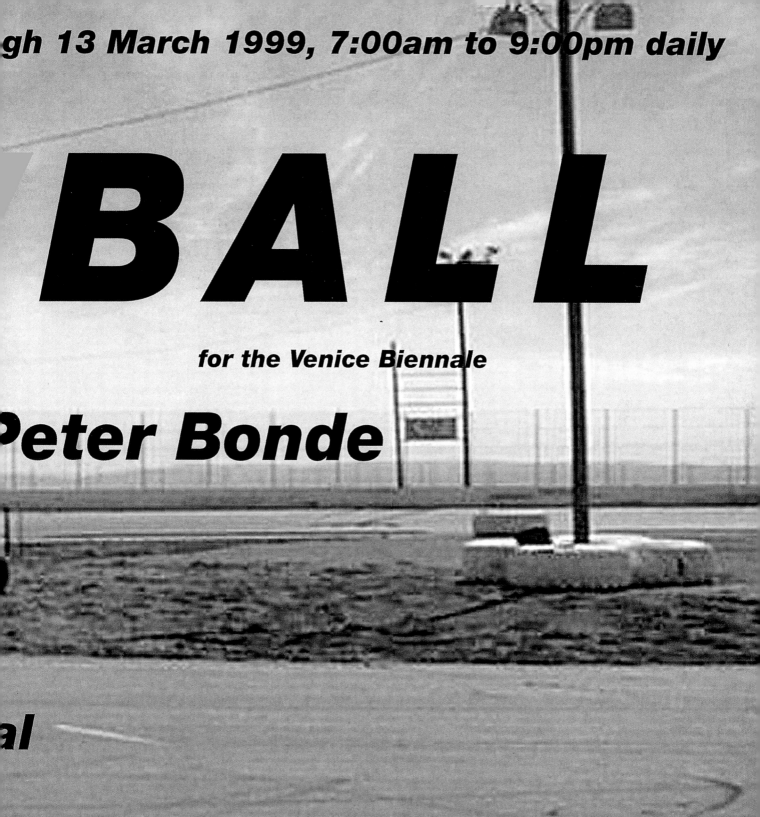

gh 13 March 1999, 7:00am to 9:00pm daily

BALL

for the Venice Biennale

Peter Bonde

al

eway direction Palmdale.
Rosamond Boulevard, Rosamond
er.
. Sign-in at gate.

rmation contact: 1301PE at (323) 938. 5822

SNOWBALL SHIPPING LIST

RED BOX 001
ziploc bag with tea bags
ziploc bag with sugar
ziploc bag with chocolate bags
2 jellos
Folgers coffee
restaurant blend foil coffee pack
4 Mexican candle lights
band-aid boxes
Melitta Premium coffee can
1 plastic pan (Tupperware)
3 frying pans
strainer
whisker
can opener
garlic press
misc. cooking material
box of ziploc bags
silverware

RED BOX 002
3 bamboo skewers packs
2 cork trivets
2 cooking gloves
3 tea towels
2 brown hot pads
1 white cooking towel
1 can Rosarita beans
Tupperware full of Lipton tea bags
2 Tupperware with creamer bags
2 cans of tuna
1 pack taco shells
2 instant lunch packs
rice bags
ziploc bags of taco shells
ziploc bags of crackers
ziploc bags of cookies
pancake mix (in ziploc bag)
ziploc bag of sugar
Spanish rice pack
4 ziploc bags of bagels

RED BOX 003
2 white motorcycle helmets

RED BOX 004
white overalls
fire extinguisher

RED BOX 005
red helmet
2 sticker printing paper rolls
scissors
1 overall
glasses packaging material
instruction book
extension cords

RED BOX 006
2 blue helmets

RED BOX 007
1 black helmet
1 red helmet

RED BOX 008
2 blue helmets

RED BOX 009
white overalls
colored flags on string
green water hose

RED BOX 010
1 black helmet
1 white helmet
instruction book for Canon digital
cameras

RED BOX 011
2 blue helmets

RED BOX 012
white overalls
fire extinguisher

RED BOX 013
white overalls
colored flags on string

RED BOX 014
white overalls

RED BOX 015
dirty dishes
cups
plastics glasses
china plates
silverware
cooking material
blue coat hangers
2 orange extension cords

RED BOX 016
instruction book for Corel Draw (for
computer)
yellow extension cord
2 orange extension cords
colored flags on string
2 orange cones

RED BOX 017
5 orange extension cords
extension cord (1 into 3)
bungee cords
tent poles
2 squeeze connector packs
battery back
tent connectors
fire extinguisher
CD pack
rubbing alcohol
hydrogen peroxide
Corel Draw 8 Effects book
screws

RED BOX 018
tent booklet
tent connectors
bag with bungee cords and bolts
1 white helmet
1 grey t-shirt
1 blue baseball hat
1 transparent plastic tube
battery instruction book
9 toy Indy cars
DC power regulator
Light bulb packs
bag of brake fluid and bolts
plastic glasses
masking tape
red cloth
electric wire
orange power strip (3 way splitter)
colored flags on string

RED BOX 019
1 hammer
M&R box with speaker wire, sign &
wrench
DC DC power

RED BOX 020
dirty towel
drill box
plastic bag w/ electric tape, washers
& thermo steel pack
thread locker pack, bolts & screws
fire extinguisher
pack of cable ties
cable ties
coffee thermos
water bottle w/ sprayer
car cigarette lighter power wires
plastic spray bottle

RED BOX 021
2 paper oil towels
air filter cleaner spray
2 Castro oil bottles
orange electrical tape
8 red cloths
blue tire pump
chain lube can
air filter oil can
technical book for car engines
engine start information
metal utility funnel
red plastic funnel

tire puncture sealant
velcro
blue masking tape
blue duct tape
M&R box of ear plugs
paper overalls

RED BOX 022
bottle of oil
plastic bread basket
stainless cookware
straps
china cups
broken china cups
vegetable oil
sticker "it's a home, keep it clean"
batteries
colored flags on string
grey t-shirt
dirty overalls

RED BOX 023
2 hands-free communicator boxes
3 red cones
gloves
orange extension cord
white t-shirt
dirty overalls

RED BOX 024
2 grey megaphones
1 CB
electrical wire
batteries
colored flags on string
white paper towels
green electric tape
red straps
1 roll of sticker printing paper
2 hands-free communicator boxes
yellow tape - tangled

RED BOX 025
white canopy tarp
Die-Hard battery charger box

RED BOX 026
Maxon communicator
video cable
2 diskette packs
audio-video selector
notice booklet
outdoor lamps on yellow cord
bungee cord

RED BOX 027
wire
electric wire
2 DC DC power converter packs
batteries
8 communication radios
dirty overalls
head phones
cardboard
old pipe
white cord with tent spikes
8 steel tubings (10")
tent spikes
used overalls

BLUE BOX 001
cord
5 colored flags on string
yellow straps

BLUE BOX 002
"service only" pad
black cooking pan
4 plastic containers of imitation
wood
dirty plates
dirty silverware
2 Tupperware lids
Tupperware box
2 plastic pads
plastic glasses
gas regulator
green water hose

BLUE BOX 003
2 plastic pitchers
4 dirty plates
large aluminum cooking pan
2 pan lids
frying pan
measuring cup
various dirty silverware

BLUE BOX 004
4 Tupperware containers
19 dirty china plates
8 dirty wooden bowls
1 small dirty plate
1 big dirty bowl
dirty silverware
dirty sponges
tent spikes

BLUE BOX 005
2 colored flags strings
plastic canopy connectors
dirty towel

BLUE BOX 006
paper towels
SNOWBALL poster
silverware
large dirty plates
medium dirty plates
small dirty plates
yellow "communication" sign

BLUE BOX 007
1 gallon container Dial anti-bacte-
rial soap
1 pack SOS steel wool pads
garbage bags
3 paper towel packs
lamp
Tupperware
colored flag string

BLUE BOX 008
plastic forks
Tupperware
foam cups
409 spray
sponges
plastic bag

BLUE BOX 009
2 packs aluminum foil
4 plastic ashtrays
bread
hamburger buns
1 pack of paper plates
Tupperware
cereal packs
aluminum pad

BLUE BOX 010
1 gallon container dish soap
honey
apple cider
100 tea candles
colored plastic plates
500 plastic plates pack
cereal packs

BLUE BOX 011
2 concrete buckets
tent pipes
foam pipes
fasteners

BLUE BOX 012
2 concrete buckets
colored flag string

BLUE BOX 013
2 concrete buckets
foam pipe

BLUE BOX 014
2 concrete buckets
colored flag string

BLUE BOX 015
2 concrete buckets
white tent pipe

BLUE BOX 016
2 concrete buckets
BLUE BOX 017
2 concrete buckets
piece of plastic

BLUE BOX 018
2 concrete buckets
black foam pipe

BLUE BOX 019
2 concrete buckets
black pipes

BLUE BOX 020
used oil containers
white tent pipe
Montana baseball hat
foam pipes

GREEN BOX 001
salad dryer
Tupperware
pack of dinner napkins

GREEN BOX 002
dirty plates
radio transmitter
dirty plastic cups
silverware
dirty cooking material
GREEN BOX 003
bag of charcoal
pasta strainer

GREEN BOX 004
spices
sugar
salt
pepper
vegetable oil
olive oil
hamburger buns
hot dog buns
liquid hand soap
black cord

GREEN BOX 005
outdoor lamps on yellow cord

GREEN BOX 006
bag of charcoal

GREEN BOX 007
fruits & vegetables
coffee filters

GREEN BOX 008
outdoor lamps on yellow cord

GREEN BOX 009
dirty cups
dirty plates
dirty silverware
dirty pitcher

GREEN BOX 010
used overalls
4 radio transmitters with head phones
plastic tent pole bases
2 plastic pans
3 canopy cross pieces

MISC. ITEMS
used oil containers
167 yellow tires
167 red tires
110 blue tires
3 white Igloo coolers
2 blue plastic barrels
2 green garbage cans with lids
43 white plastic chairs
2 charcoal grills
50 large orange cones

50 small orange cones
4 red 6 gallon gas cans
2 black plastic patches
2 cooking clear plastic pads
yellow steel board
blue disc with glove - from painting
shop
5 green hunting towers
wood dolly
2 car ramps
2 cooking ranges
3 plastic pans
large bag w/ canopy tent
microwave oven
blue hand truck
large steel ice maker
bag of concrete mix
2 wood stools
2 black plastic shelves
2 green/white tents
1 large canvas tent
1 carport tent
8 white car pallets
2 chafing dishes
1 aluminum pan
box of green umbrellas
PVC pipes
9 green camping tables
extra large white tire (from
Heather's
crash)
salad bowls

Misc. Items Cont.

white bucket
8 miniature cars
Roland large scale printer
UMax laptop computer with mouse
Metal stand for printer
blue plastic roll table
wood rack
ear plug
dazzle
2 boxes for burner ranges
4 sets tool boxes
black case w/ transmitter car plug,
50F - 006 50 ohm connector, ohm
connector, small antenna
antenna in clear orange tube
digital camera (in box)
1 camera battery
battery charger and cord
DC to AC inverter
Canon DV-100 input-output
eye-visor for camera
plastic screen door
VCR remote control
TV remote control
camera remote control
Canon black pocket
glass screen in white paper
camera strap
ohm cable in plastic
RCA video cables
RG59/V coaxial cable
cables ties
70 ohm cables
power strip
antenna w/ 2 cables
antenna plate
black light shield for monitor
clamp for cameras in car
VCR
TV
color tape
instruction books for cameras, VCRs,
TVs
red Craftsman toolboxes
2 coaxial connectors
3 power transformers
6 plywood bush cut-outs
6 wooden stands for bushes

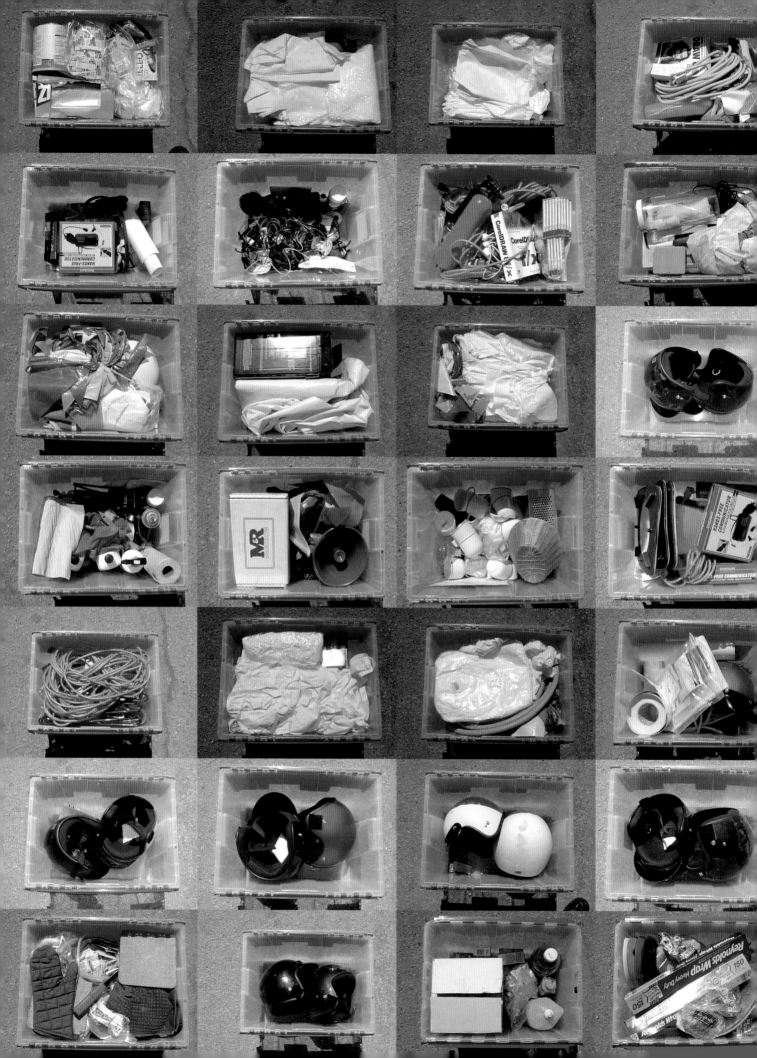

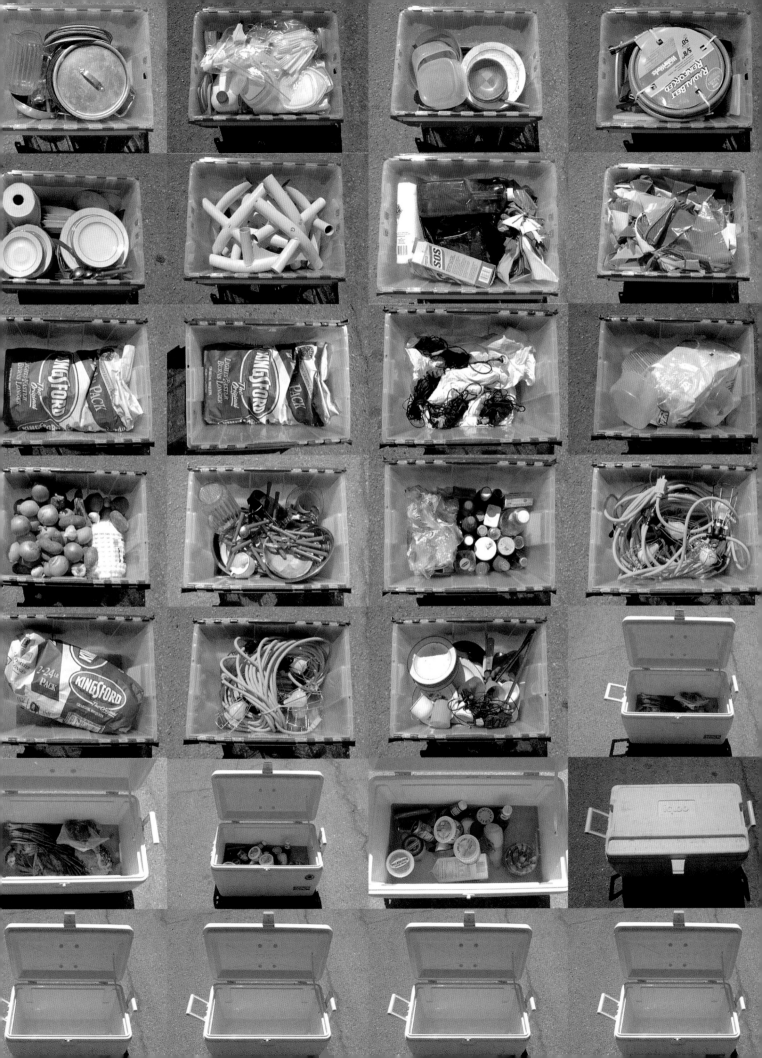

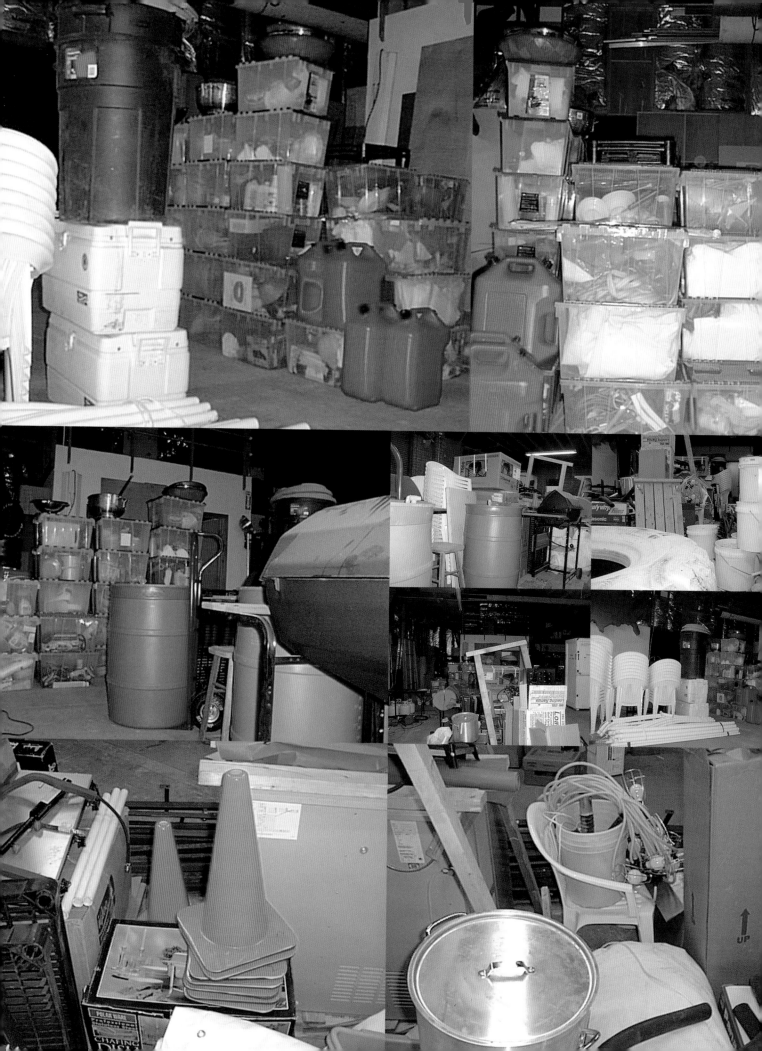

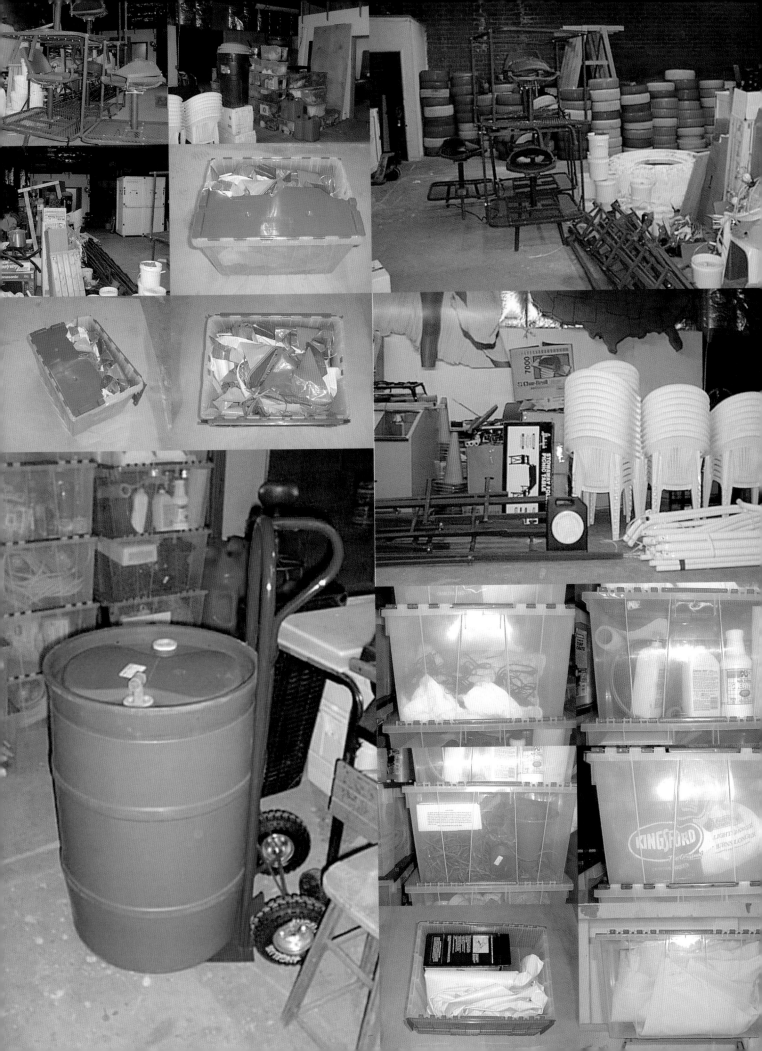

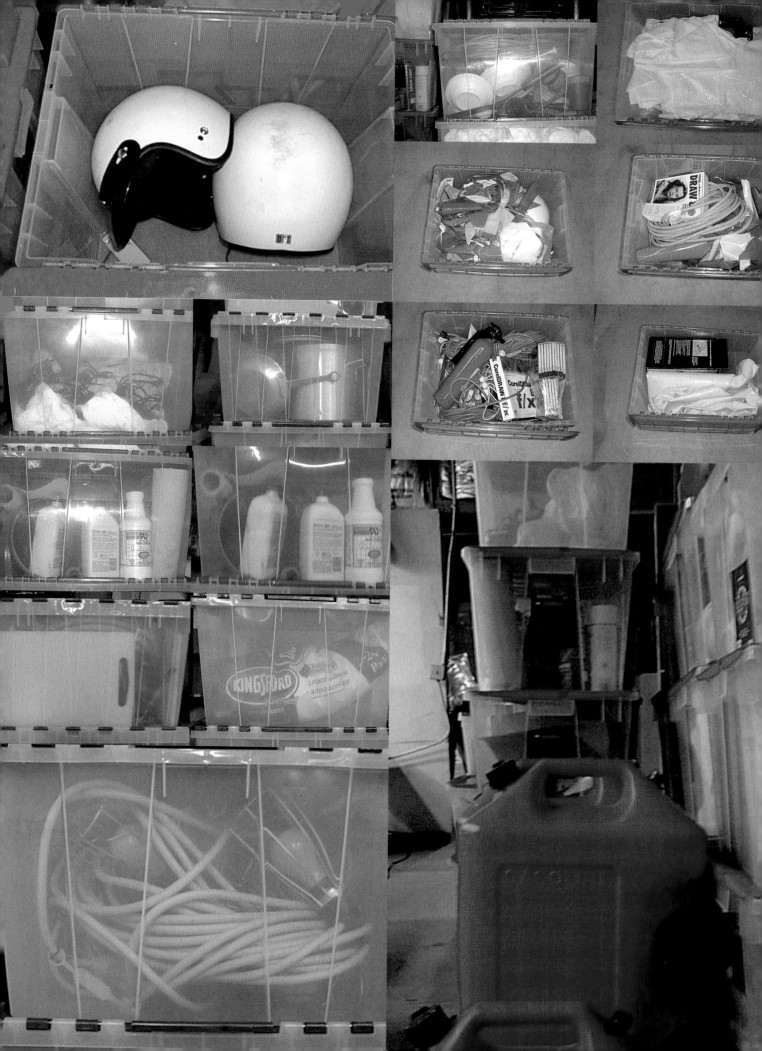

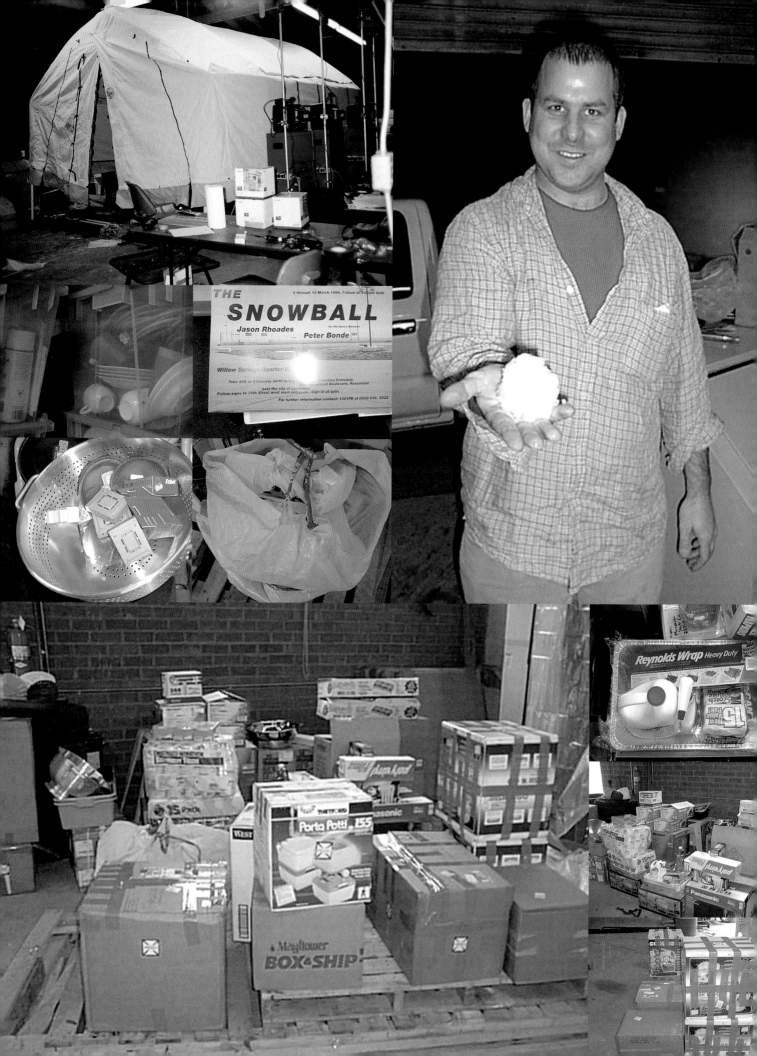

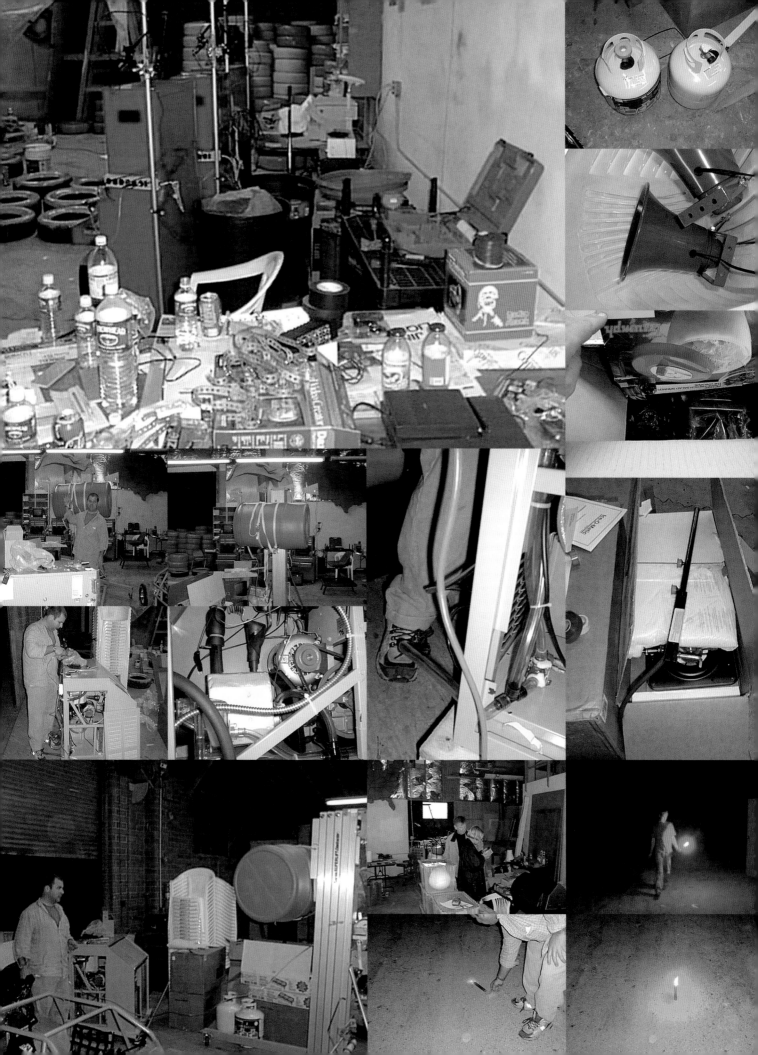

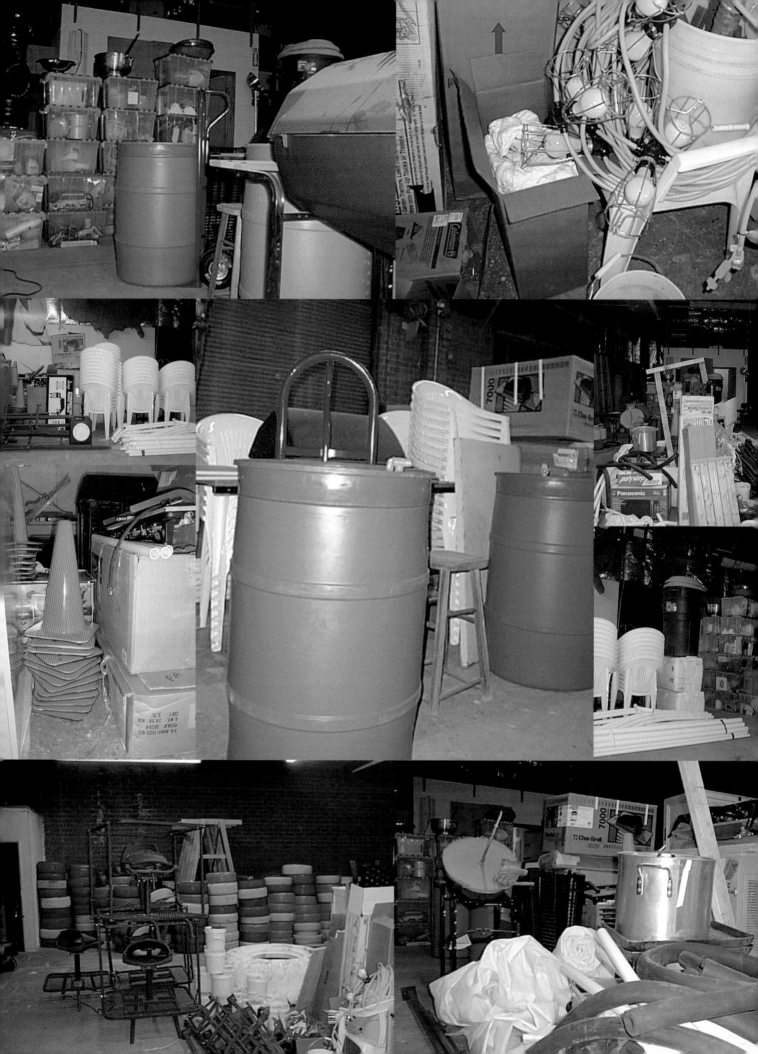

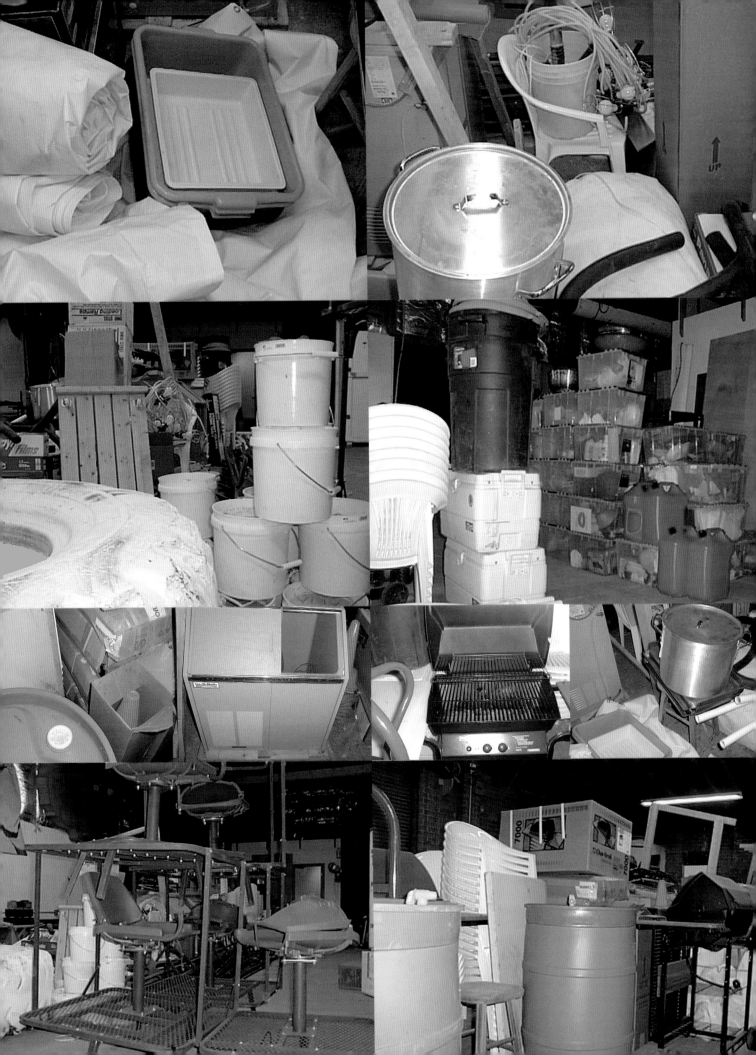

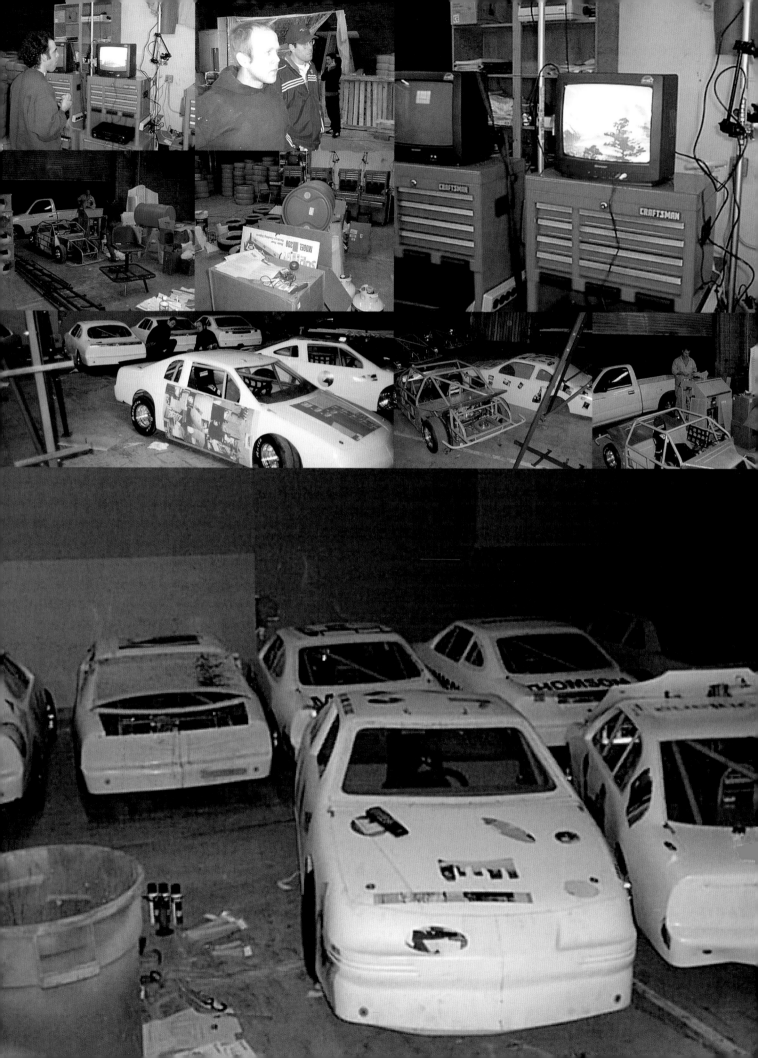

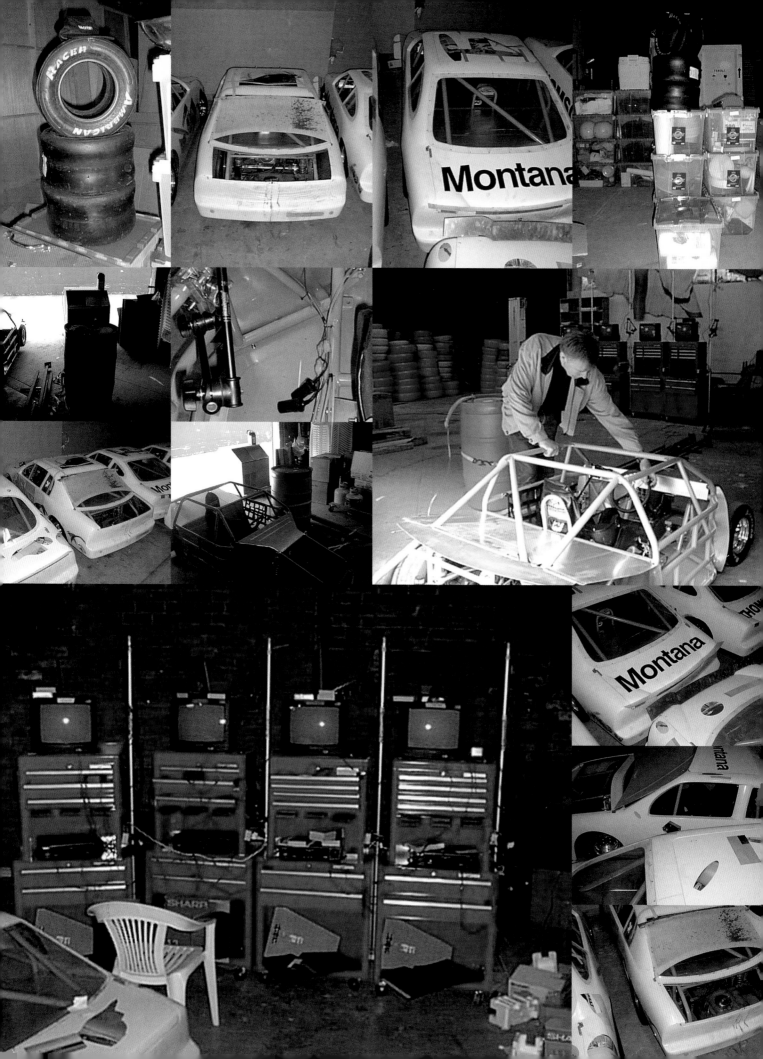

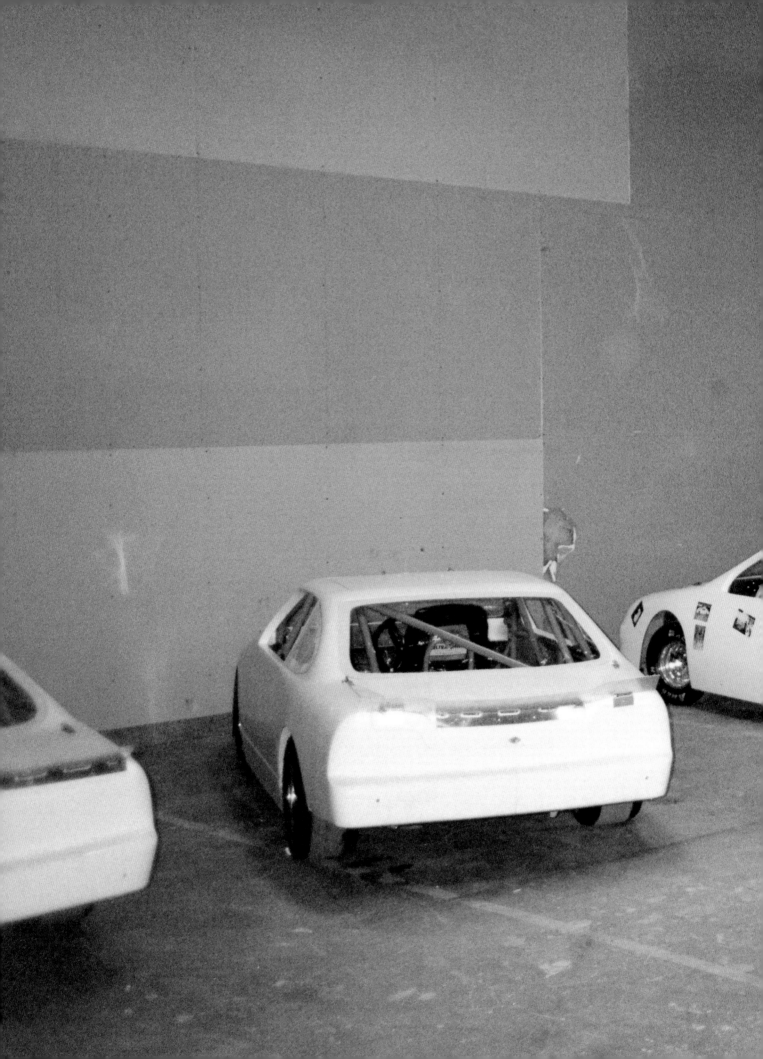

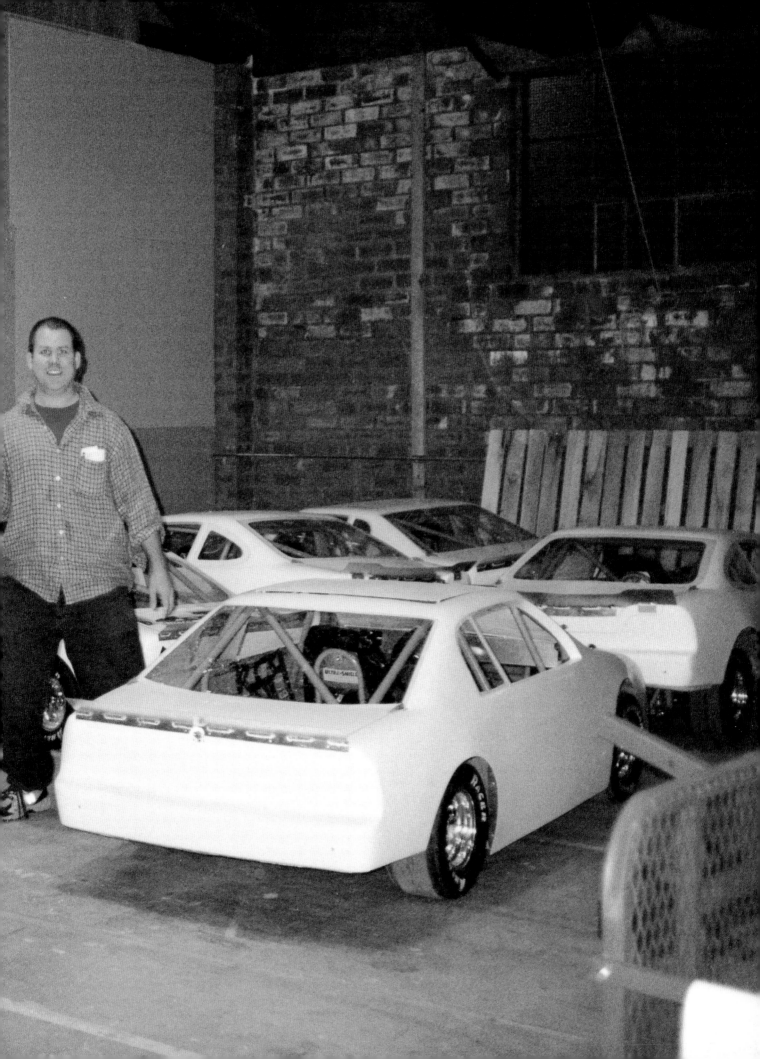

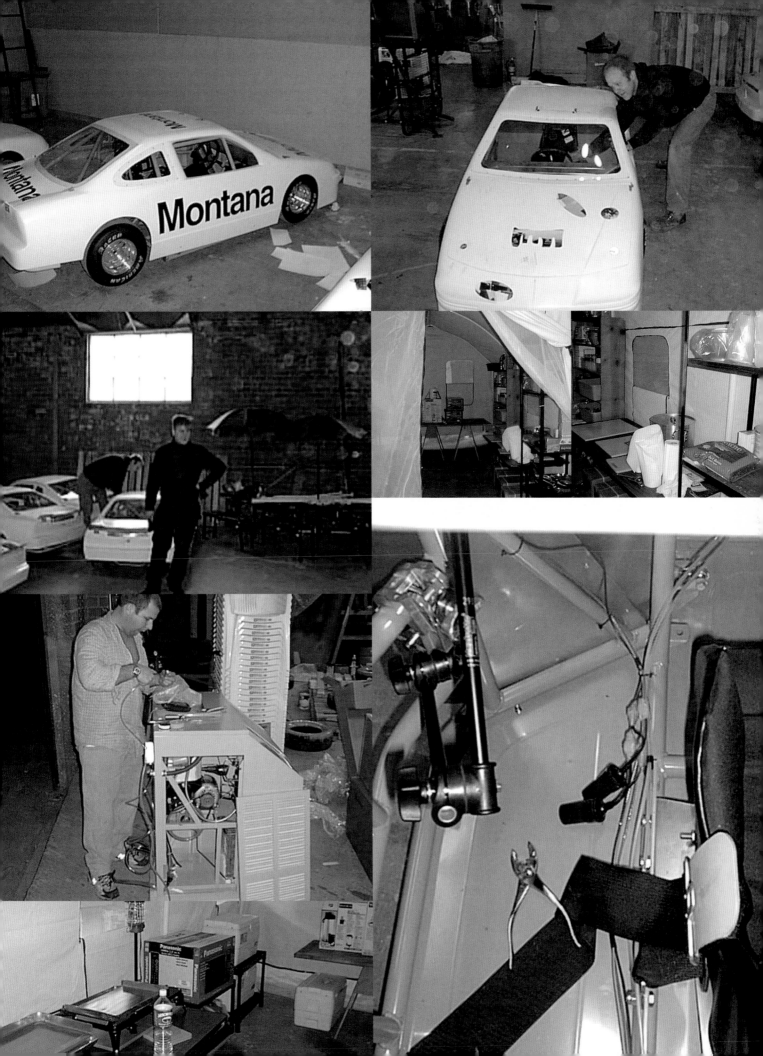

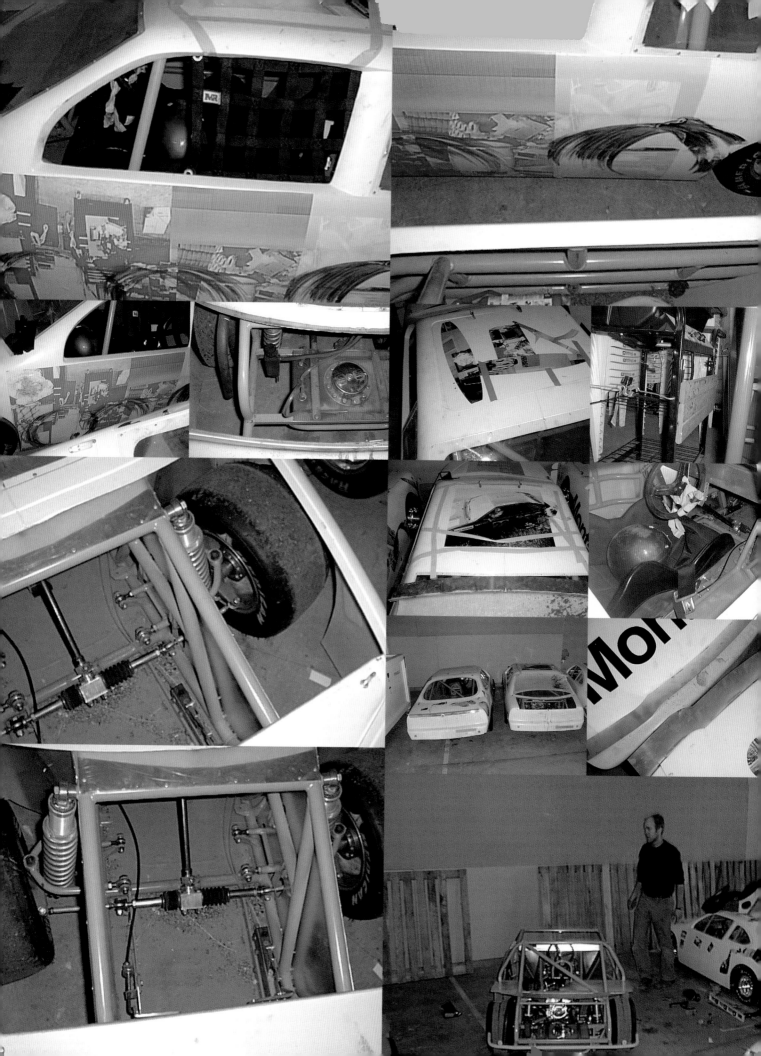

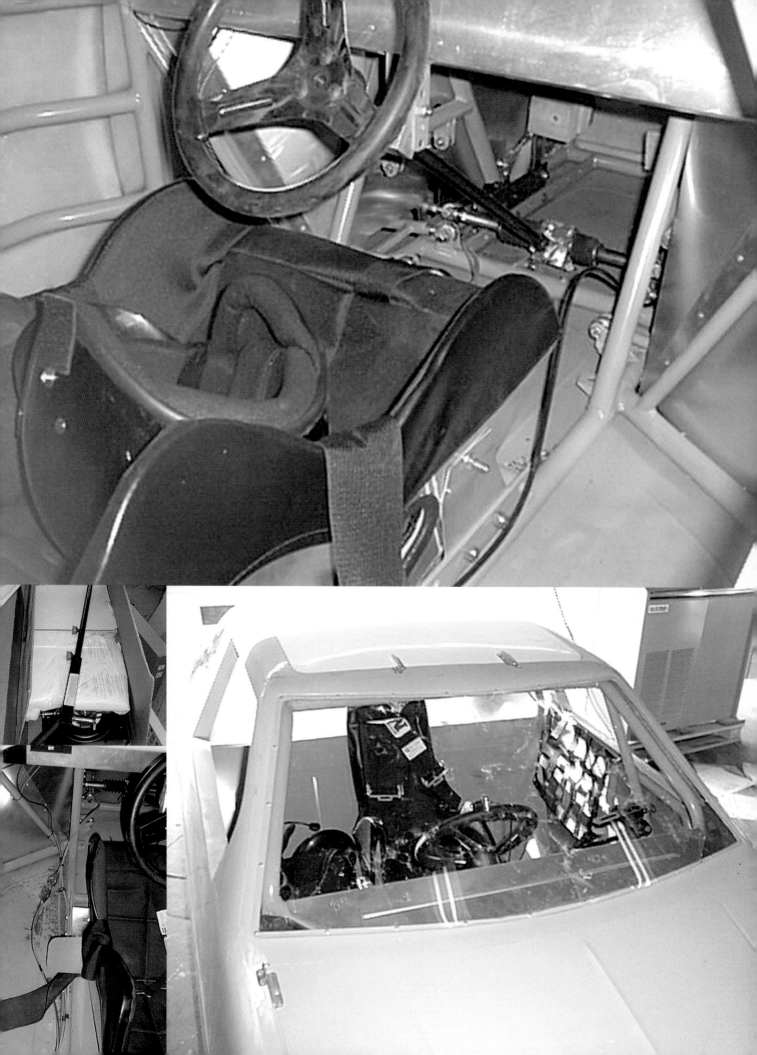

The Oval Interview

PETER BONDE

JASON RHOADES

MARIANNE ØCKENHOLT

JÉRÔME SANS

JÉRÔME SANS: Peter and Jason, could both of you tell us where you met?

JASON RHOADES: We met at the airport in Copenhagen. I saw this tall guy with no hair, wearing a leather jacket.

PETER BONDE: You had heard about me?

RHOADES: I had heard about Peter, and I came to Odense (Denmark) to teach a workshop with his class.

MARIANNE ØCKENHOLT: When was this?

BONDE & RHOADES: Four of five years ago.

SANS: How did you become friends?

BONDE: I don't know if we really are friends.

RHOADES: It's a dynamic, as we like to call it. It's a relationship.
I don't think we've really spent enough time together to really know each other's work or know how each person would work together. That's part of the experiment. I would say of the endeavour.

SANS: Without knowing each other that well, how come you accepted the idea of collaborating when during the Fall of 1997 I suggested the idea for an exhibit in a Danish Museum?

BONDE: Already in Odense, we had actually been talking about the possibility of doing something together, at some point, without really making anything clear – you know just dreaming a little and joking around – but at the same time actually meaning it. Afterwards it was always in the back of our mind.

RHOADES: There was this kind of a weird interest that Peter had, I thought, from NASCAR style car-racing. As for me, I am interested in Formula 1.

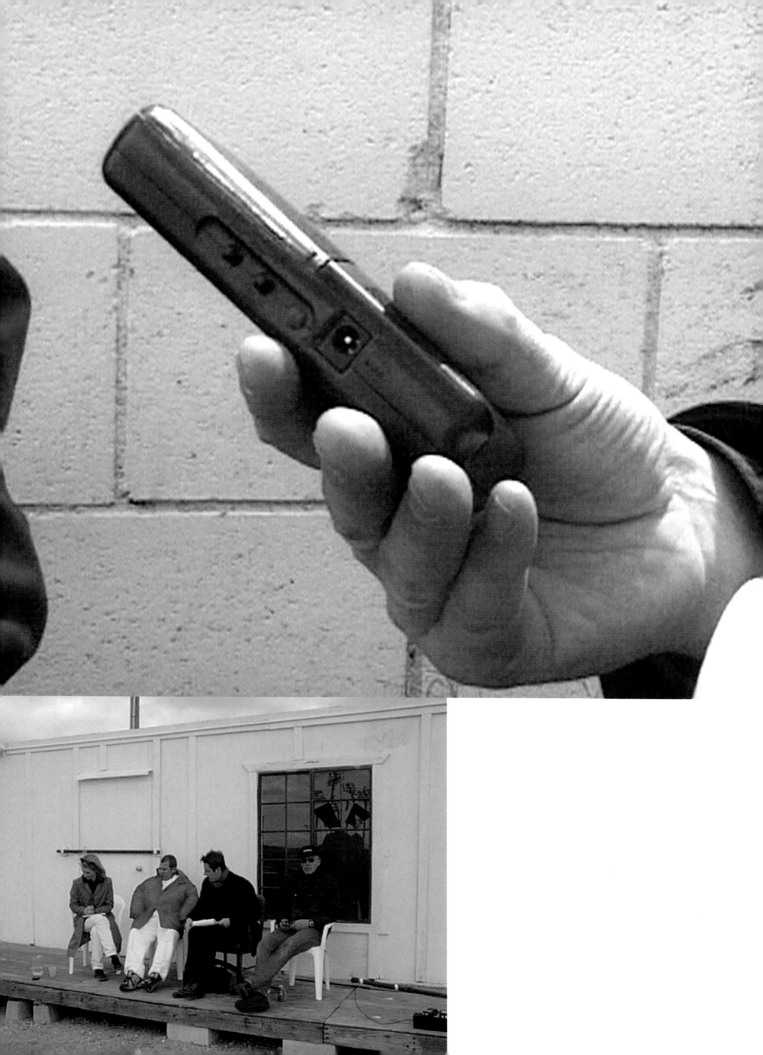

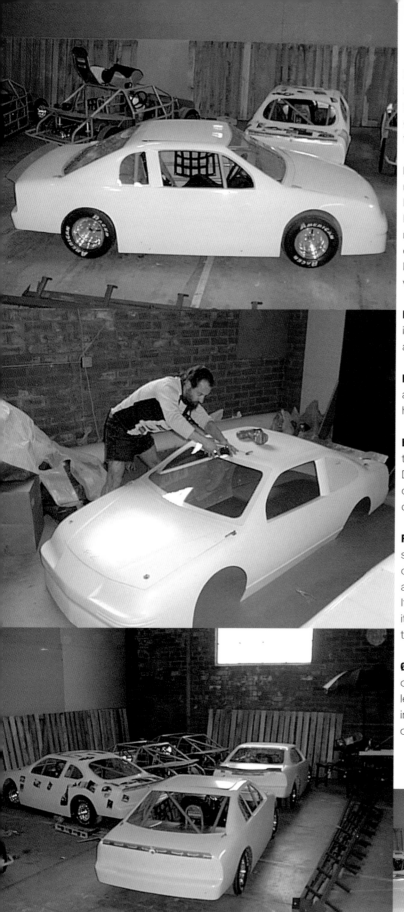

BONDE : Yes, that was the initial idea. And I suggested that a collaboration between Jason and me maybe started out from this shared interest in car racing, and race film, and the whole aesthetic of that field.

RHOADES : Peter's interest in American stock car racing and my interest in Formula 1 are kind of weird. It's a little bit like doing it with a European, in Europe. Taking these two different backgrounds and meshing them together seemed like an interesting challenge actually – and I'm not afraid!
I found it was interesting to try something like that – it was on a very small scale at that point.

BONDE : It was more like an idea – we weren't sure if it was going to happen or not we just kept talking about it.

RHOADES : It was kind of the thing you always talk about with certain people and hope it will never happen. Then Peter called.

BONDE : At some point you actually try to do it! But at the beginning, it wasn't real until Jérôme Sans and a Danish Museum approached me about a collaborative project with Jason. From there, it developed into a normal brainstorm.

RHOADES : Peter really had an idea. It started very small and it started to roll forward, without my control. The weird thing is I don't think I even ever agreed to do a project formally.
It was more like a small thing that went on and had its own momentum with it and that's what we're trying to keep going.

ØCKENHOLT : Did this situation of not being in total control of a process, and the idea of giving in, and letting the thing happen, actually become an important part of the whole structure of the collaboration?

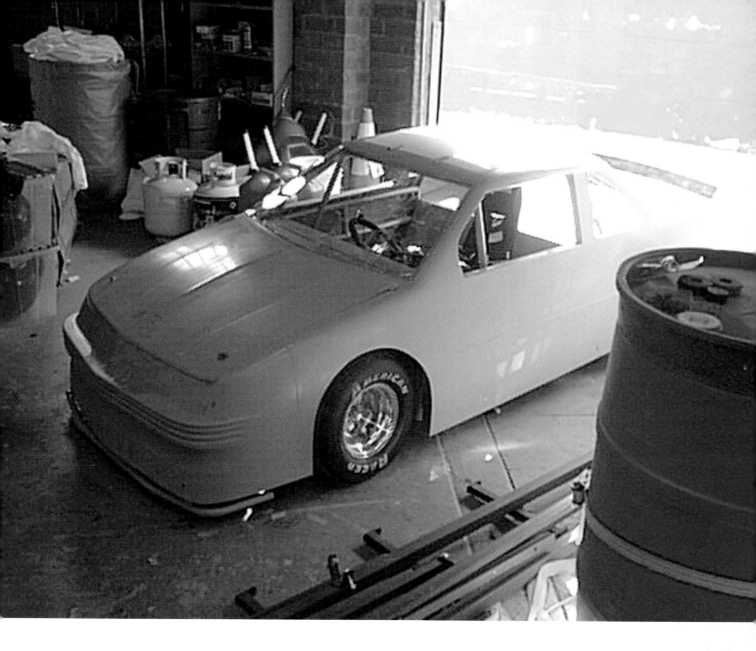

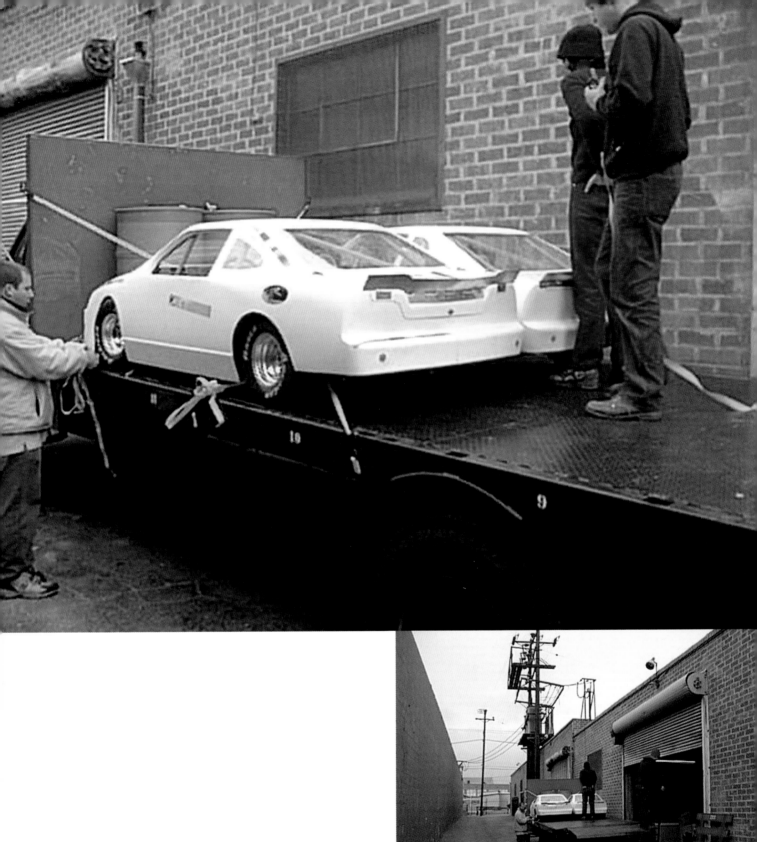

BONDE: Yes, in a way. As Jason says sometimes the momentum of the project itself becomes crucial. And that is very much what we intend with this project, too - it gets bigger, incorporating ideas and new stuff as it proceeds. It has a dynamic of its own, that we can not really control.

RHOADES: To sum it up: it started very small and then it evolved into something else.

SANS: So it was really like a snowball?

BONDE: You could say that. But the snowball came later on.
By the way it really snowed back then in Odense.

RHOADES: One day I woke up and there was a lot of fucking snow on the ground. And it was cold!

SANS: Let's go back to the snowball.
How did you actually reach the idea of a Snowball?

RHOADES: Just like the process of pieces of shit, kind of meeting in space, the way a comet would start - by momentum - things in the air, building and attracting other things, attracting other things, attracting other things and attracting other things. And it goes on without you. It develops its own momentum out of something that is so ephemeral like snow, ice or dust. Something very physical and very emotional and very dangerous could come out of it. It's playing off the whole idea of the comet running into the earth.

ØCKENHOLT: Is this project all about the concept of the snowball as a phenomenon that adds material, goes through different stages and changes according to its environment?

RHOADES: It runs through the whole project. Being able to accommodate certain people – or influences, being able to accommodate advertising, being able to accommodate all this shit out there. That was part of the idea.

BONDE: The exchange of energy, which the snowball represents, seems important. And also the idea or principal of inertia – this ongoing movement of the rolling snowball – is very much part of the idea. I like this very simple thing referring so specifically to energy and rotation, which is also very characteristic of car racing.

RHOADES: As well as this redundant American thing, which I saw in NASCAR, which has the physical and formal elements of a snowball, such as a solar system might be built – things come in and spin.

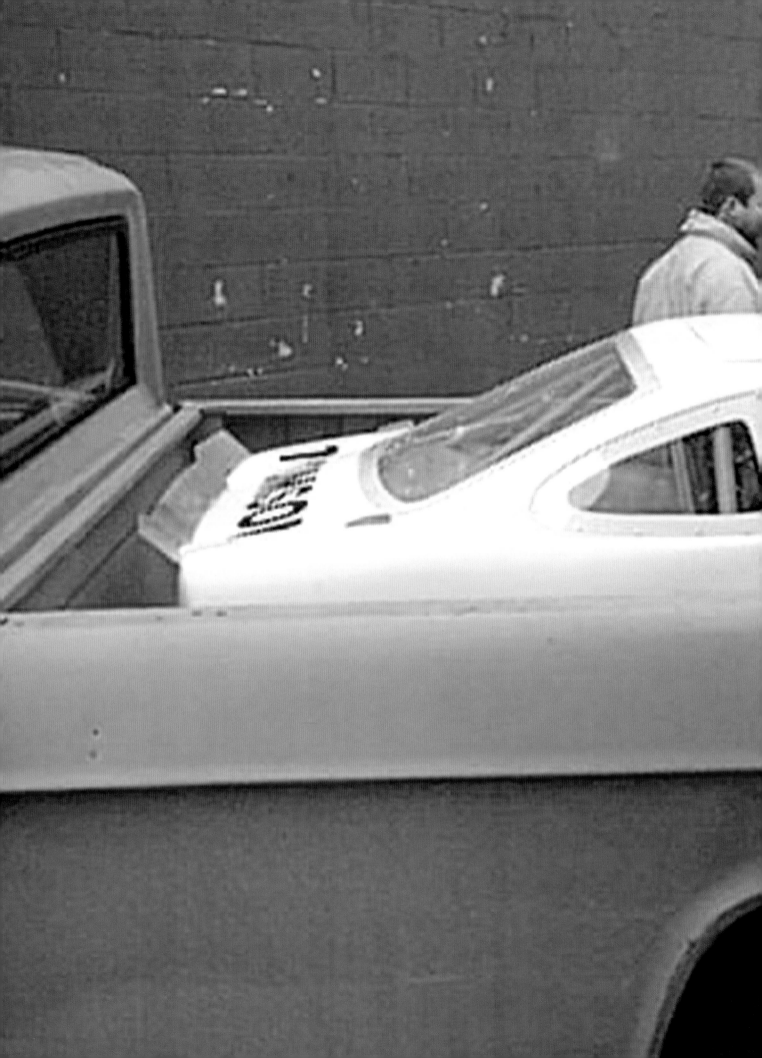

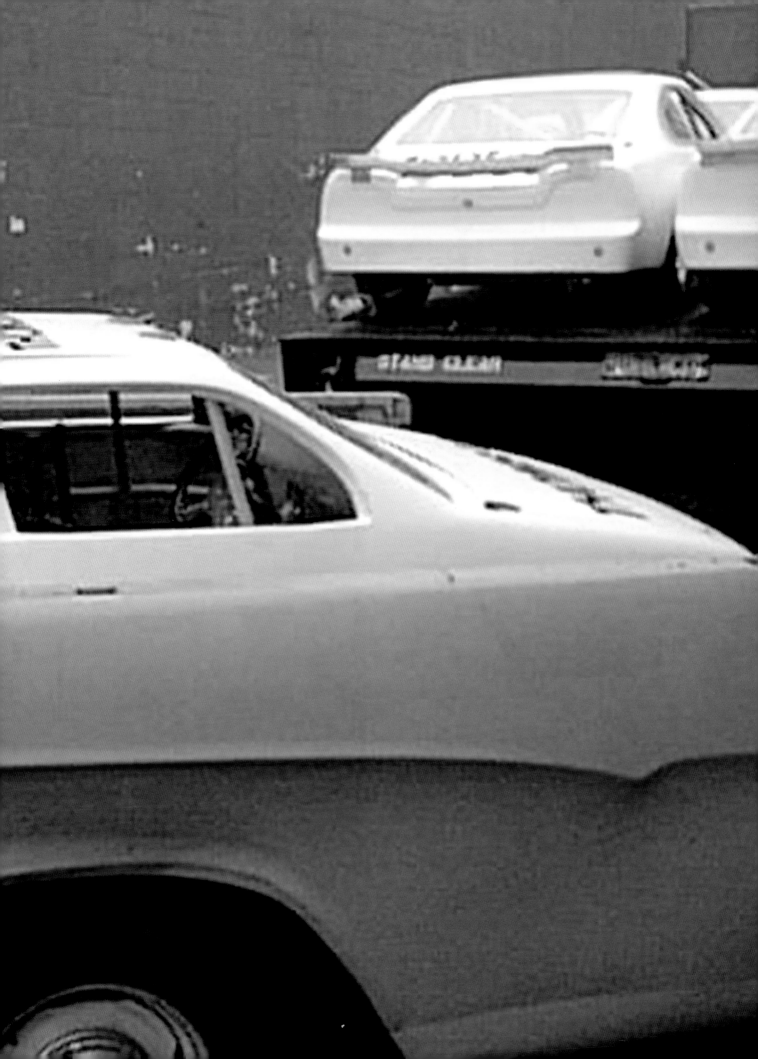

SANS: The snowball is a metaphor of a laboratory – of an open platform. It's a laboratory of ideas.

RHOADES: Yes. It's a platform and then it evolved into a more formal idea. The idea of a panel discussion, of being able to bring things and drafting their momentum in a way you would draft in a car, you would get behind a car to get it going, and being able to harness the energy that people bring to it.

SANS: It's an unfixed open form which is normally the case of an exhibition.

RHOADES: It has the capacity to evolve and to become bigger. It has the capacity to go on. We're just at one point. It's not beginning or ending here. It's just one part of the Snowball. The idea that a performance could become a sculpture which could became a performance again, which could become a piece of architecture, which could become a piece of garbage. Maybe it busts up, maybe it doesn't.

SANS: It's a fluid structure.

RHOADES: There's fluidity to it. But a structure nonetheless.

BONDE: It might also melt. The Snowball might melt, you never know if the heat gets too high.

ØCKENHOLT: Do you think it might stop rolling at some point?

RHOADES: That's the idea: it could melt down. After all, it's a flying ball of ice propelled by a few individuals and other energies coming in.

SANS: How do you include these energies in the Snowball?

RHOADES: You make an enticing thing and draw them in – and slam the door shut and they're too involved to get out – you set up the forum.

SANS: Where is the limit of this opening?

RHOADES: The limit of the opening where somebody could come in and do what they want? That's what we're discovering. That's part of what you would call this «laboratory idea». Where the lines are drawn. That's part of the experiment.

BONDE: The lines pop up by themselves.

ØCKENHOLT: What is the link between the race car going round and round, continuously, and the snowball?

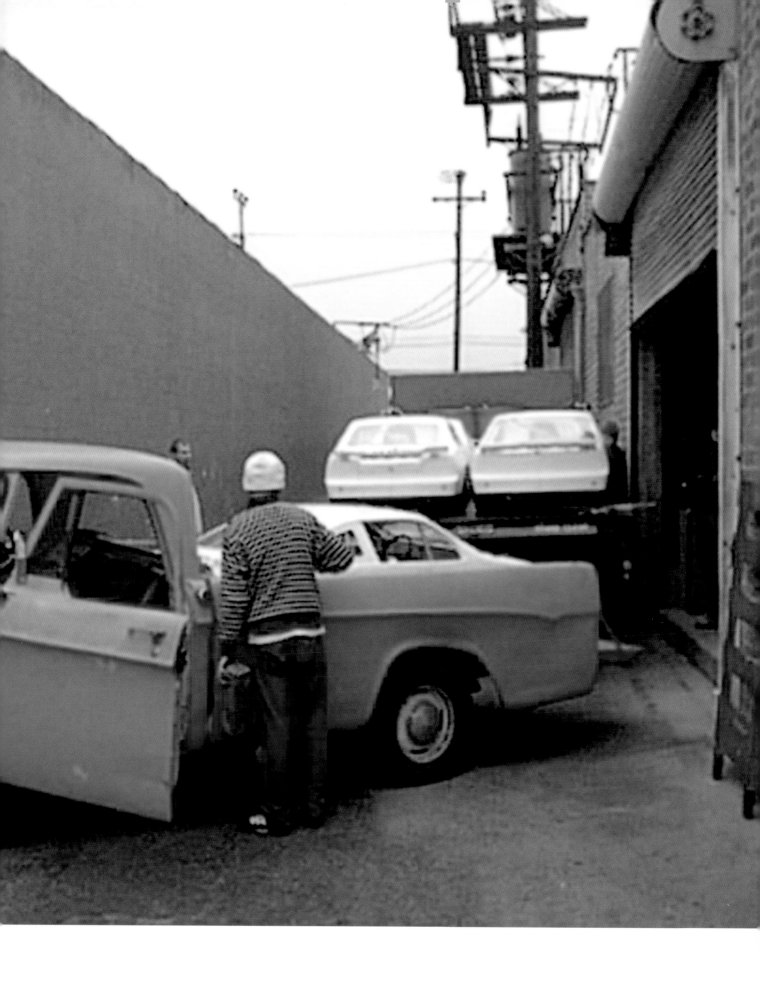

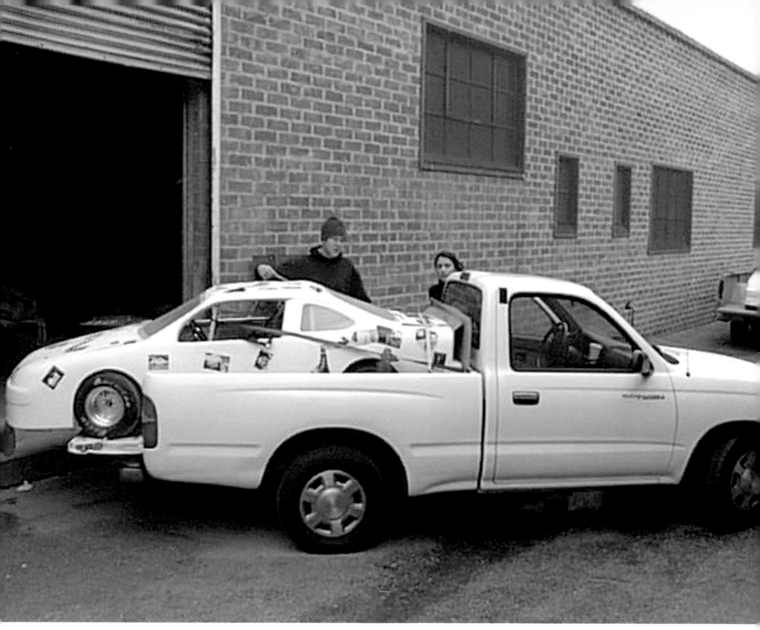

BONDE: I think the car is the motor, like the generator. The car – or the racing – is an excuse for all the other things around the cars which somehow become the really interesting part. The competition, the sexuality, the repetition, the communication, or whatever. And ultimately the whole thing is just an excuse for all the rest.

RHOADES: It's somehow a bait. People are enticed by a certain competition or a certain mechanical thing. The lust for the internal combustion engine. It's a boys-and-cars story.

ØCKENHOLT: When the cars have been around driving for a while you might have an idea of the logic of a race, but in fact you are not able to see what car is actually leading the race because they pass each other and form one long tail of cars.

BONDE: The idea is that you think it's part of a race, but it's not.

RHOADES: Exactly: there is no race. It was never intended to be an organized race. There is never a stop and never a finish. We don't even have any flags. It wasn't about the celebration of victory.

SANS: It's more like a platform of experiences.

RHOADES: It's a platform, I would say but an open one. I see it – but that's me personally – as a weird panel discussion where certain people and certain things are invited in and then they're put on stage, where the audience is participatory.
Once you're in the whole machine...it's too late. There is no spectator, no performer. It's just pure energy or information.

RHOADES: The oval structure is a perfect forum. It's the grand forum for all discussions and all information set forth from Rome to the Superbowl.

SANS: The name of the Willow Springs race track, «Paved Oval», echoes the antique oval Roman «agora». Since the shape is a little like a loop, where driving is continuous, with no end and no beginning, it's not a race in that sense, just a place to perform, to experiment with no idea of loosing or winning, but the idea of participating.

RHOADES: And just building on that idea.

BONDE: In a way it's really a stupid event, people are driving round and round. At a certain point you can

say the looser is a winner and it's much more about the audience, about the show. It's not about the race, it's about the whole show.
Who wins is unimportant.

RHOADES: It's decided, we already know who wins.

SANS: I think there is something very important here. It looks like a Grand Prix. It's kind of an irony to bring this Snowball project to Venice, where all the nations, represented by their pavilions, are racing to win the prize. But what does this nationalism mean today? How can we continue to follow this model? Why remain insular? Why not open the barriers and start the dialogue? Where is the global village? In order to establish a true competition, all the participants must have the same means.

RHOADES: It has a lot to do with the idea of conversation and competition. This interesting thing where one is driven to compete but within this competition you can chose to have a conversation. But you might not compete at the same level.

BONDE: This has to do with the Venice Biennale in a way: somebody actually wins prizes, but nobody really cares.

SANS: The Snowball in itself offers the possibility of an open dialogue. It's more a situation than a race.

RHOADES: Hopefully it won't be a static thing. It doesn't have to perform for anybody and doesn't have to sit there as a dead thing. Hopefully that's part of it. That it stays open, that it's accommodating.

ØCKENHOLT: This project is ambiguous. On one hand there is a very formal structure where everybody has to fit in -this oval running round and round – and yet there is an openness within the structure. In a way, you repeat this ambiguity when you place your dynamic Snowball installation within the very static structure of the Biennale itself. There seems to be a permanent tension between dynamics and structure.

RHOADES: Control and un-control ability.

BONDE: It's also about capturing images. You have to make that visible sometimes. You have to stop the ball. You have to shoot the picture. You have to install it.

RHOADES: The Snowball does not end at the Venice Biennale in the Danish pavilion; it didn't begin at the Pavilion either.

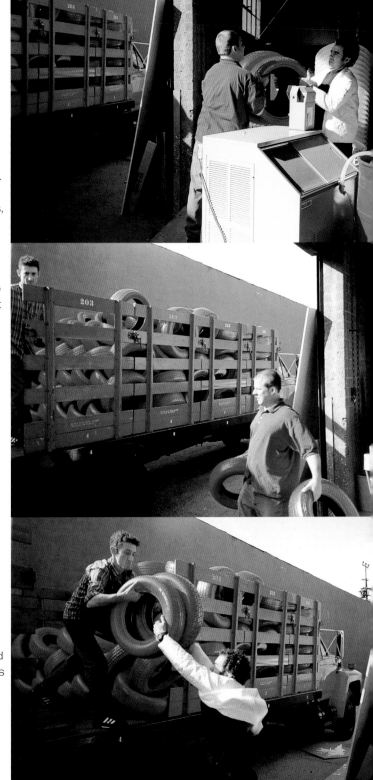

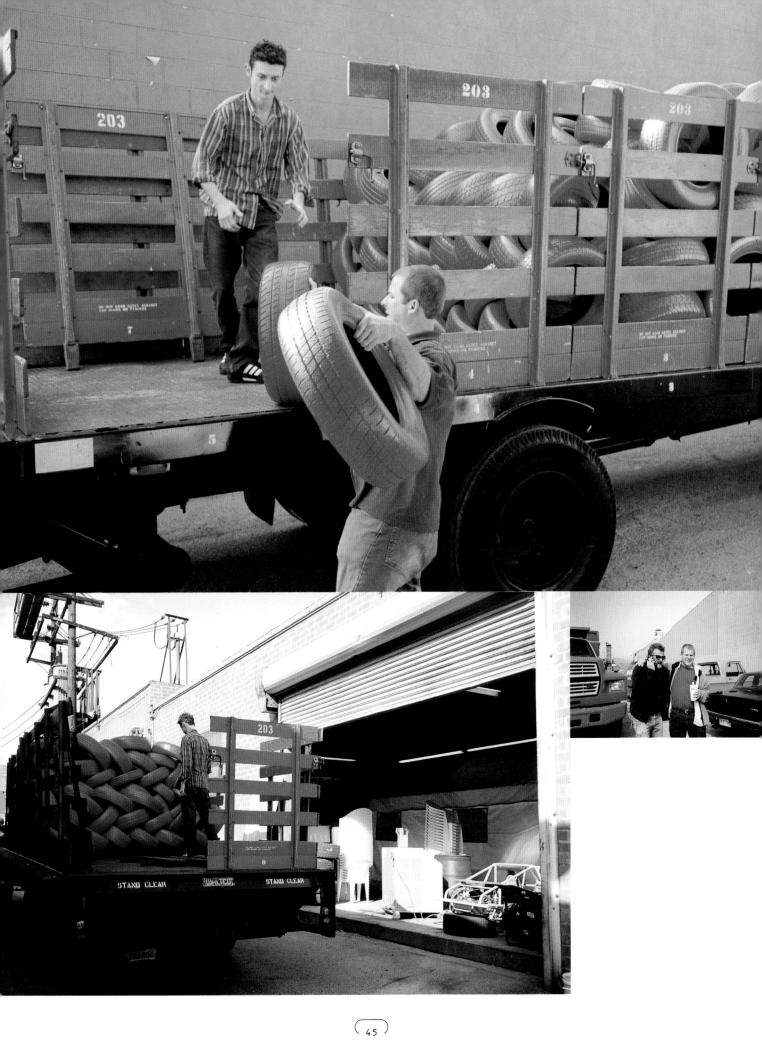

DO NOT LEAN GATES AGAINST
CAB DOORS OR FENDERS

12

12

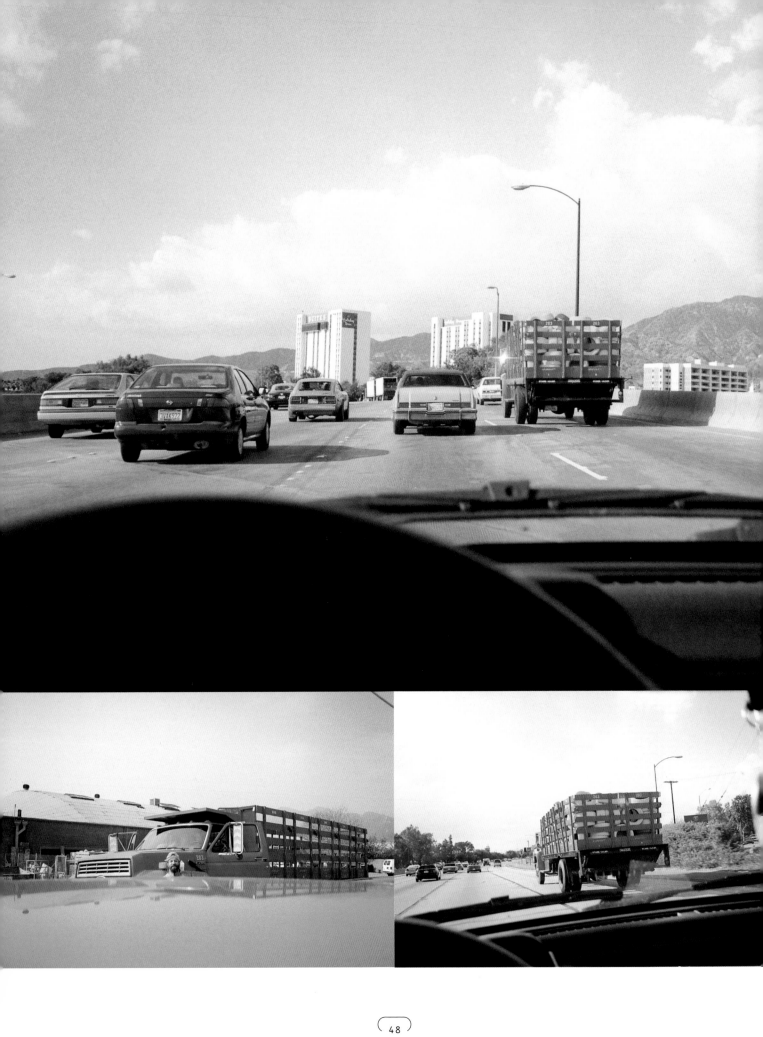

The Pavilion is just a stop. It goes out of our hands, maybe it can be done without us in a way.

ØCKENHOLT: Within the static Biennale setup, you have a dynamic, energetic thing going on. Your idea of movement, openness, and lack of control is in total contradiction with the concept of the prestigious, formality of the Biennale – just like the very architectural set up of the Danish pavilion refers to a totally different, conventional idea of the art piece as an ultimate and finished statement.

BONDE: We don't know what will happen. That's part of the dynamics as well –that the snowball is propelled into these different situations, and that it clashes with meanings and ideas that are beyond our control.

SANS: When an autonomous work of art is created, its destiny is unknown. The Snowball plays with this metaphor of the work of art and its development.

RHOADES: The idea of these grand Pavilions in Venice is an absurdity. But here we have a Danish artist, a French curator, an American artist and a Danish curator. It's an odd bunch anyway. It's a bit dysfunctional, too. In a way it's an impossible project – building it conceptually as a Danish thing – filmed in Los Angeles, brought to Venice, and then sent on this weird tour. That absurdity and that dysfunctionalism are an important part of it. The logistics are crazy.

SANS: It's a challenging project. Normally for such an exhibition, things are very fixed, very set: a curator, a place, a project. This is also what we are living here - at this very moment, on this track, where everything can change.

BONDE: Hopefully nothing is fixed, and nothing gets too fixed in our minds. The project should be kept alive.

RHOADES: The momentum implies that things should be able to come in and out. This way nothing is static. Our project doesn't have to perform for anybody and doesn't have to sit there as a dead thing. Hopefully, that's part of it. It stays open.

ØCKENHOLT: You also use the video material from the races as part of the installation, and doing that you linger to a temporal or non-static aspect.

BONDE: Yes that's right, in a way. Of course film and video will add dynamics. But I think we will try to handle it pretty much as the rest of the material and the other elements which are part of the installation.

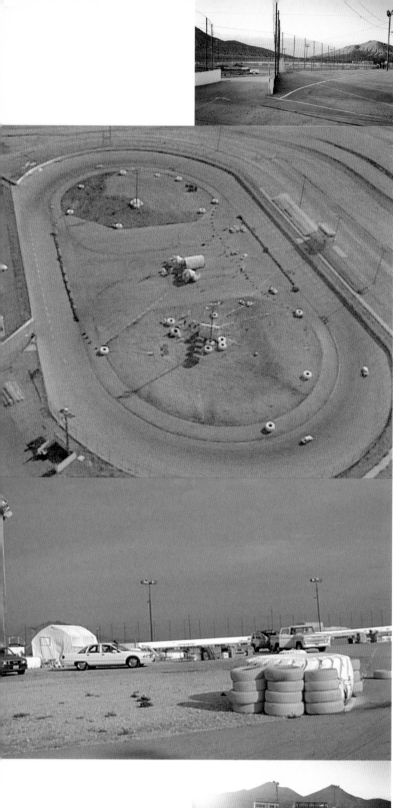

It's a specific kind of material leading to a specific kind of meaning and visuality.

ØCKENHOLT: This project is all about dialogue and change and evolvement. That's why the Snowball Tour, the future installations of the project in other venues, after Venice, become such an important part of the project itself.

SANS: It's like a snowball that is rolling from one place to another. That's why we subtitled it: «the ongoing-tour exhibition», in opposition to a traditional travelling one, which can only repeat itself at each new stop.
The Snowball is always «live». In each new place it is re-shaped, re-actualized, re-activated through new forms.

RHOADES: Hopefully, it will take on its own momentum. Actually it already has in a way.

BONDE: This ongoing tour might stop somewhere, but the idea of the Snowball will somehow keep rolling.

SANS: Is there an end to the Snowball?

BONDE: I don't know.

RHOADES: I think it ends and begins all the time. I think it ended today; it ends tomorrow. It begins yesterday. Each little part is just as important as the other part. It's a melting ephemera.

SANS: What different forms of the Snowball will occur in different places. Do you plan it ahead of time or is the concept open until the last second?

BONDE: It can develop in alterations. It all depends on the place and the situations.

RHOADES: I think it's interesting that after we're dead, someone could start it up again. They could do it. They could turn it on without us. There is enough information and enough stuff there that maybe it can be put on. It can just go on.

ØCKENHOLT: In the Danish Pavilion of Venice, you will install the videos and all these props from the races. How will you make this data into something other than plain evidence or documentation of an event?

RHOADES: I would never call them props. I would refer to them as parts of the Snowball – or parts of the project. Our job is not to archive them. Otherwise, the project stops.

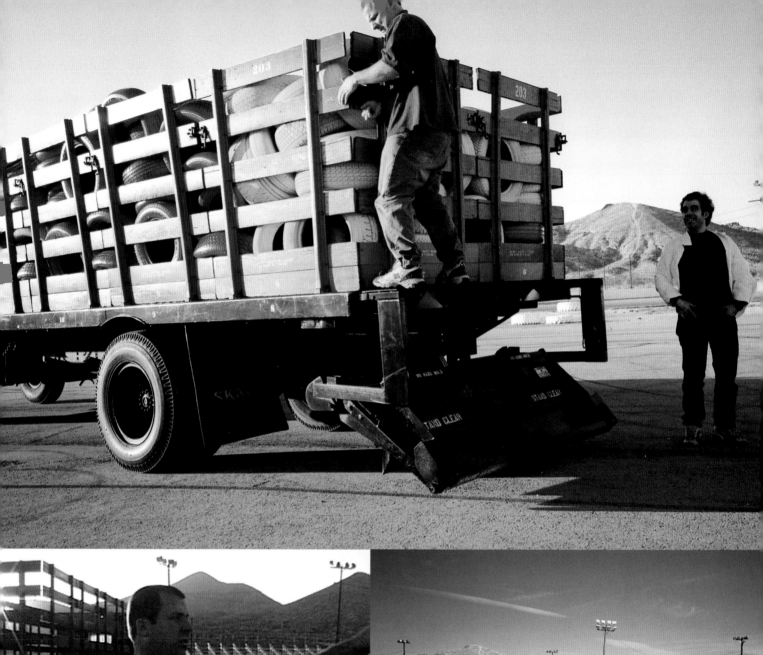

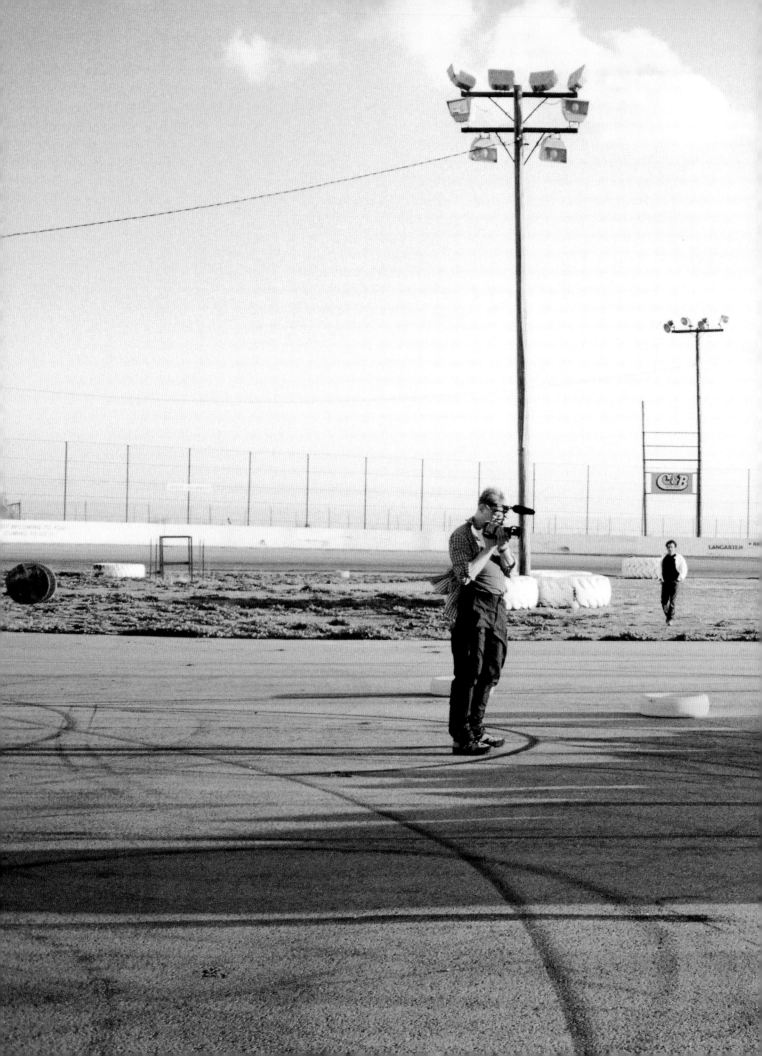

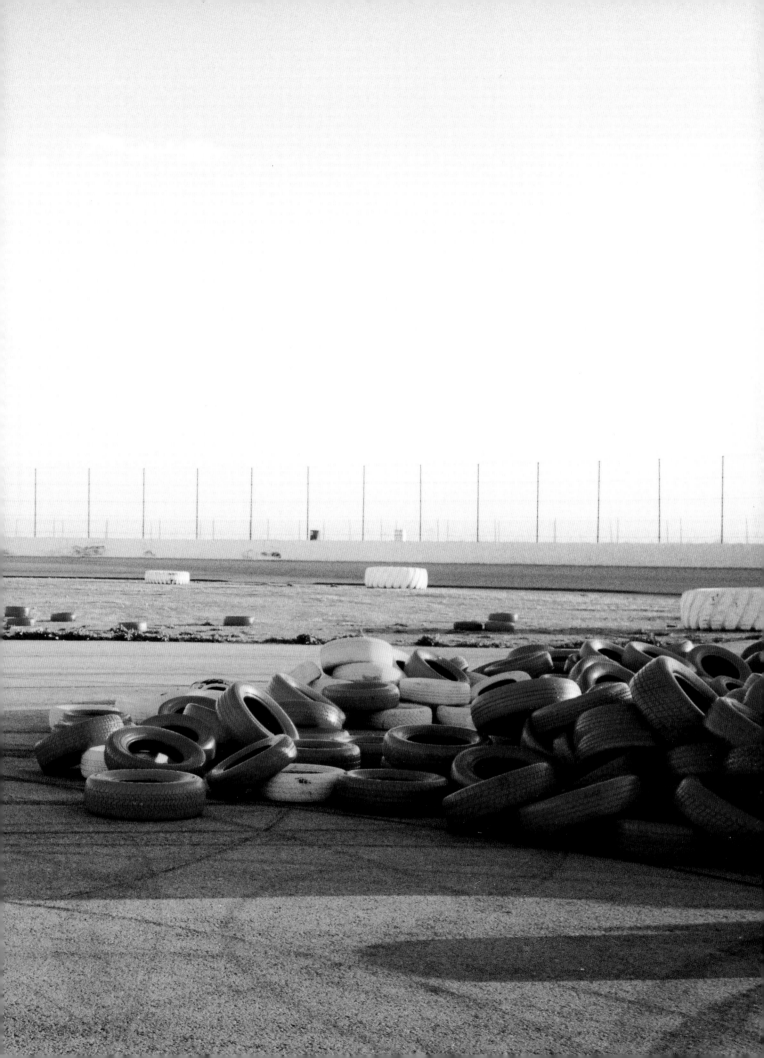

ØCKENHOLT: In the pavilion these things which had a very practical meaning and specific function during the races will turn into something else and take on other forms. The very process of transformation and adjustment is also part of the Snowball concept. The cars will not function – not be racing – in the pavilion. Instead they will be transformed into something else – maybe into sculpture?

RHOADES: Sculptures... relics... As we set up this whole thing visually: the images are taken live off cars during the races, and then printed as huge stickers and put back onto the cars again. The advertising for the piece is the piece: it's self-promotion, it's self-perpetuating.

BONDE: We are back to this image-as-image-as-image thing again. Image and depiction and objects relate and add layers of meanings to each other all the time.

RHOADES: What will be interesting in Venice is how we end up deciding what is really installed and what is not. To keep the flow somehow where we're not trying to crescendo it.

BONDE: In Venice, and wherever it's going to be shown afterwards, the importance is that it still rolls, that it's alive, that it's moving.

SANS: In this Snowball, there is a cold metaphor – a cold background with the ice, with the snow. Is it a reference to the obsessive presence of ice in America? In every drink, you have piles of ice and at the same time, there's a parallel with Nordic countries, where you have chilly winds. Americans have an obsession with being «cool!» Wherever you go, there's this dreadful air-conditioning.

ØCKENHOLT: Yes, it's amazing, coolness seems to be understood as the ultimate luxury here! Being from Denmark you just don't get it!

RHOADES: In Denmark or Europe, you can't buy ice. We tried to buy ice in Copenhagen once. We couldn't! Ice is a fantastic thing.

SANS: What is your relationship to this cold culture?

RHOADES: Ice is really alchemy. It's biblical.

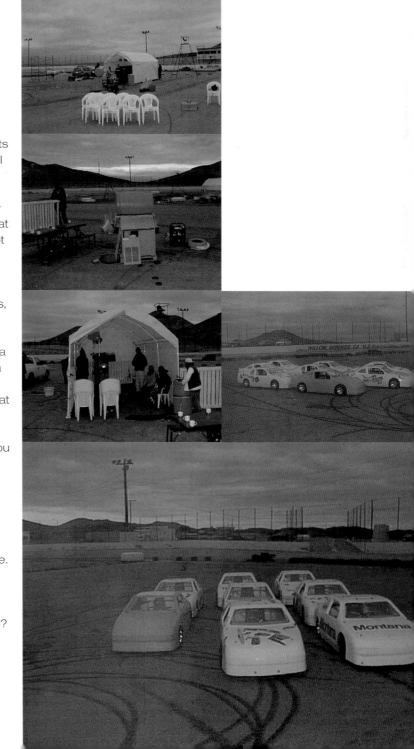

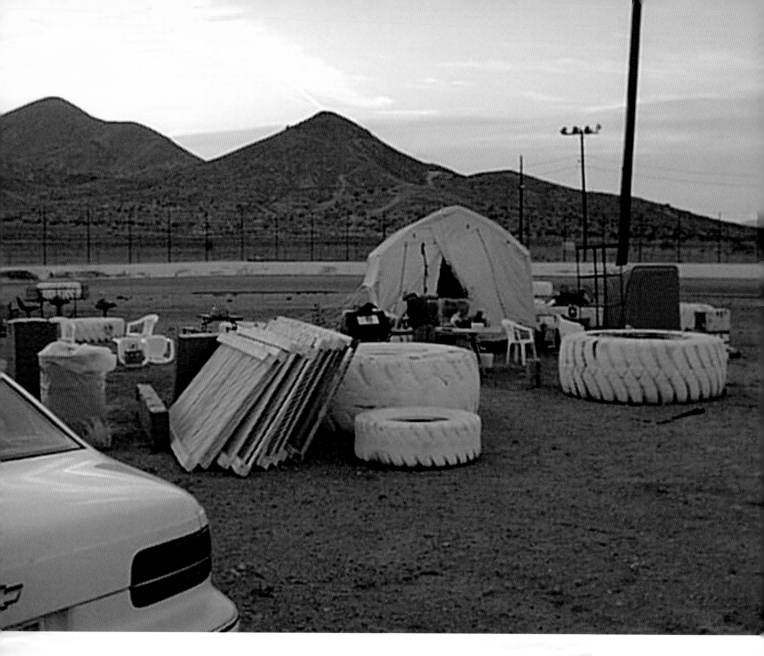

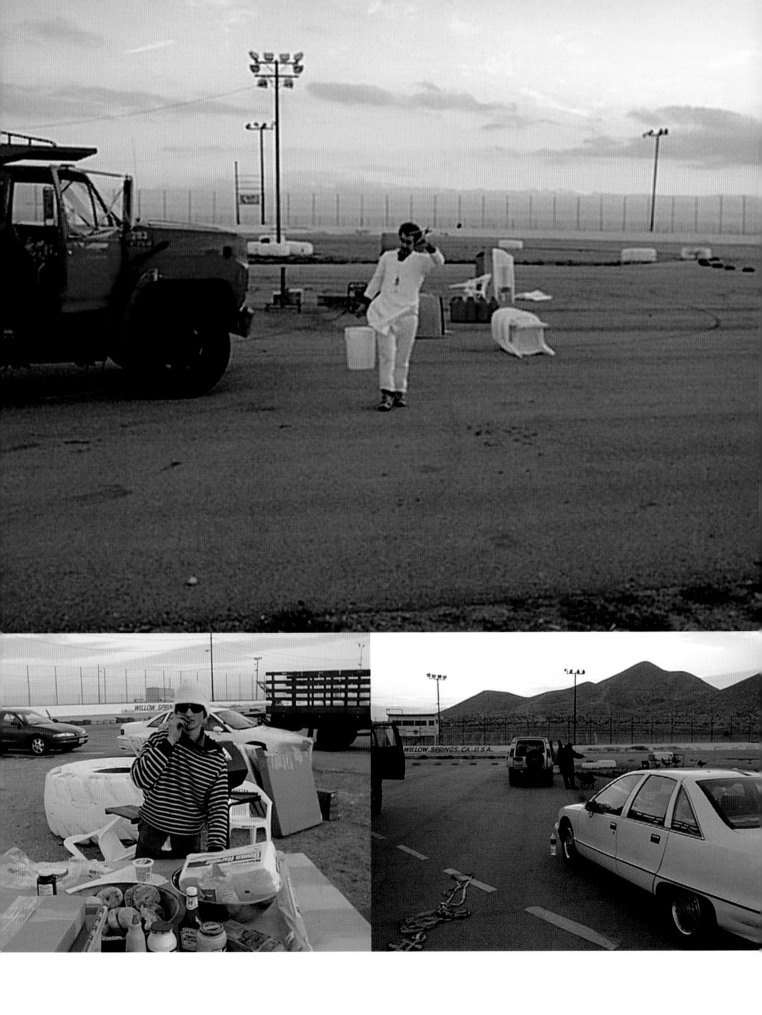

BONDE: In fact, it's actually heat that produces ice. That's a nice idea.

RHOADES: Early on when Peter talked about the project in Venice, the only thing I really thought would be a great work was to air-condition one of those fucking pavilions. It's so hot and it's so miserable and sweaty.

SANS: Don't both of you guys share this cold culture? You, Jason, the American, with your air conditioning and ice machines culture, and you, Peter, the Dane, with your Nordic climate and extremely cold weather?

BONDE. The reason you can't buy ice in Denmark is because the weather is too cold. It has to be warm.

RHOADES: I think there is a real need there and I've always thought that when the Snowball is shown in Denmark, we really should market «ice». Maybe the catalogue could come with a five gallon bucket full of ice. It's a great ephemera.
What a great place to put a sculpture: in your freezer!
You don't have to see it all the time. And it won't stink!
The ice machine, we have here as part of the project, produces snowflakes. This is snowball ice. It crushes the ice and makes 400 pounds a day.

SANS: And what do you use it for?

BONDE: Coca-Cola

SANS: It's the real American drink, a universal one that some people prefer drinking rather than any other liquid, just like you Peter!

BONDE: It's a great drink. It's my favorite.
I don't drink coffee or anything else.

RHOADES: And we didn't get them as sponsors? We should work on that!

SANS: That's another part of the Snowball which is very important. In Venice, as in most museums, sponsors are usually hidden. But with the Snowball, sponsors become active participants and their logos will be inside and outside the Pavilion itself. So the Snowball is reversing the system by putting the sponsors in the front instead of the back.

RHOADES: Yes, that has to do with racing where it's the opposite. It didn't really work like we thought it might, but that's good. It's an interesting function.

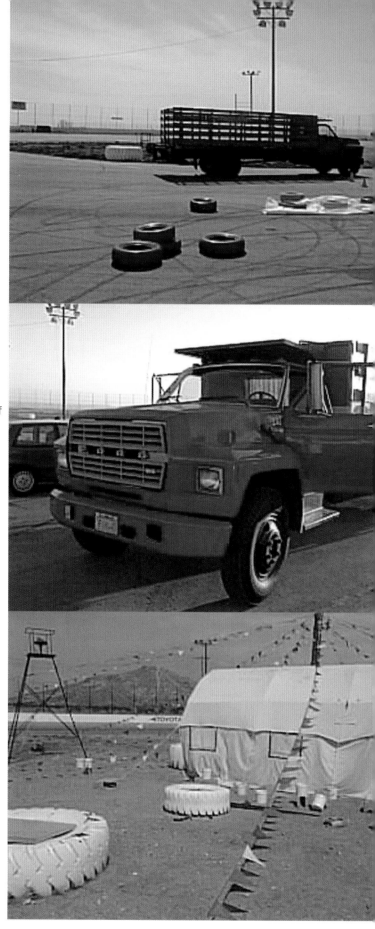

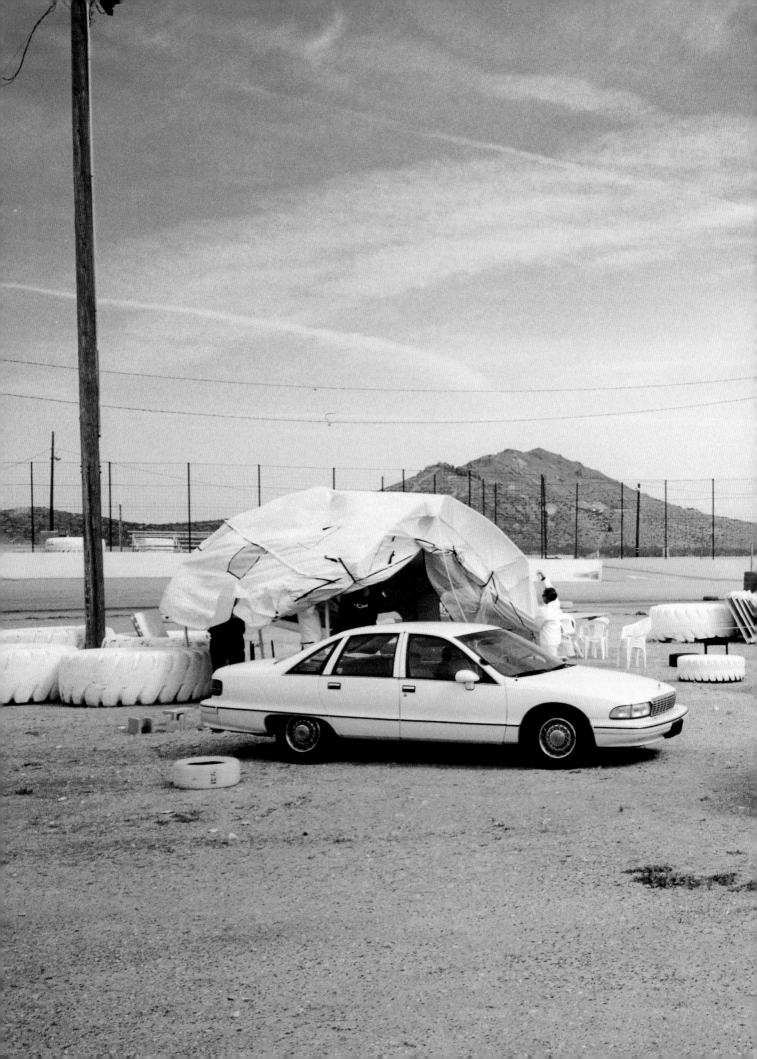

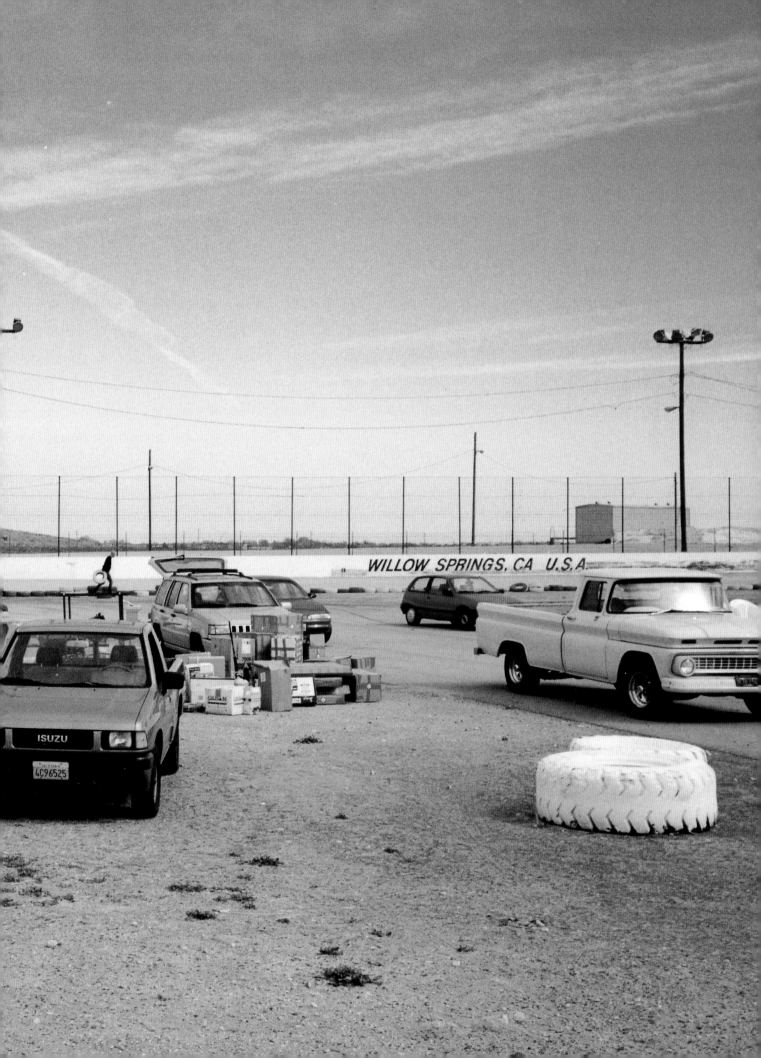

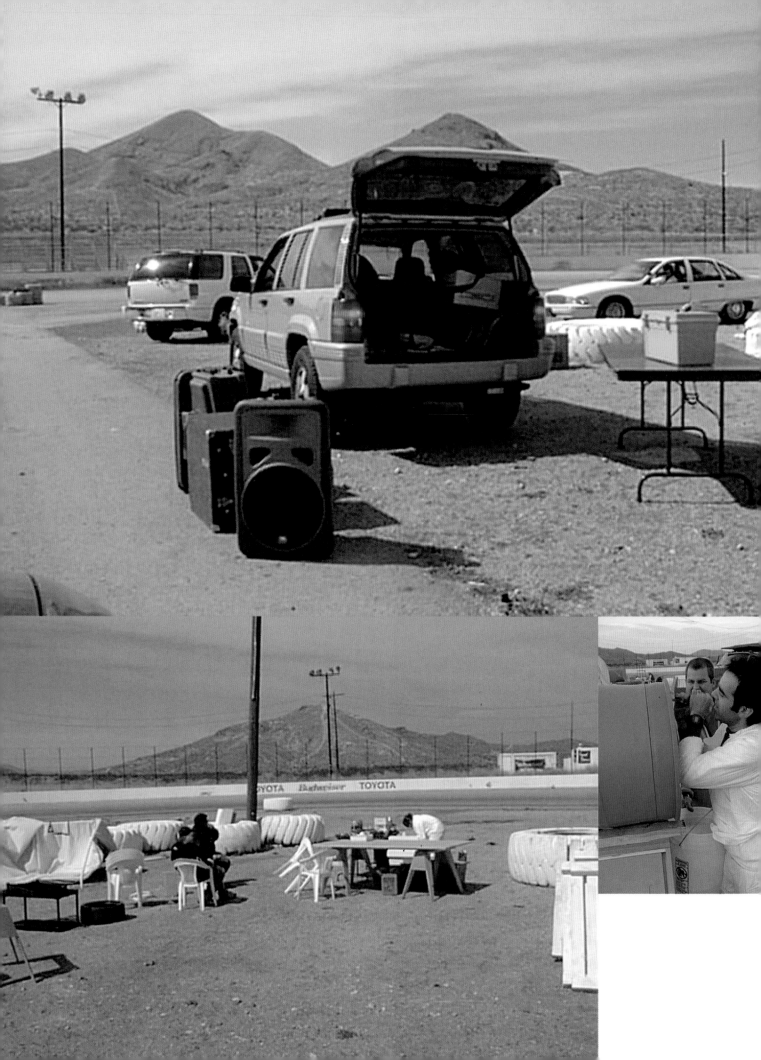

BONDE: Even the mini tape recorder you have in your hand is part of the Snowball. Even us being here is part of the Snowball. Everything here is part of the Snowball. It incorporates everything. And everything sticks to it.

RHOADES: We're trying to freeze it. We're trying to freeze the ephemera. Freeze the water and make it into a construction and then keep it cold for as long as possible and then it melts and goes away. The whole thing is just about being cool.

ØCKENHOLT: Obviously you share a fascination of motor sports. Digging into this material, you refer to a variety of images and aesthetics, linked to that environment. But how are you going to integrate the filmed material into the whole piece?

BONDE: The idea of the film or the video part developed into the Snowball pretty late. But racing and film are really linked together – it's all about speed. And racing generates pictures. You have these many different ways of depicting motor sports which you cannot really ignore or escape once you start exploring. Hollywood movies, sport transmissions on TV. All these connotations are part of the Snowball. It's also interesting formally. How the aesthetics of the moving picture clash with the static image of the painting or the photo, and how these different structures of imagery and meaning relate and influence each other.

RHOADES: There is a technology issue in the piece that's very interesting also. It only works to a certain extent, but then it doesn't. It's not an end-all thing whether it functions perfectly or not. The pursuit is there. The production value in car racing is one of the more interesting ways of making films or trying to capture this stuff and the dialogue that goes along with it.

BONDE: We are filming - not to document it, but to provide another textuality. We are driving around with these small cameras in the cars – as though we were inside a video game. While driving, you actually see your image on this little digital screen. It's weird. It turns the whole experience into a video game, instead of the real thing.

RHOADES: Motion, technology and quality refer to a video game, to virtual space. This video game become virtual while racing becomes simulation, and vice-versa.

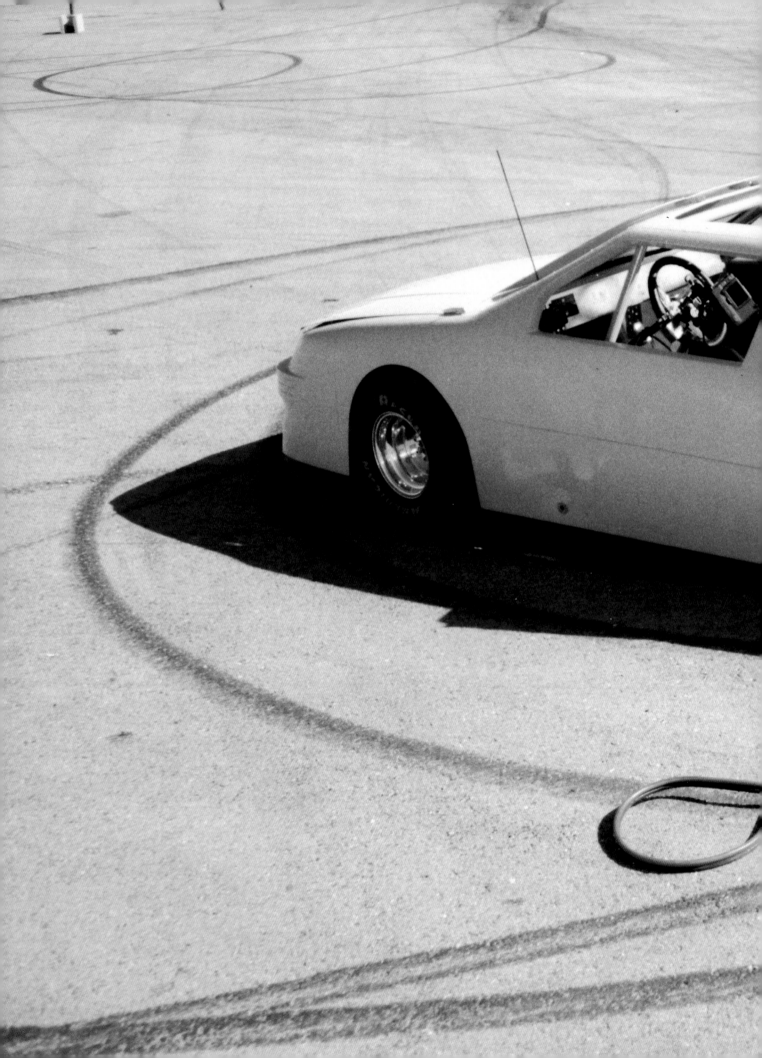

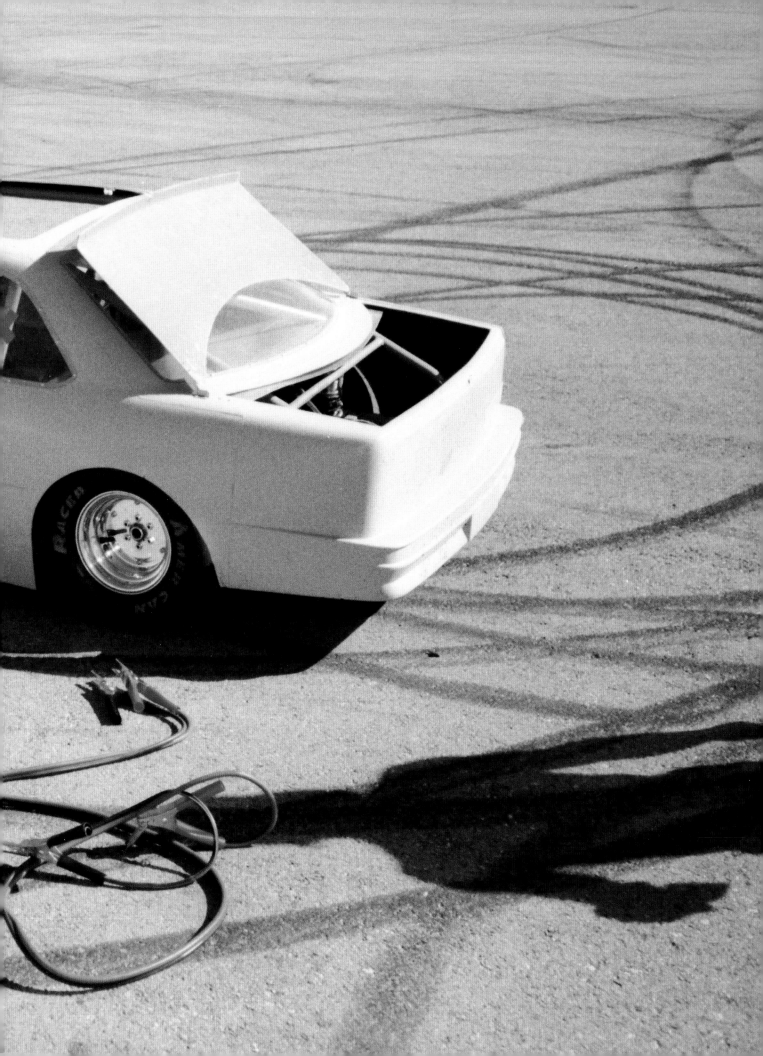

BONDE: I also think the idea of capturing speed by using a slow motion camera – as we have been doing – is really interesting. You try to capture speed and you actually shoot it in slow motion – the logic is reversed. I don't know precisely what we're going to do with the material; it just developped...it's all just part of the concept.

RHOADES: It's weird... It's all part of this process. Through the project, I really got very good at playstation NASCAR 99, that's the only thing I really did in preparation for it. And I learned a lot about the project, the whole esthetical aspect.

RHOADES: And what do you think of the landscape? Do you like the spot we chose?

SANS: It's a fantastic landscape in the middle of nowhere, in the middle of the desert, surrounded by mountains. This old track was reopened for us and by us. It's very nice, very exciting to bring all these people here.

RHOADES: There's a certain freedom and it's good for Venice also.

ØCKENHOLT: It's interesting to have all this horizontal, wide open landscape as the initial setting for this project. There's so much land here and in Venice it will be totally cramped!

RHOADES: This is what's great; here it's one big parking lot. There is no parking lot in Venice.

SANS: This location is typically American, but at the same time, we could be anywhere here. We could be in Spain, in Mexico or in Montana, filming a Western. There is no architectural reference point indicating where we are.
It's timeless.

RHOADES: The functionality of the track is pure. That's what this oval formation is all about: The spectator. That's a pure thing.

BONDE: I think it's nice that we can start off this project here at this oval track, which has been closed for several years. It was reopened for us. Even the people who own it are wondering what's going on. I think that's very nice. Very much a cliché about American landscape, big sky and everything.

RHOADES: It would never be cold like this on TV.

ØCKENHOLT: You are of course very aware of these historical connotations of the oval space.

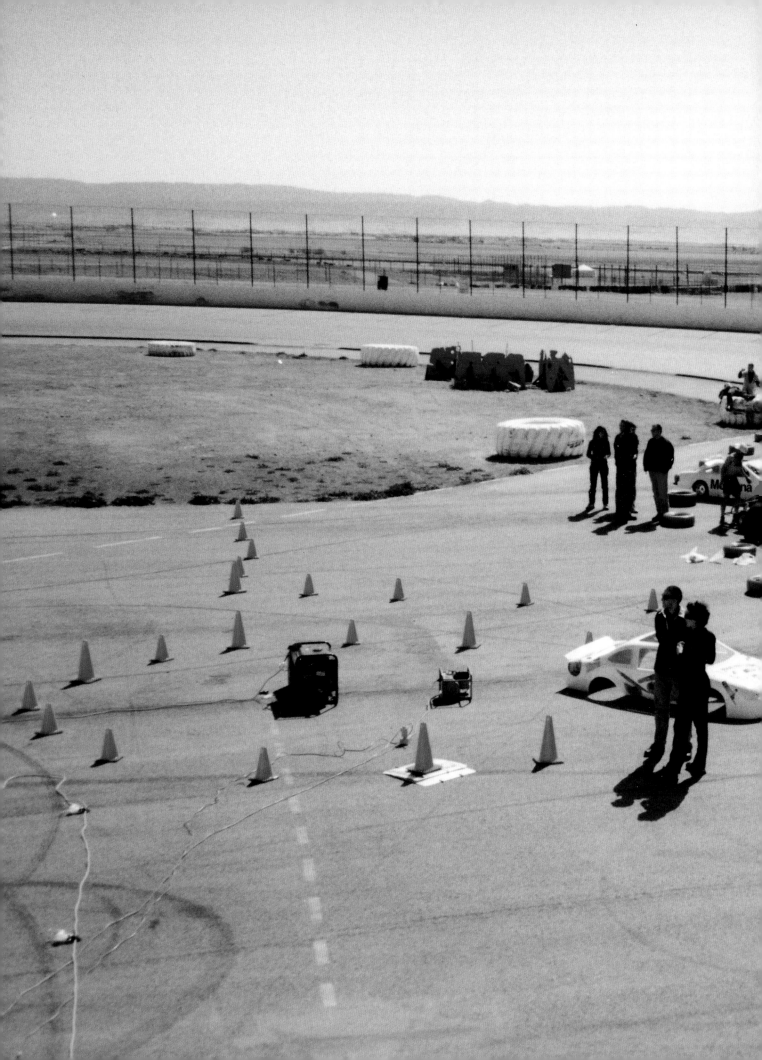

RHOADES: The oval is feminine. We're doing a very masculine thing and it has a very feminine shape. The internal combustion engine is masculine. We're going round and round. The redundant American oval doesn't have these curves like European style racing. American racing was based on dragracing and moon shining. And driving in a straight line in one direction as fast as you can, while European racing was always about how to take corners and the elegance of the race, the elegance of the car and the driver.

BONDE: I also think the oval is built for the spectators, for the audience it has to be easy. In a lot of sports in America, you have to be able to sit down and watch all of it, to be able to see everything that is happening.

RHOADES: They also come to see crashes, which I really don't want to be part of.

BONDE: When you watch a race, you somehow feel that it would be nice to see a crash. Even if I don't really want it, at the same time I do. It's kind of an extension: like playing with death.

SANS: Don't you think that in this Snowball, there is a presence of the risk, of the danger, which for me should be the metaphor for every artwork, for every exhibition.

RHOADES: It's a great part, a great line. Real racing can be dangerous. I think the potential is really good for something.

BONDE: You can go at full speed all the way around the oval: it takes a little bit away from the danger. It's a little too safe.

RHOADES: It's dangerous enough.
Cars don't kill people, people kill people !!!

SANS: I see this oval as a possible meditative thing, something hypnotic (like Steve Reich's repetitive music) where you continue to make the same gesture then you forget what you're doing. It's the opposite of the curves one finds on European tracks. Where you just can't let go.

RHOADES: You want to pass that next person, but that's all you want to get past. That's kind of beautifully elegant. You take one full flat footstep at a time. It's an interesting art metaphor.

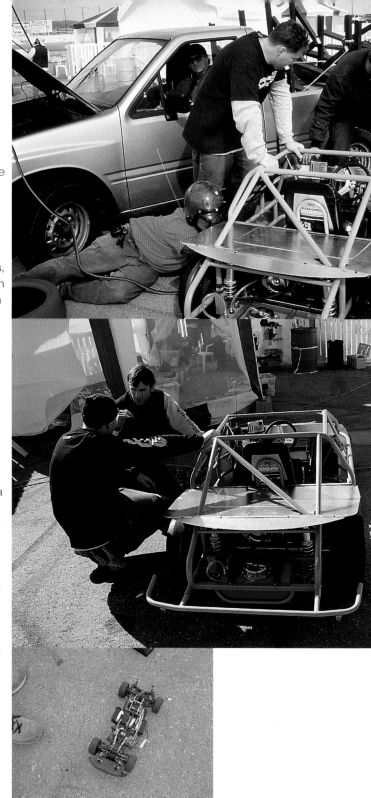

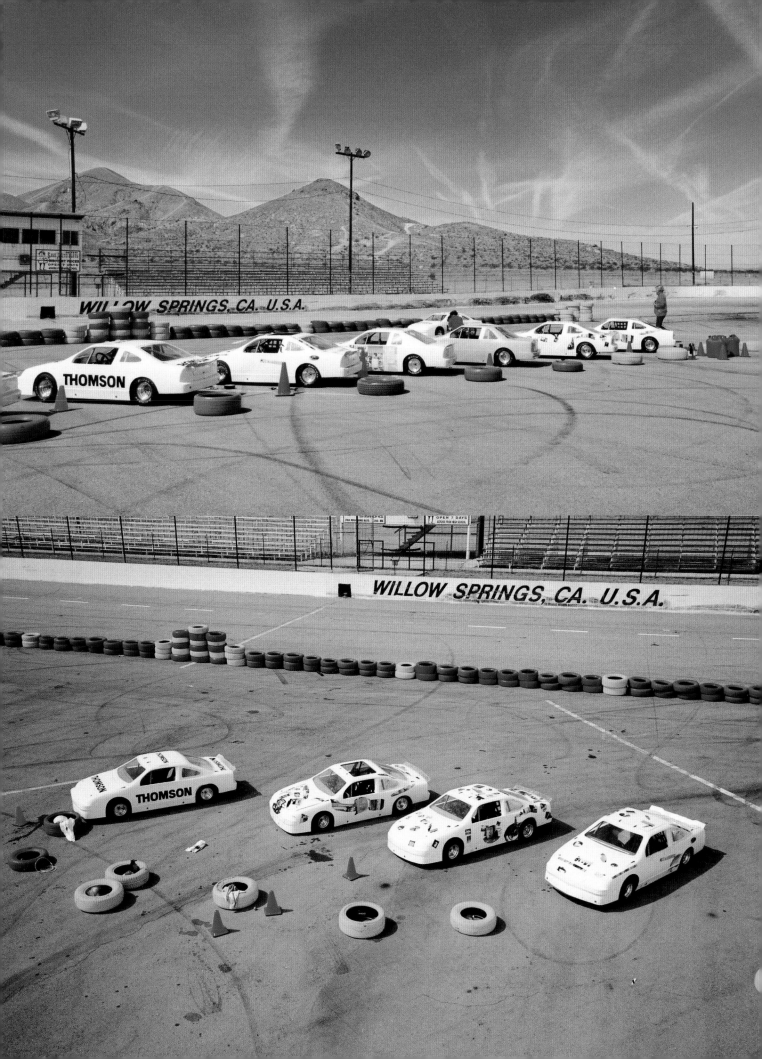

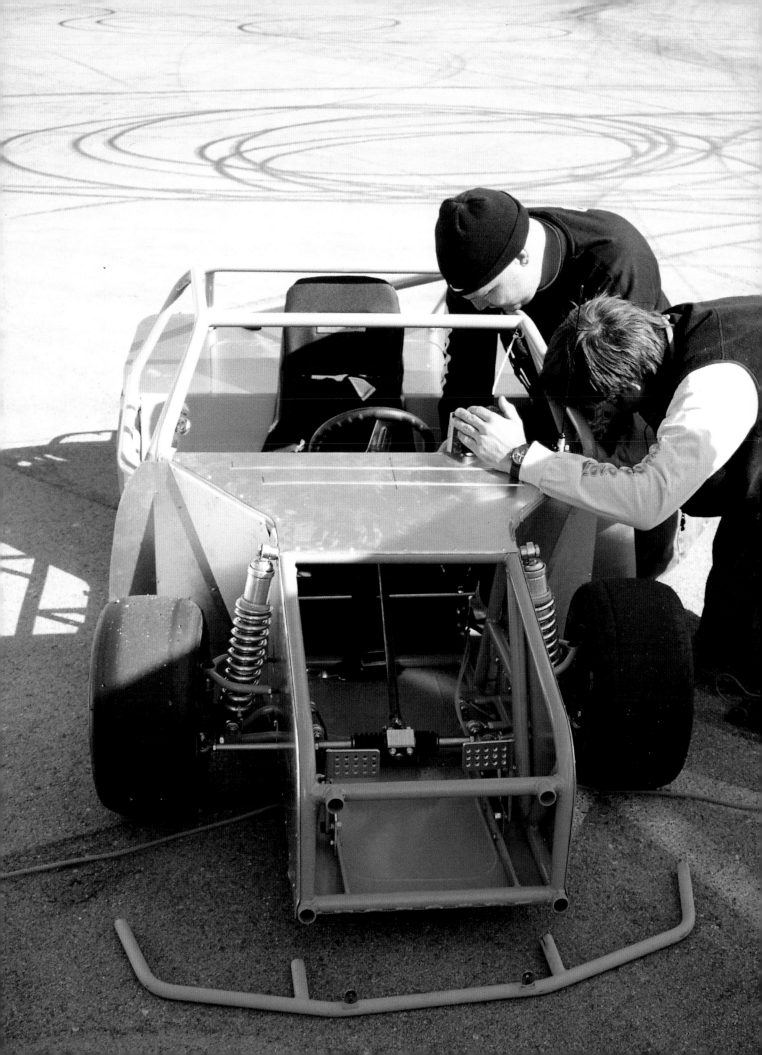

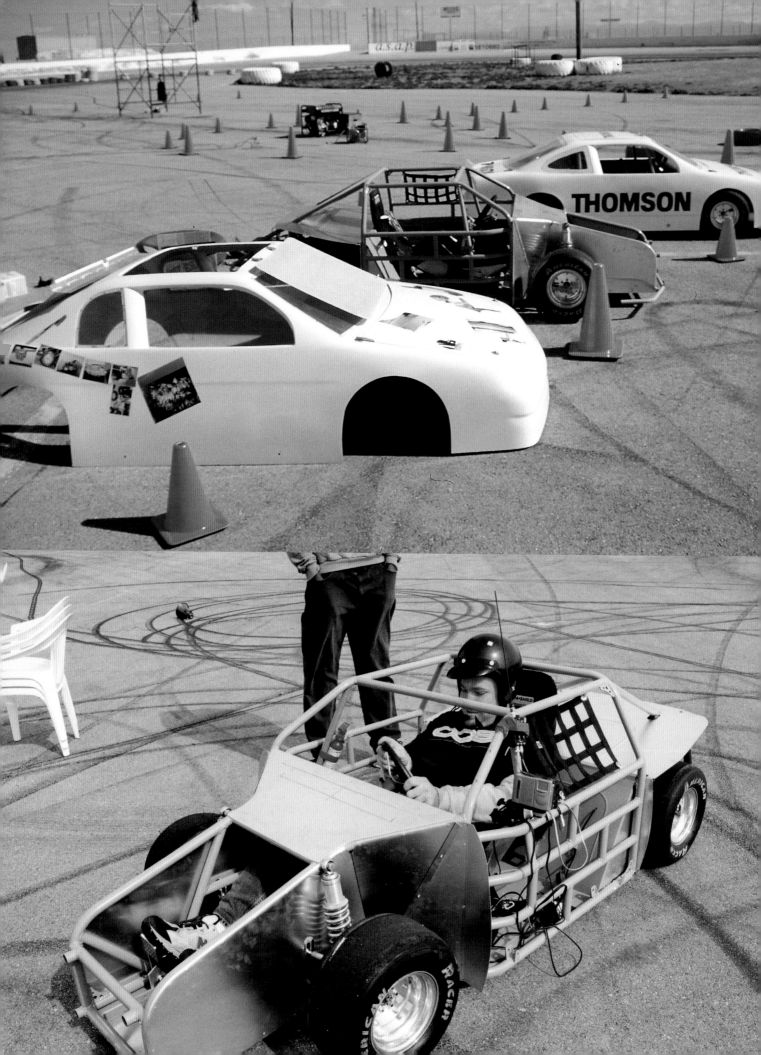

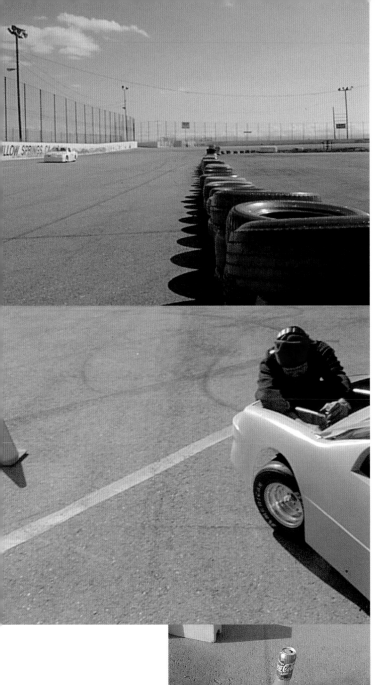

BONDE: It was really interesting getting out of the car yesterday. I felt all dizzy. It's like being on dope or something like that. I didn't realize it.

RHOADES: That's what's good. We don't realize what the thing does and when you go into a project like this, you don't know anything about all this stuff.

BONDE: I think the noise is a very big part of this and it's killing you really.

SANS: It may be killing you, but just like when you go to a rock concert, the sound stays with you for several hours afterwards. It stays with your body.

BONDE: That's not funny.

RHOADES: It's a good thing to take with you. It's a redundant American thing done over and over. It's beautiful to sit in the middle of a loop (and watch) these things chased around.
It's a beautiful abstraction, it's a real interesting level of abstraction that occurs with the noise, with the physicality, with the danger, with the control, with the visual things.
It's important that we're harnessing some aesthetics, but we're not following an aesthetic which we know.

SANS: That's why The Snowball oval works...it's open-ended.

BONDE: Let's just start over.

RHOADES: Back to the airport, leather jacket, no hair. I bought this leather jacket the day we met.

SANS: Does anyone know which day it is?

BONDE: Today is Thursday March 12th, 1999

ØCKENHOLT: No, today is the 11th.

RHOADES: When does this all have to go?

(ENDIT)

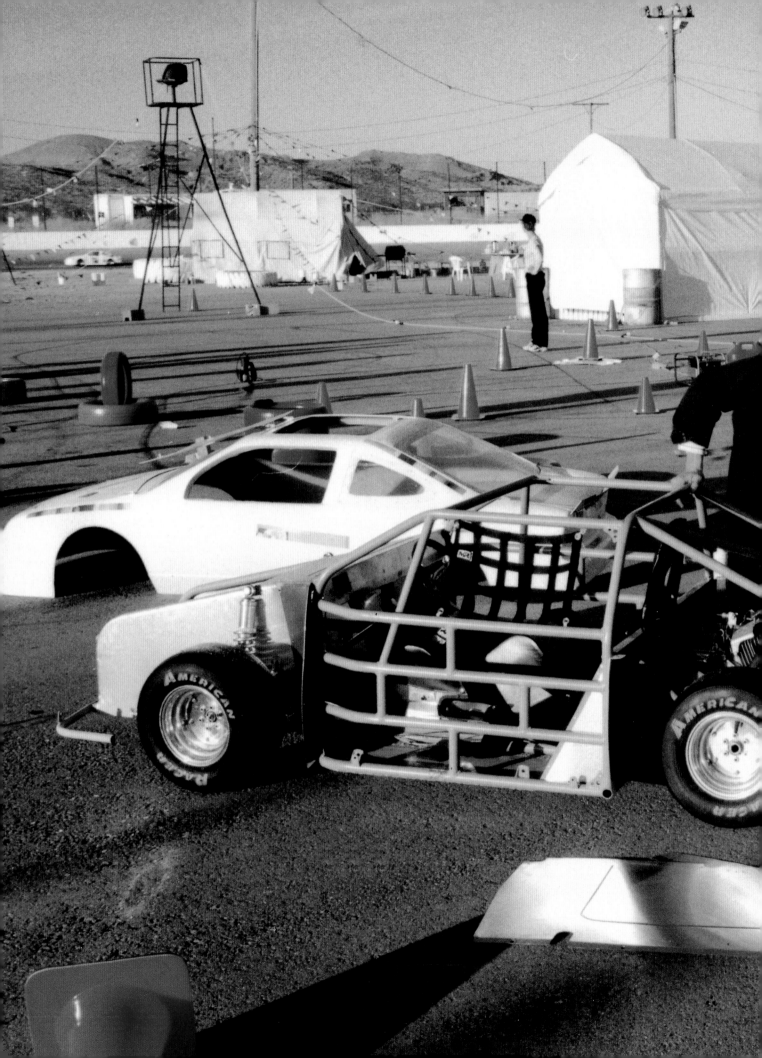

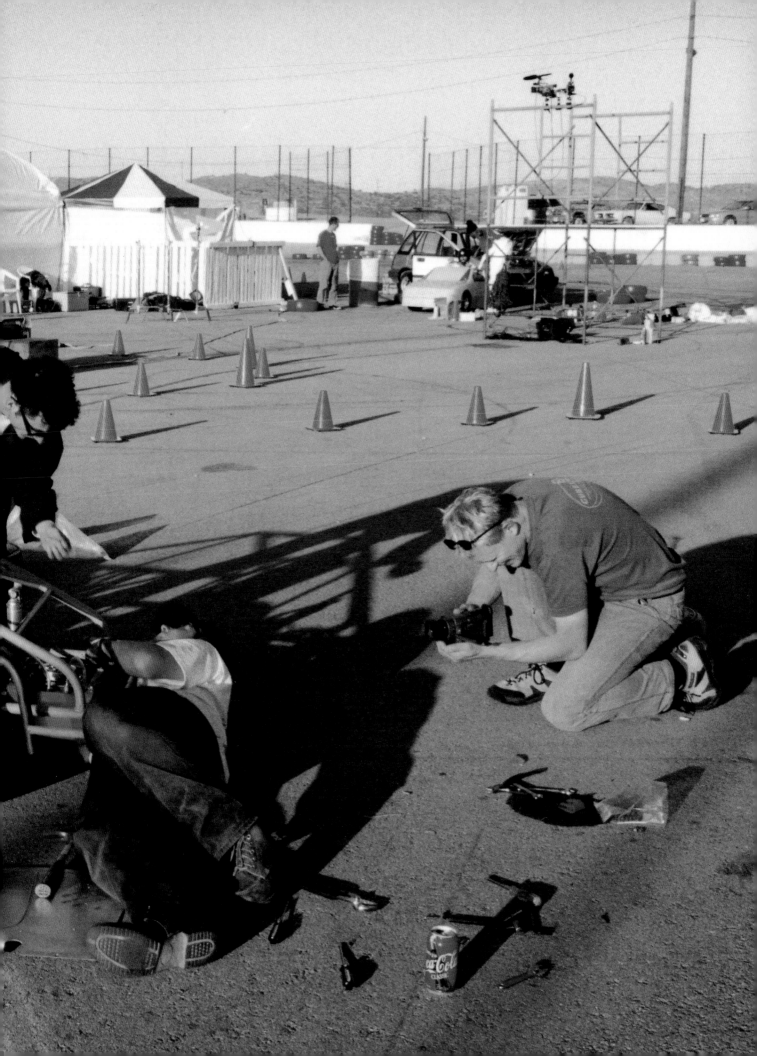

Oil, Gasoline, Checked Flag, Dumb Blond, Champagne, and Chupacabra

The Snowball: an open-ended philosophy

PETER DOROSHENKO
Director of the Institute of Visual Arts
Milwaukee, Wisconsin, USA

The presentation of Peter Bonde's and Jason Rhoades' collaborative project, The Snowball, in the Danish Pavilion will challenge and inform, startle, and excite, many who see it. It may also confuse some traditionally-minded visitors expecting to see an oil painting or bronze sculpture, but it is hoped that they will be disposed to look more intently at the work and be able to derive some feeling for the contemporary nature of the works exhibited.

For the artists, Peter Bonde and Jason Rhoades, this exhibition of new works tries to address the problem of art and how to serve as a repository for reality in a simulated world. Traditionally, people were able to think of art literally, as oil paint on canvas or various bronze forms. In a context where the definition of reality is changing, oil on canvas and bronze forms have lost their symbolic significance; they certainly do not have the same significance they had in the early part of the century. But society's visual relationship to the world has changed irrevocably, and within its relationship to concepts of beauty and aesthetics.

With the Snowball project, both artists point out that it is no longer sufficient to put together a pastiche of late century images together and expect it to have an impact on people who have encountered new forms of organization and information. In order for art to retain a relevant discourse, one that carries symbolic value that it has traditionally carried, it must respond to current knowledge advancement and articulate that struggle between society and knowledge. The Snowball project thus involves a philosophical condition called deconstruction, which has affected so many disciplines, including theology, literature, and architecture, and which suggests that many familiar things may have always been far more complex than we have allowed. In calling for the incorporation of deconstruction into aesthetics,

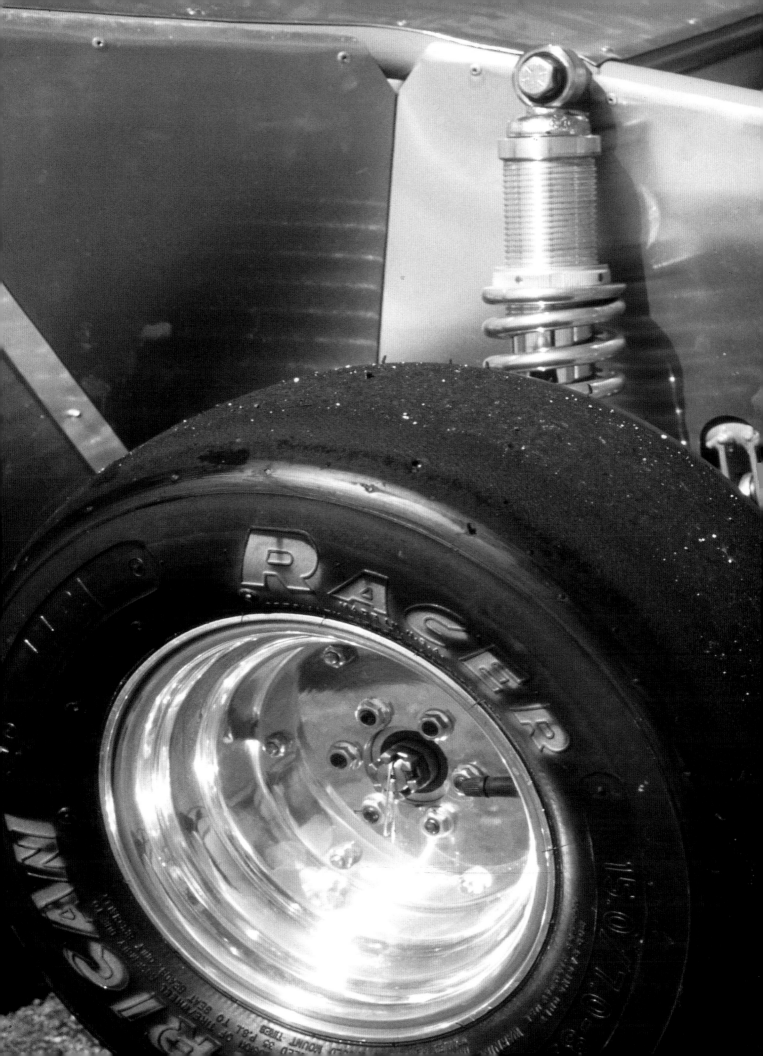

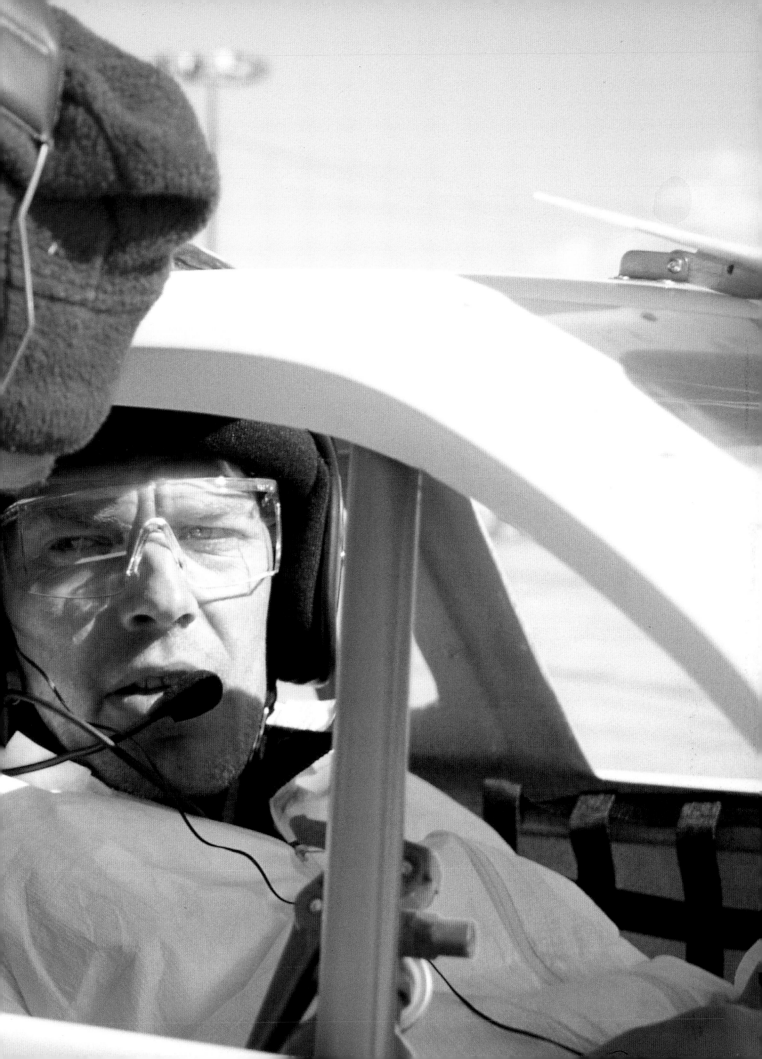

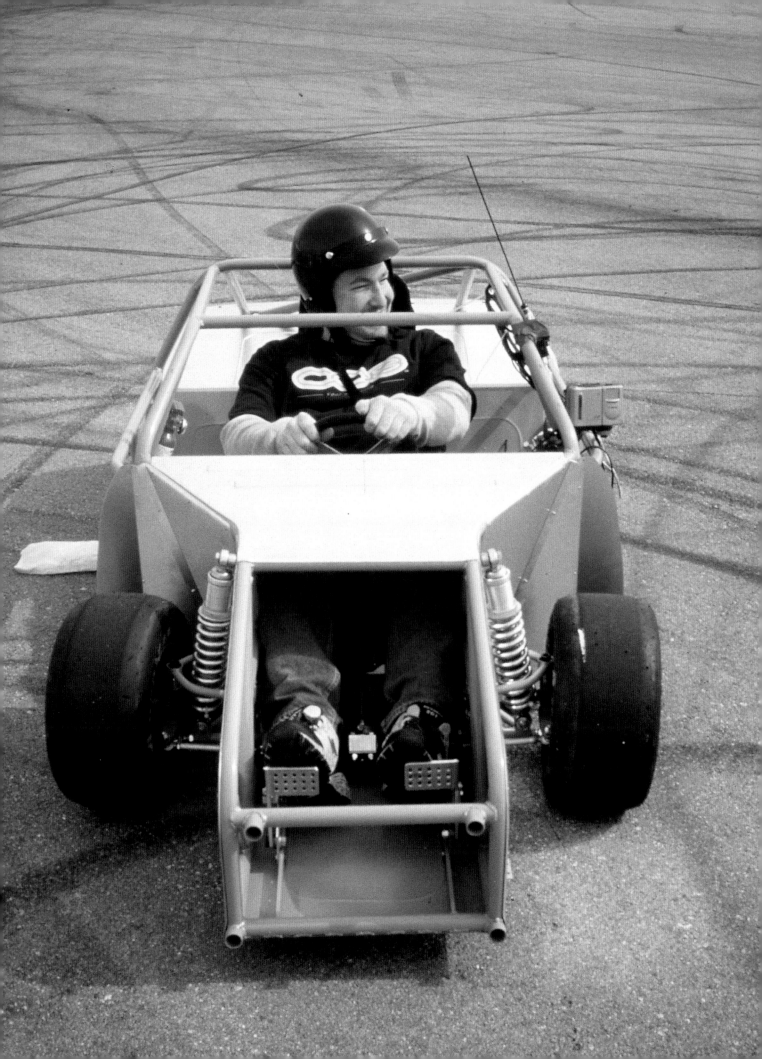

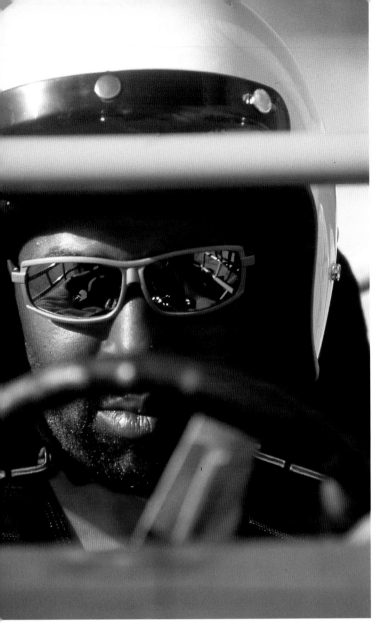

Bonde and Rhoades make it clear that they are not calling for more complex imagery, but instead for new ways of presenting traditional art metaphors.

Both artists suggest that there may be other ways of making and reading art, new ways that address the deconstructive concept of the text. Both have remarked that textuality has always been a component of art, as in the texts of beauty, shape, color, and form. A deconstructive approach would assume that the response to the text is not one to one as in the edict form follows function or any of the earlier approaches to iconic representation in art. For Bonde and Rhoades, deconstruction would reveal the latent complexity in these apparently simple formulations and provide a non-hierarchical, non-dialectical way of looking at the world.

To turn one's back on new ideas is tantamount to insisting that a Chupacabra, a blood sucking, flying beast, lives in the desert of northern Mexico. Here, the Snowball artists insist that they are not proposing an answer to contemporary traditions, just asking questions that are relevant for the creative individual today. For example, who is the author of a photograph or a videotape? What is the nature of authority or authenticity when the human subject has been displaced? To be an artist in the broadest sense is to deal directly with the potential of human beings to represent, symbolize, and spiritualize the problems they encounter because they aspire to wisdom, instead of merely to the possibility of knowledge. Peter Bonde and Jason Rhoades reaffirm their belief that humans have wisdom, and that in our wisdom lies the possibility of a poetic world. A poetry which is not closed and pre-ordained, but which is problematic and open-ended.

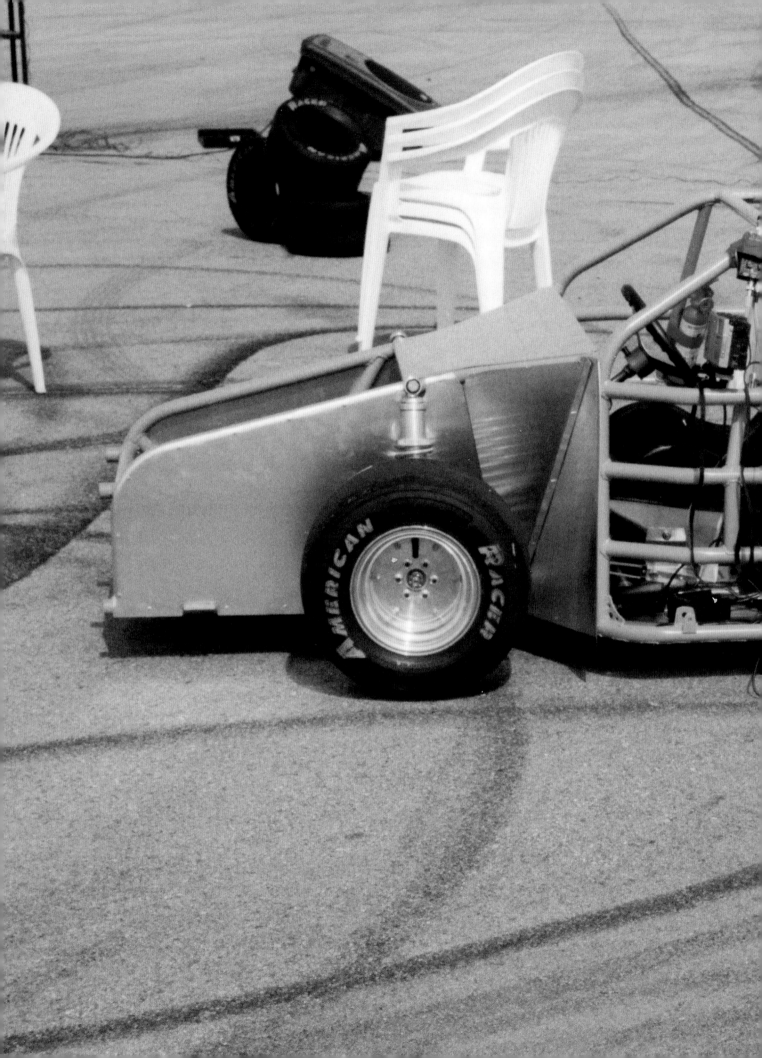

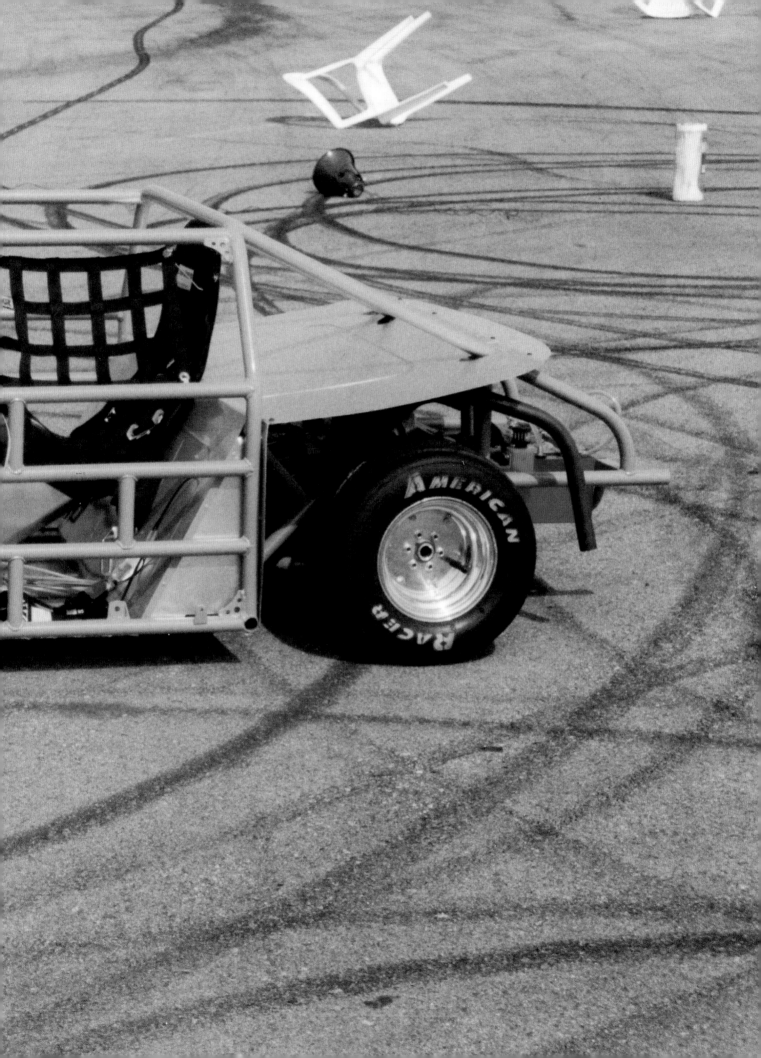

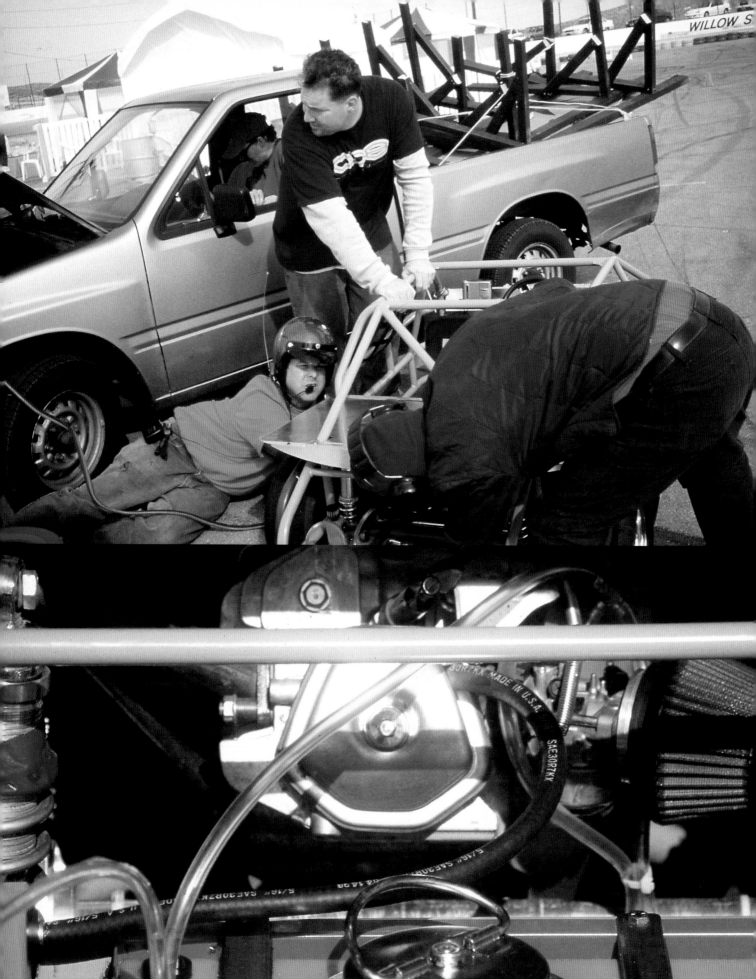

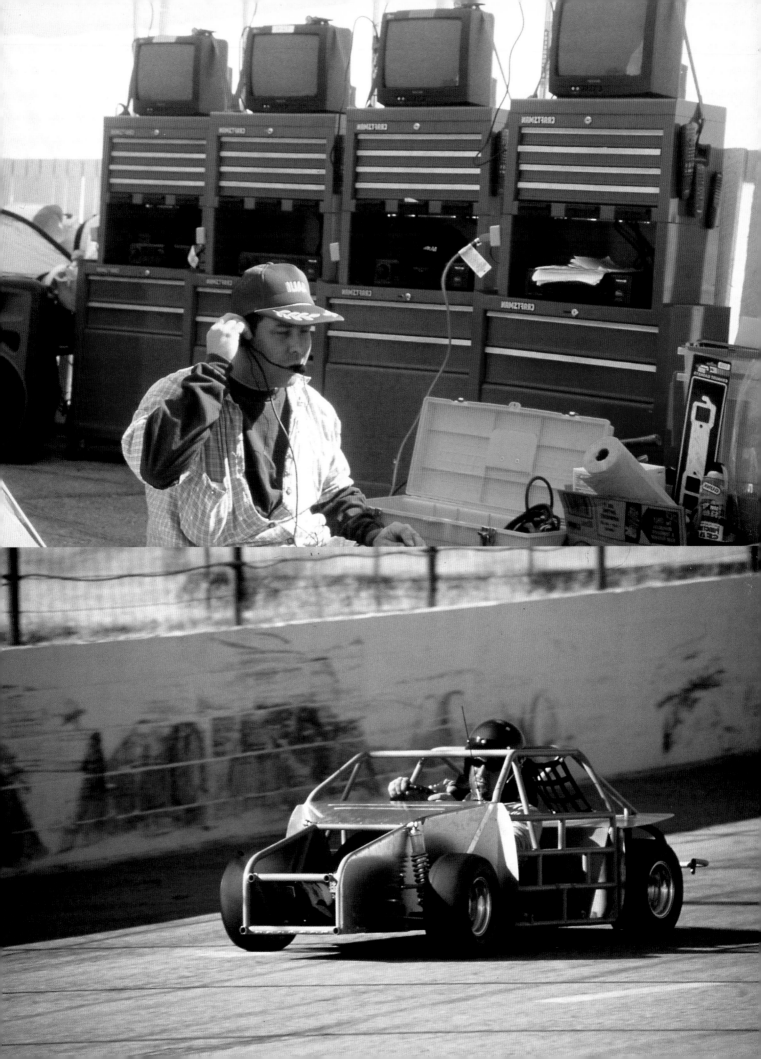

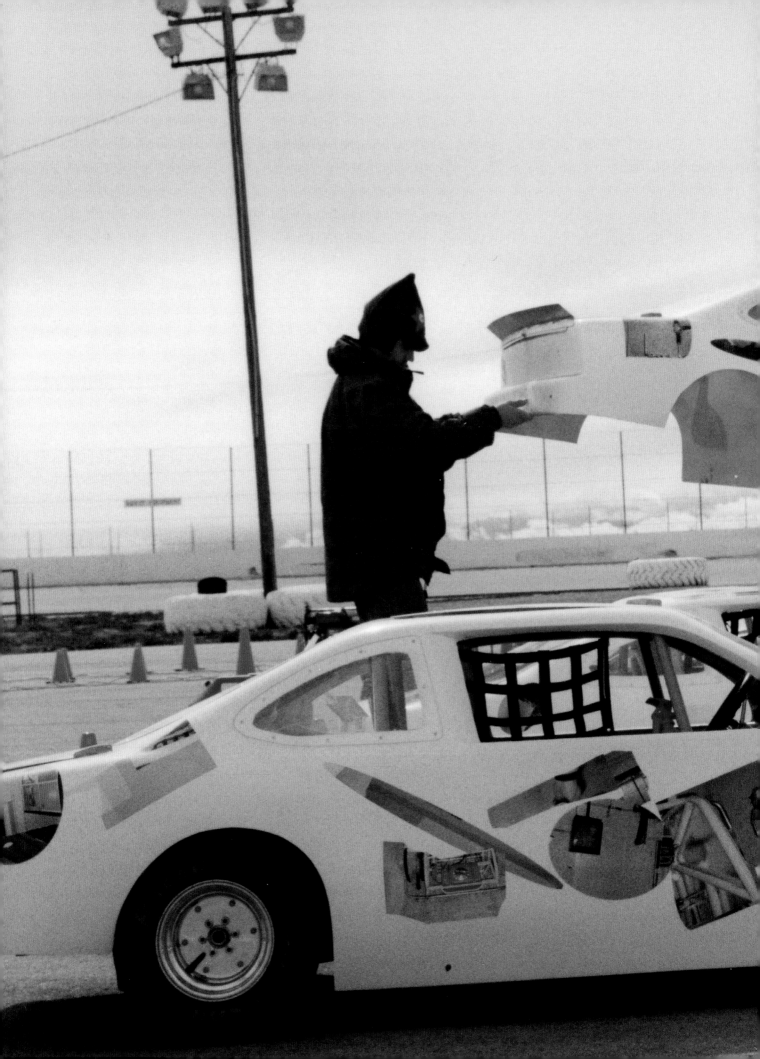

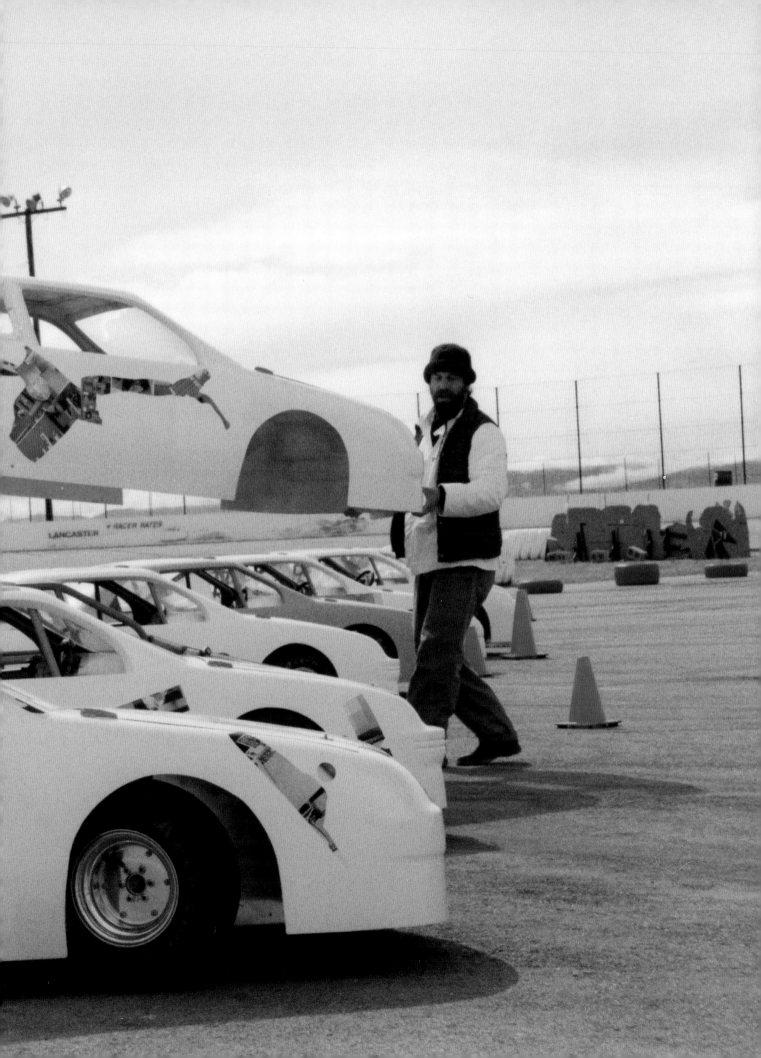

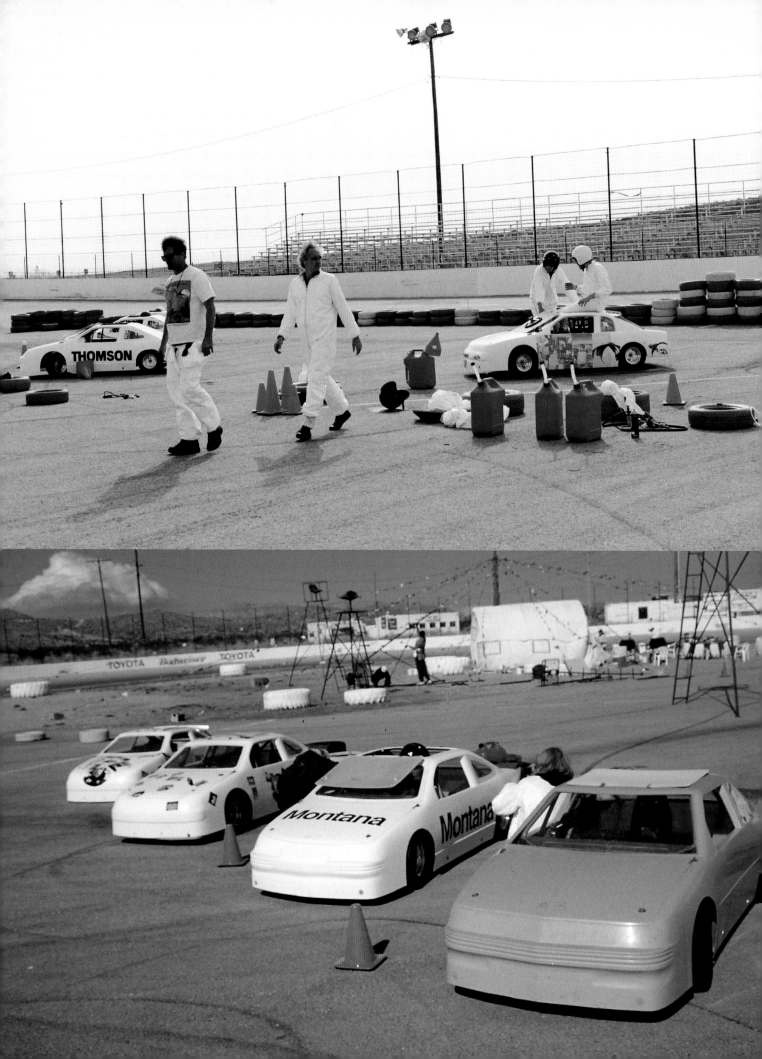

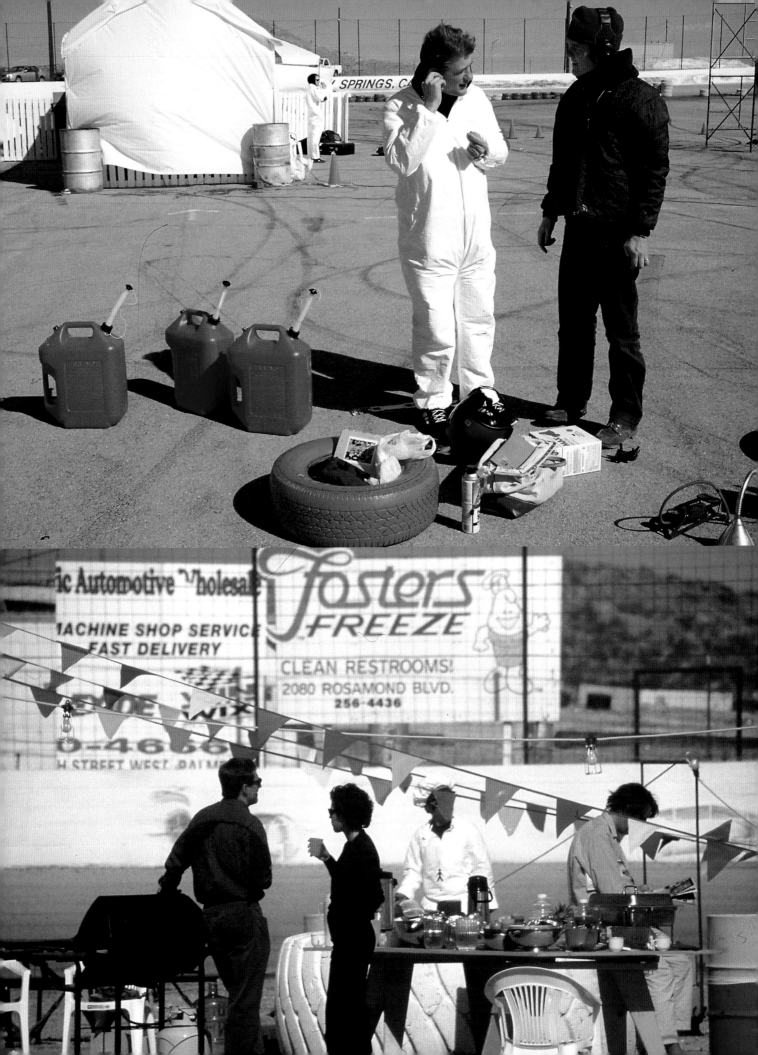

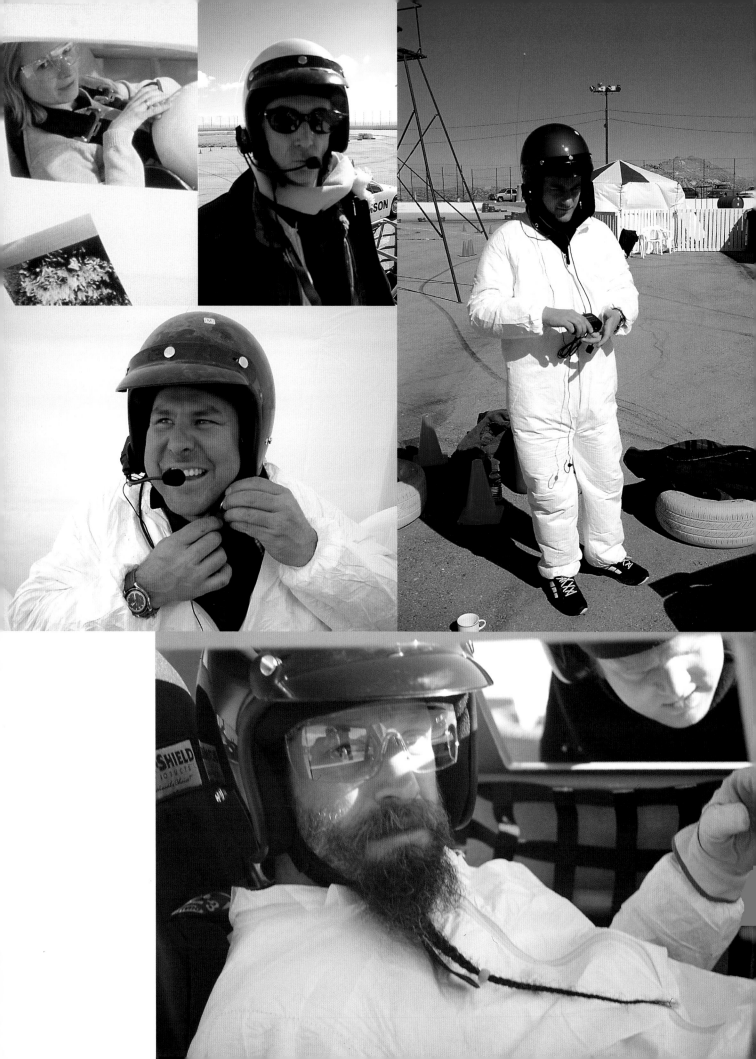

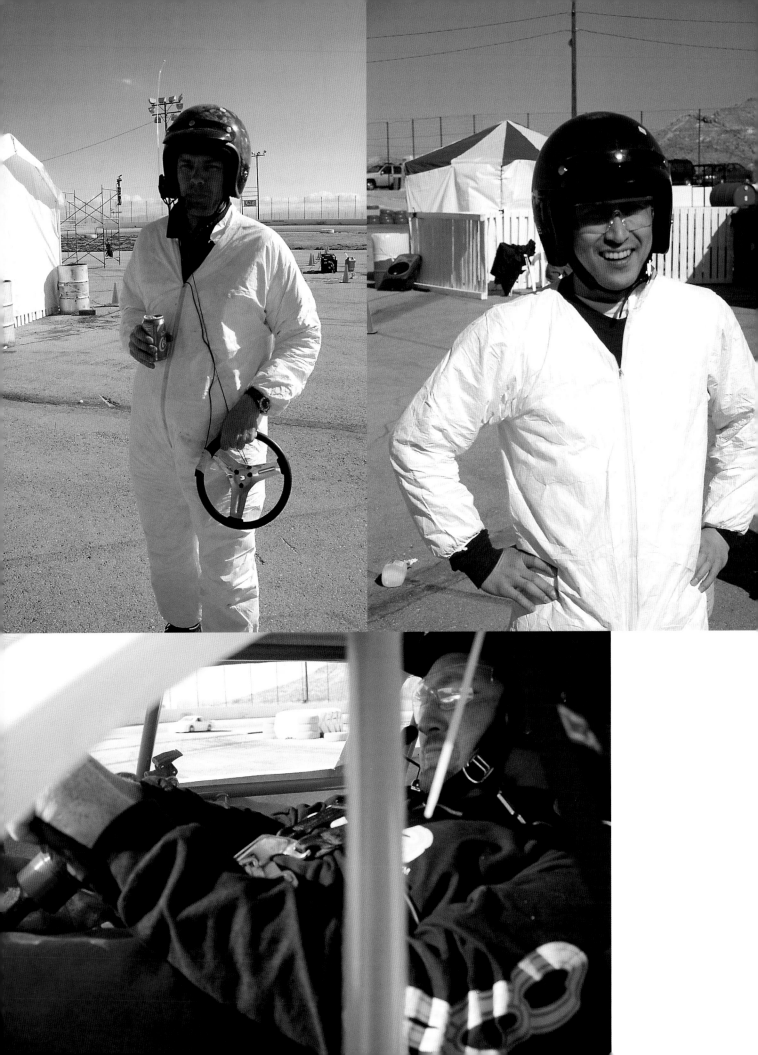

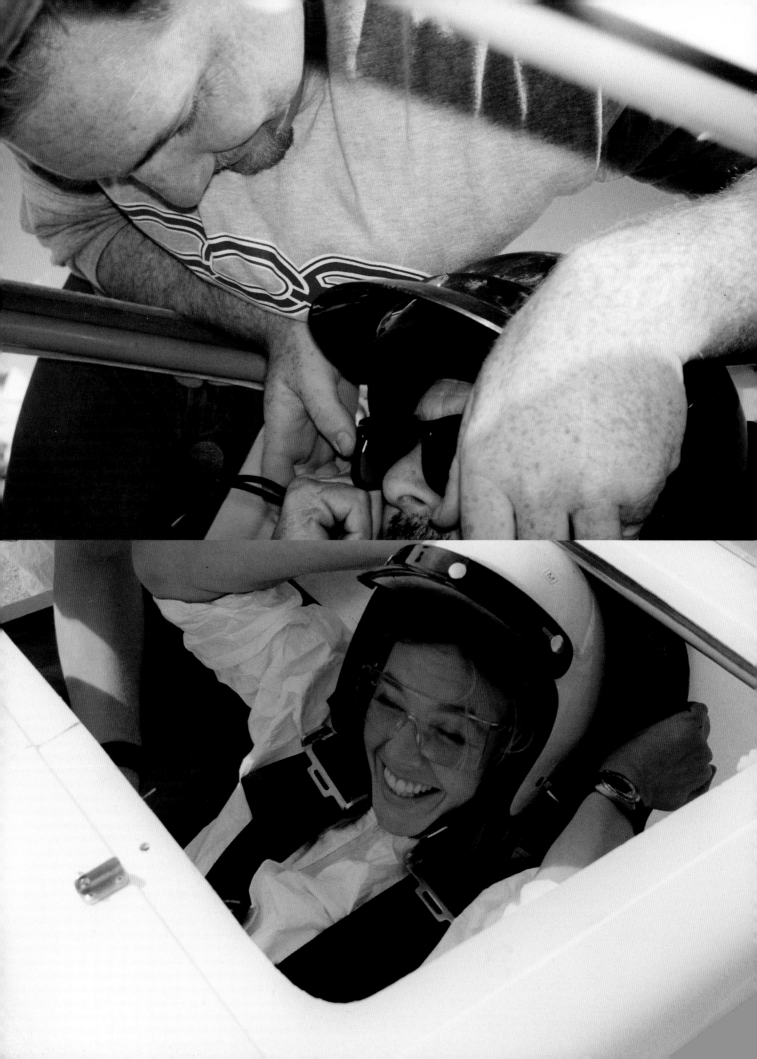

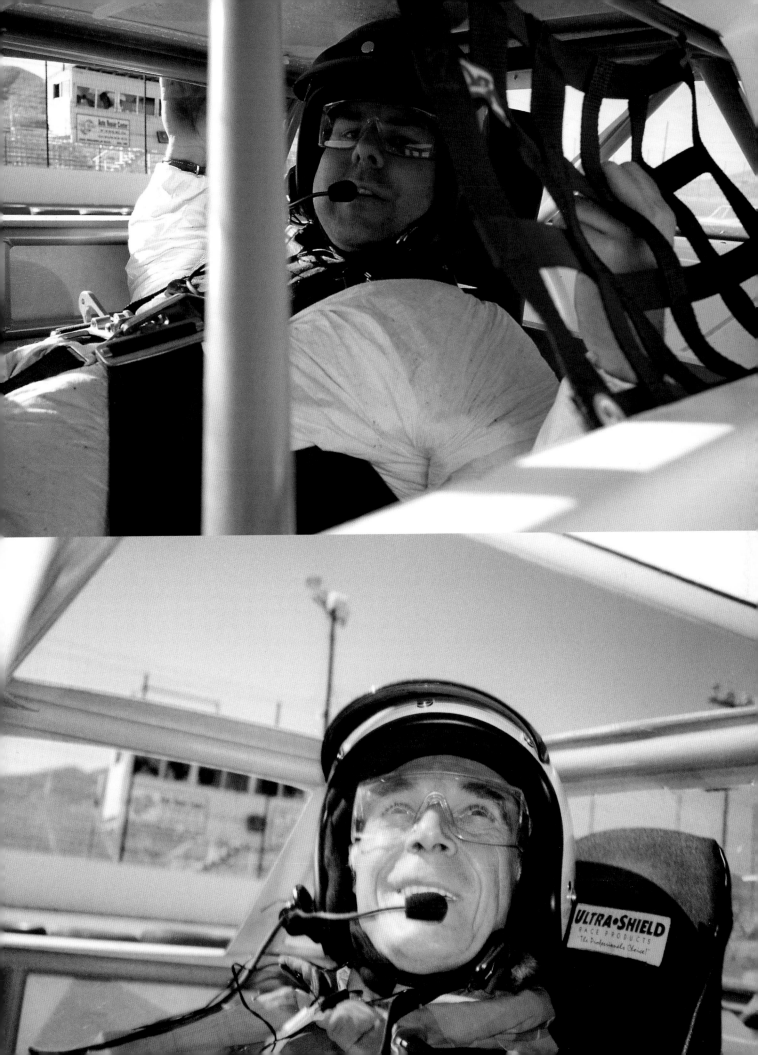

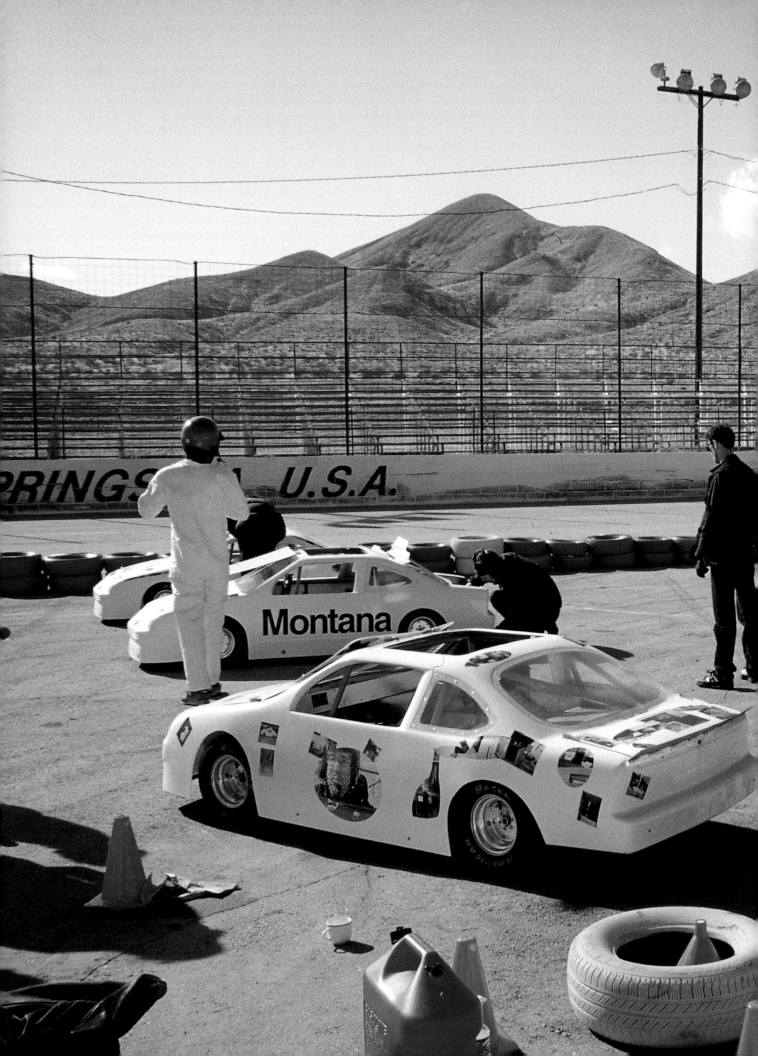

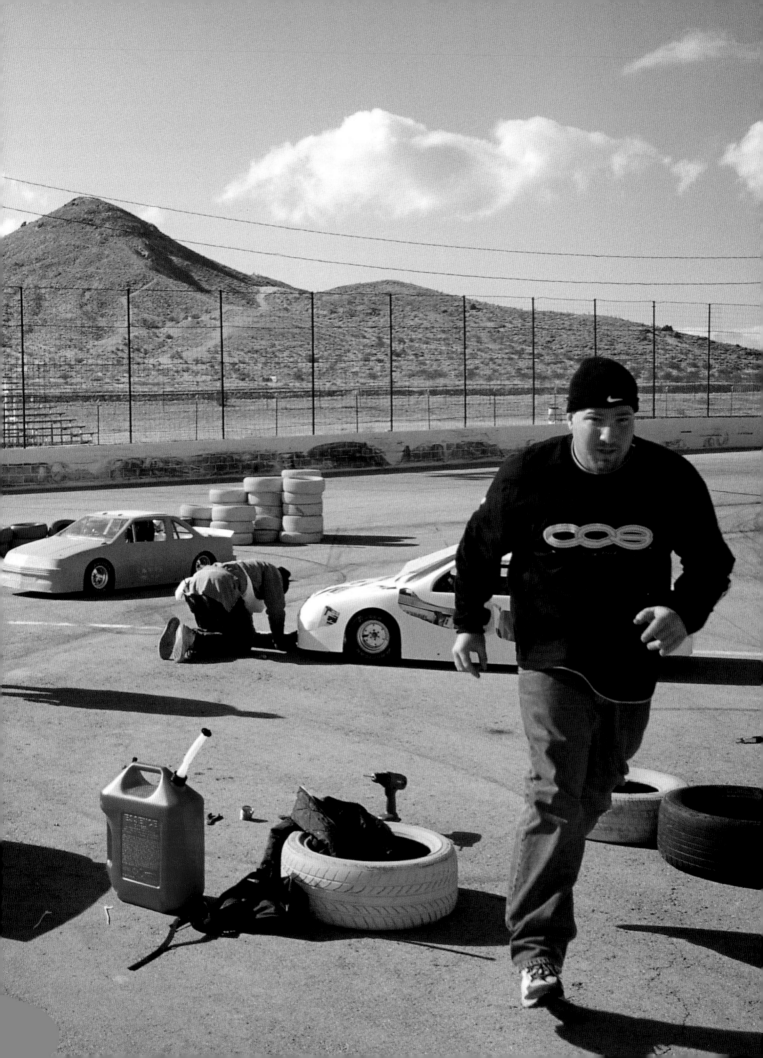

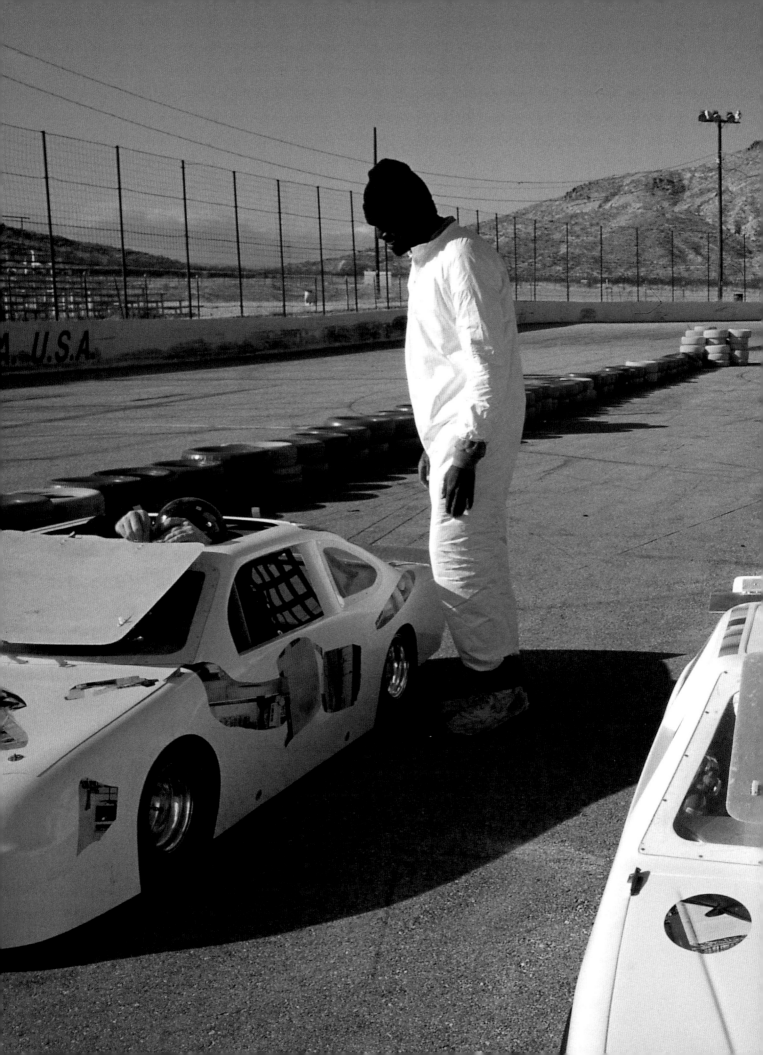

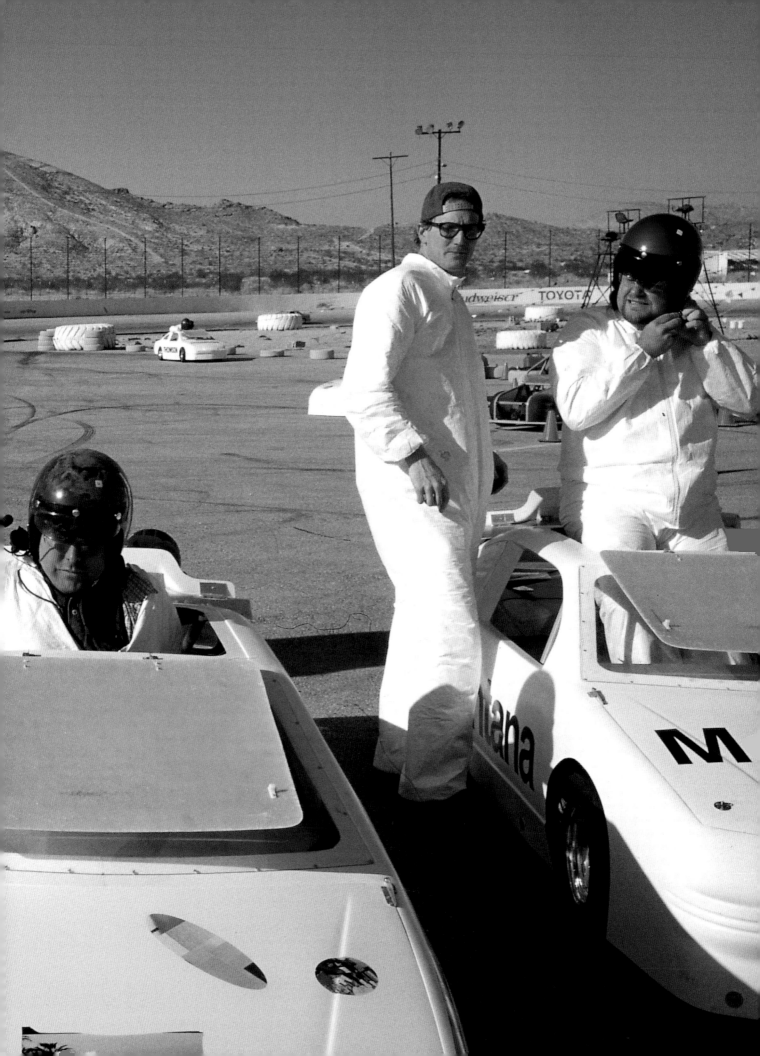

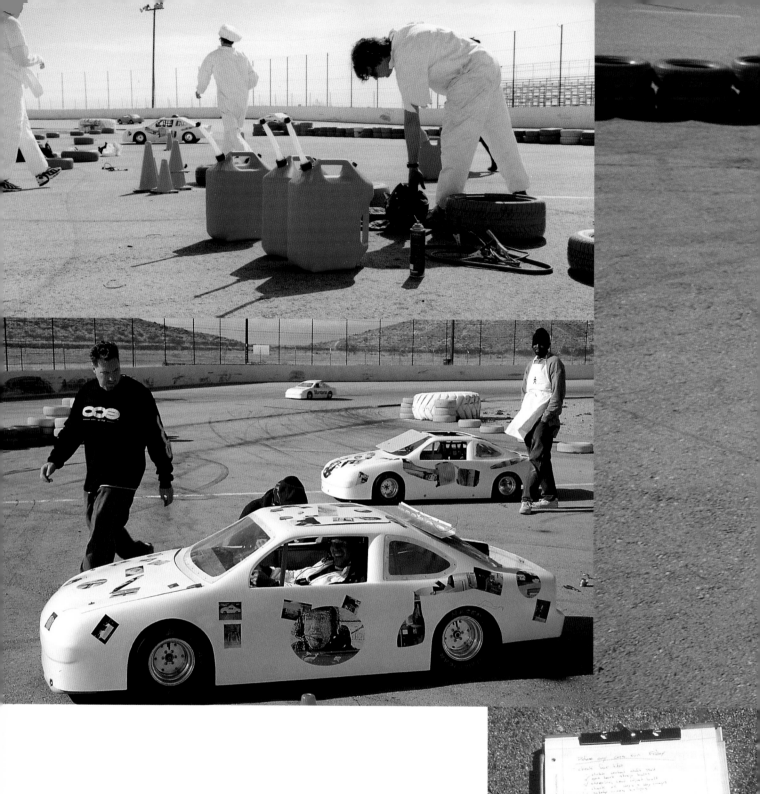

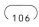

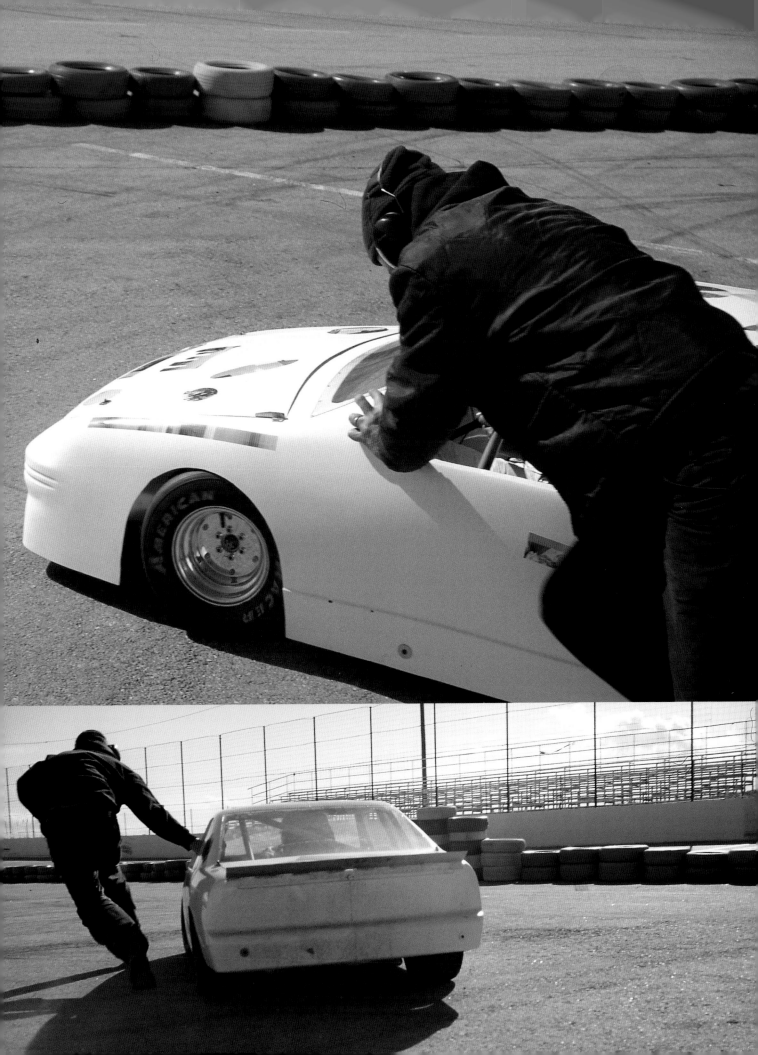

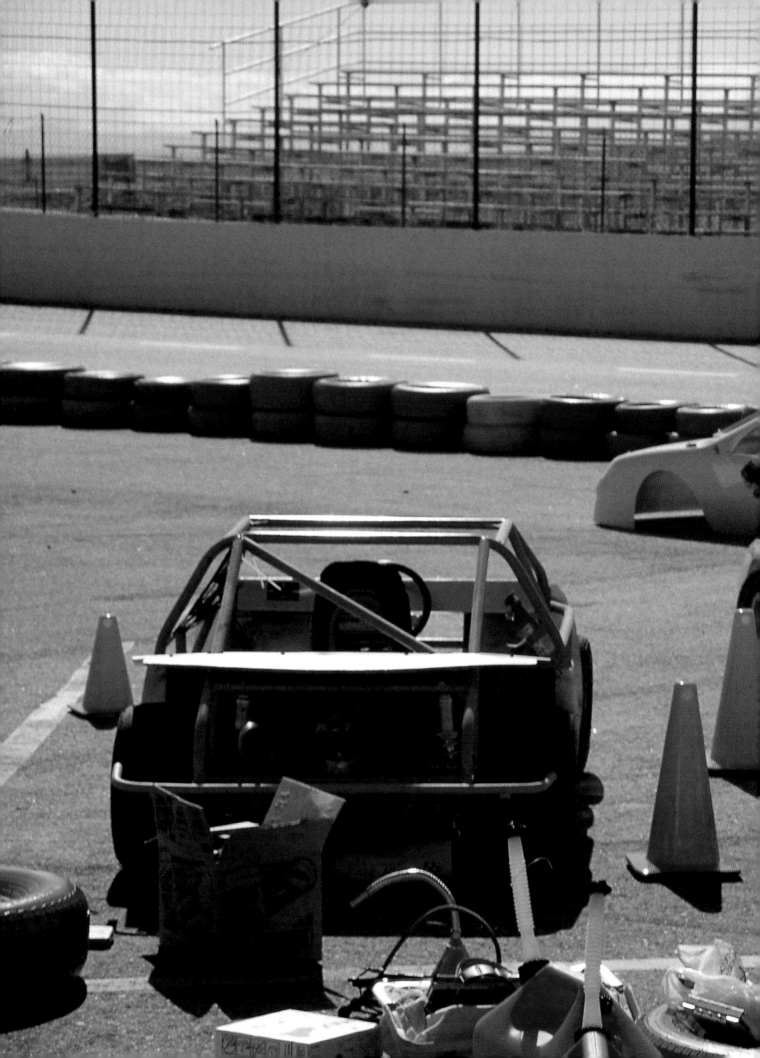

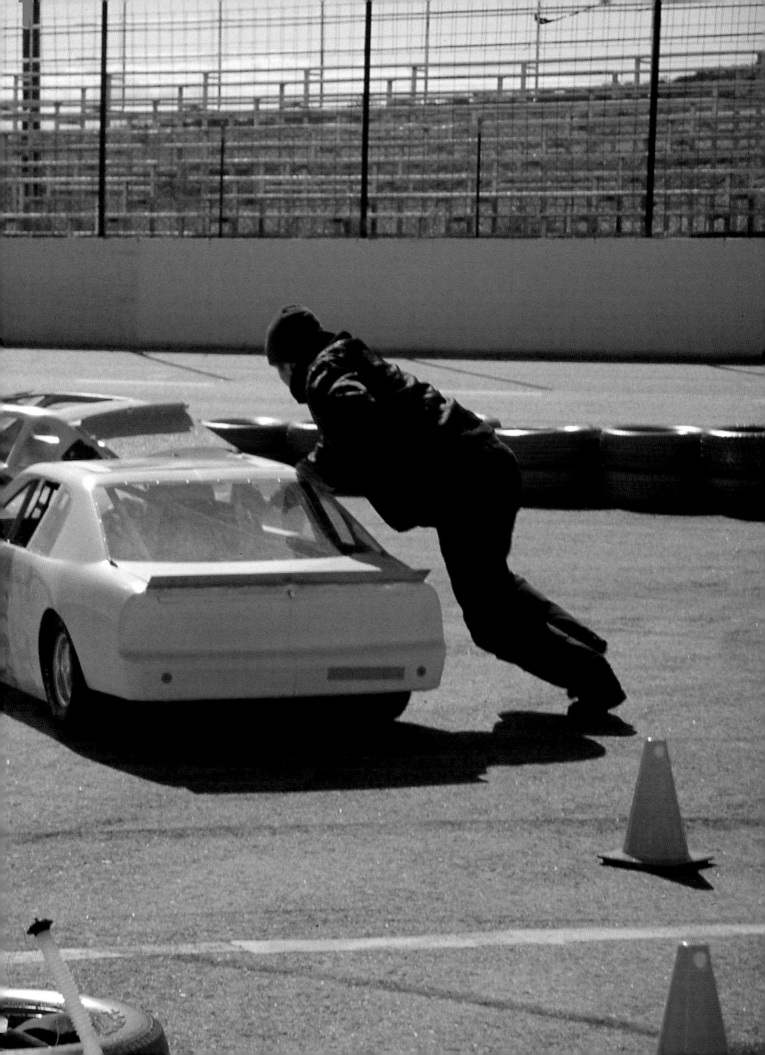

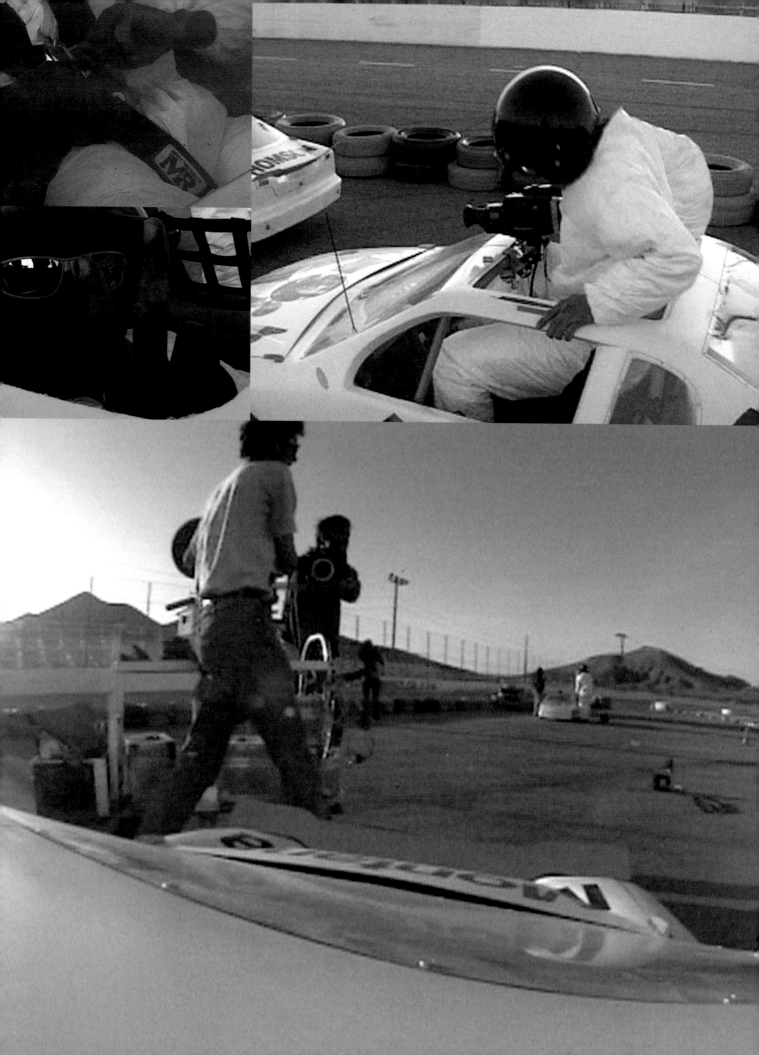

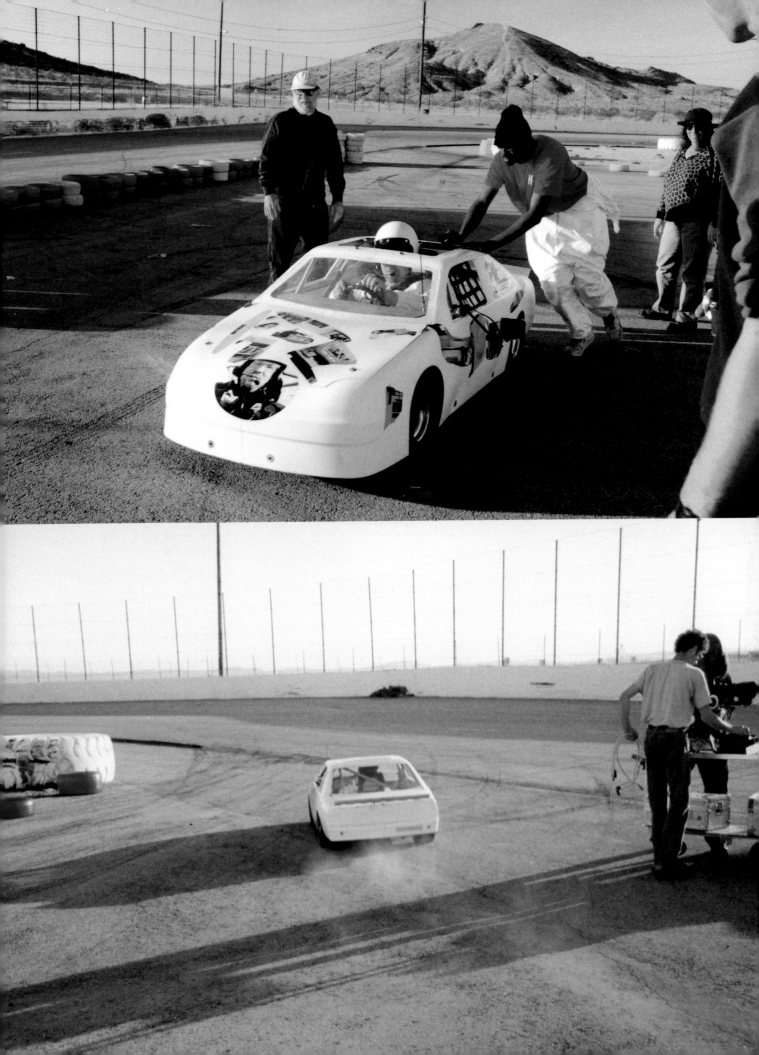

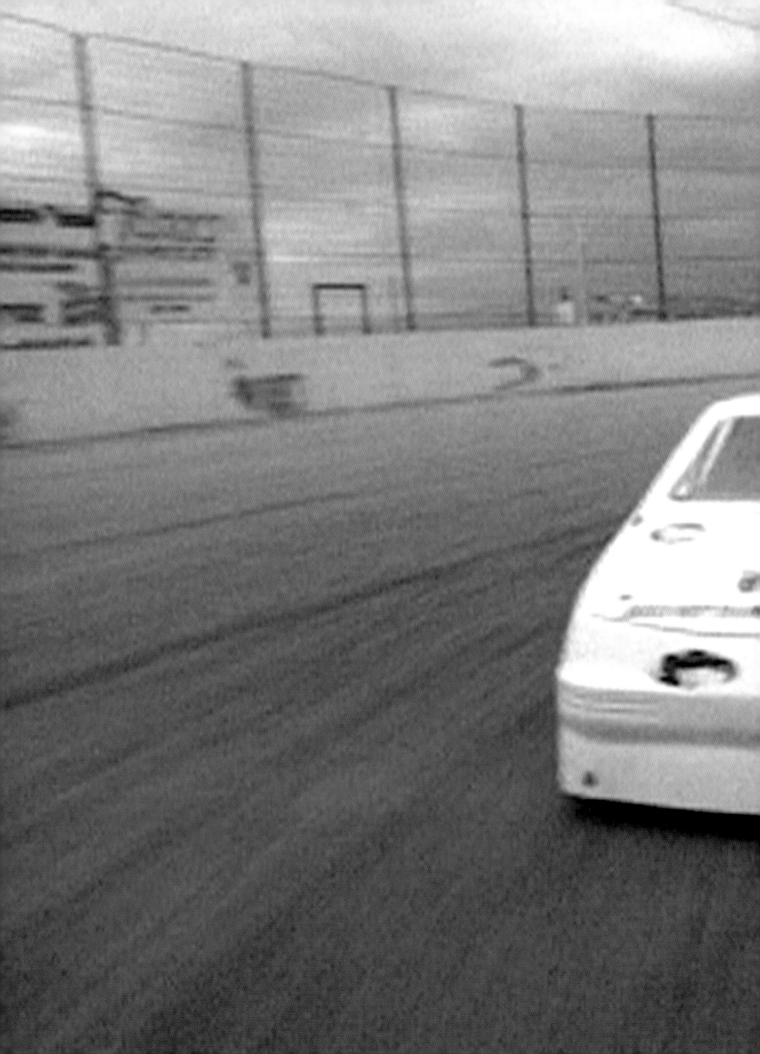

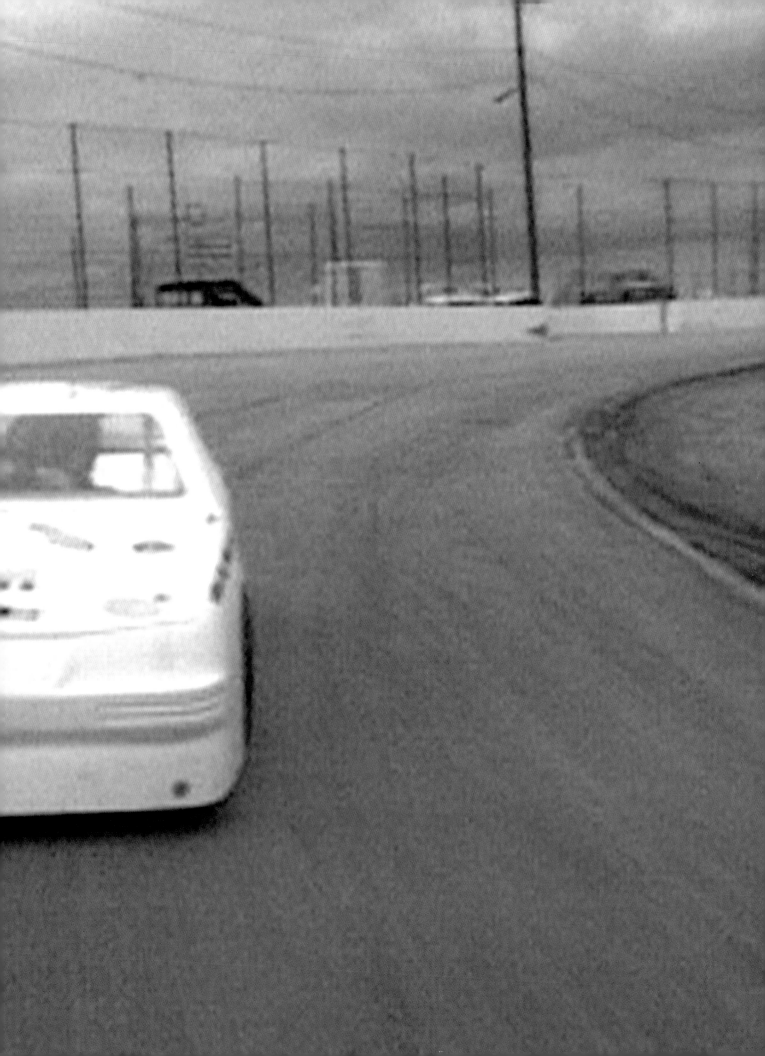

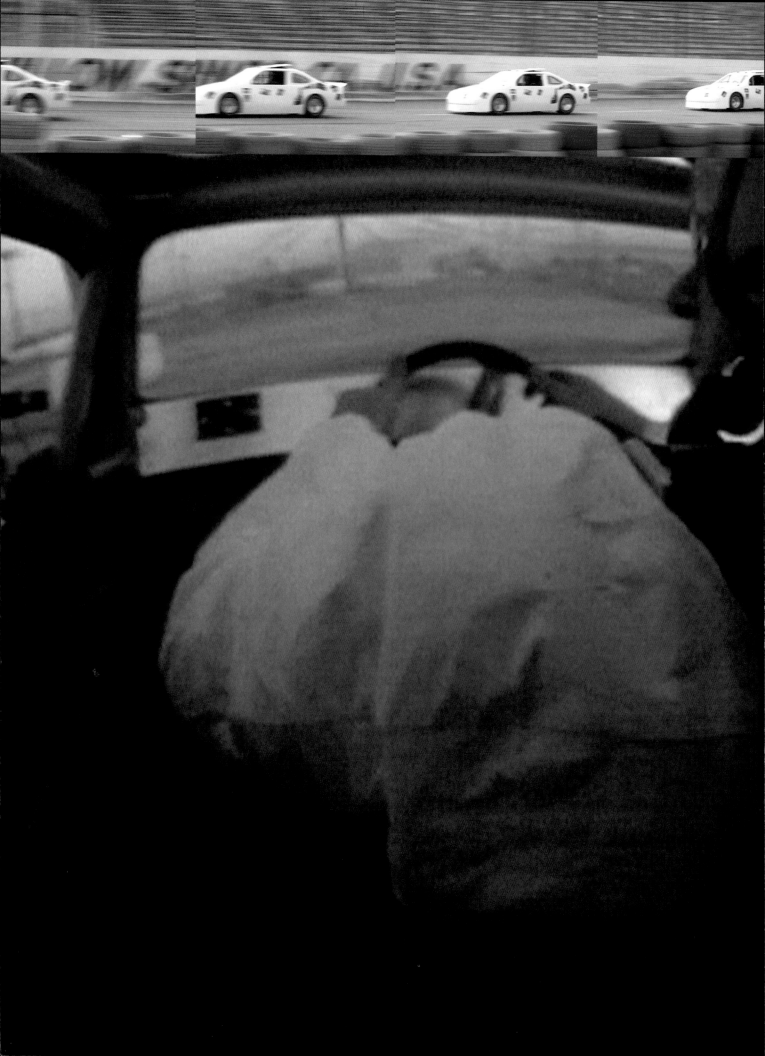

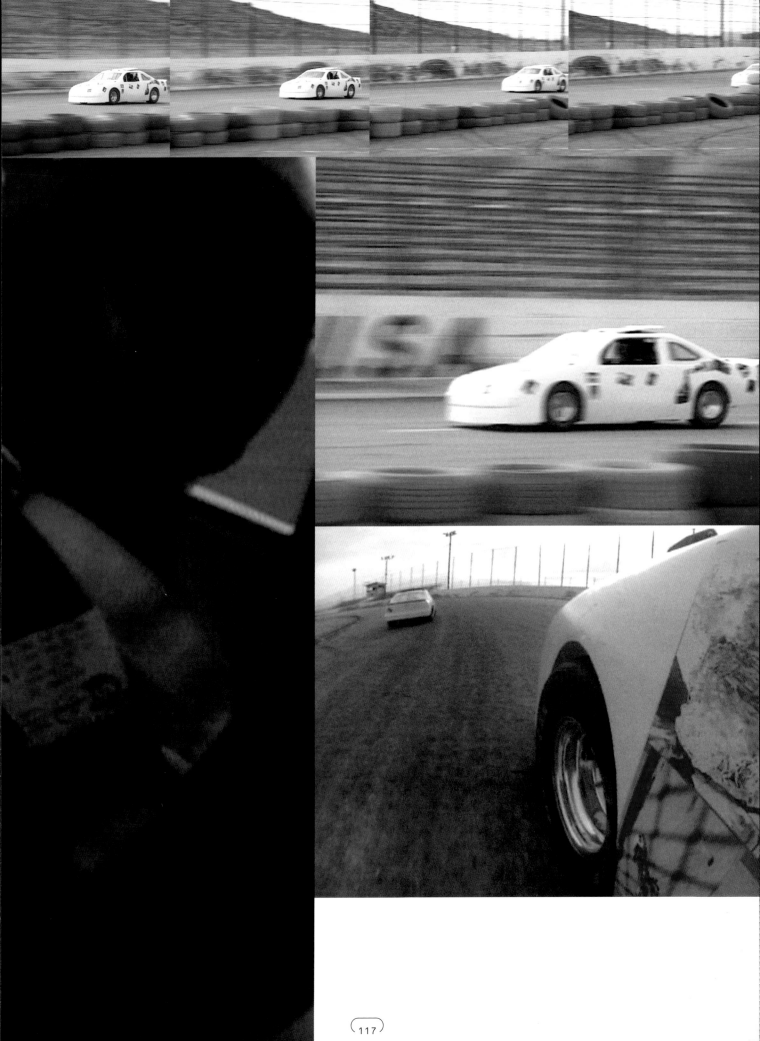

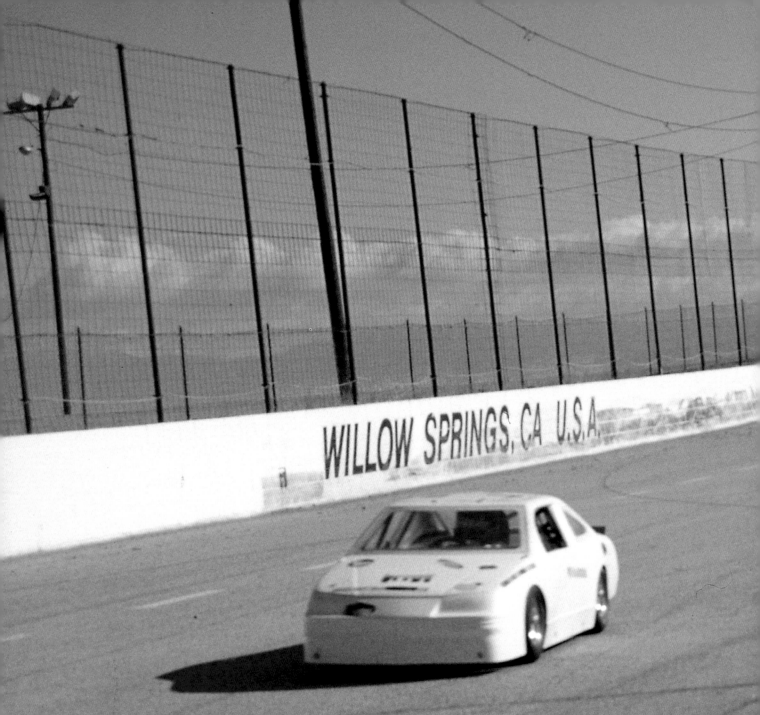

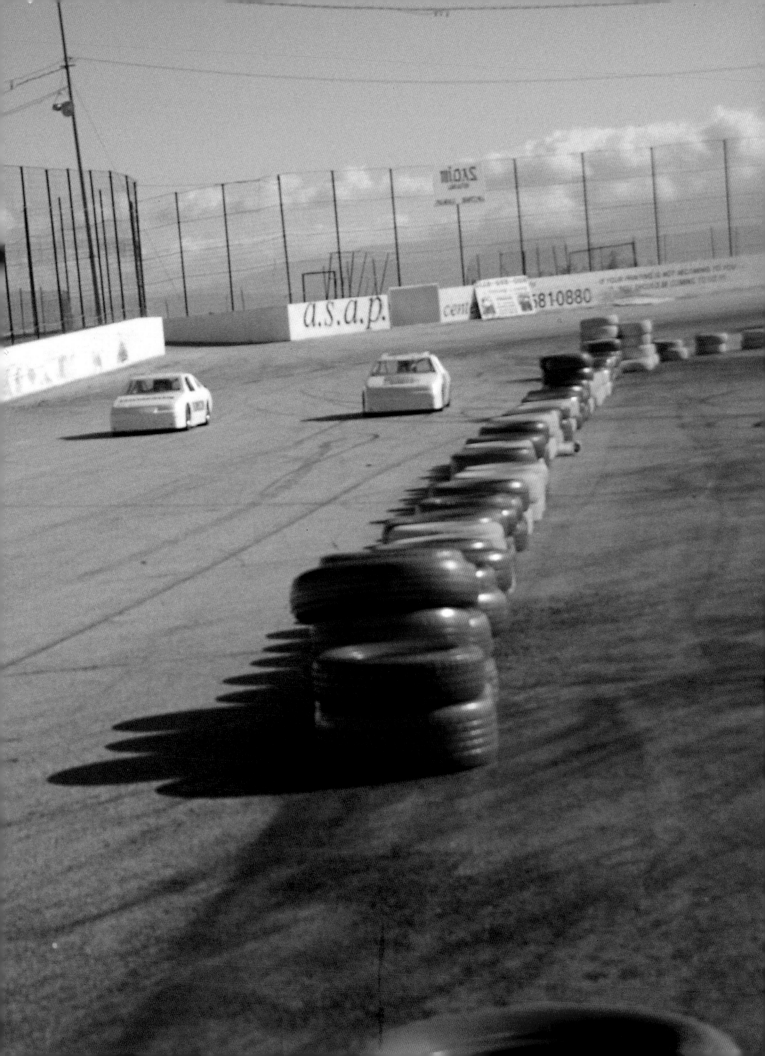

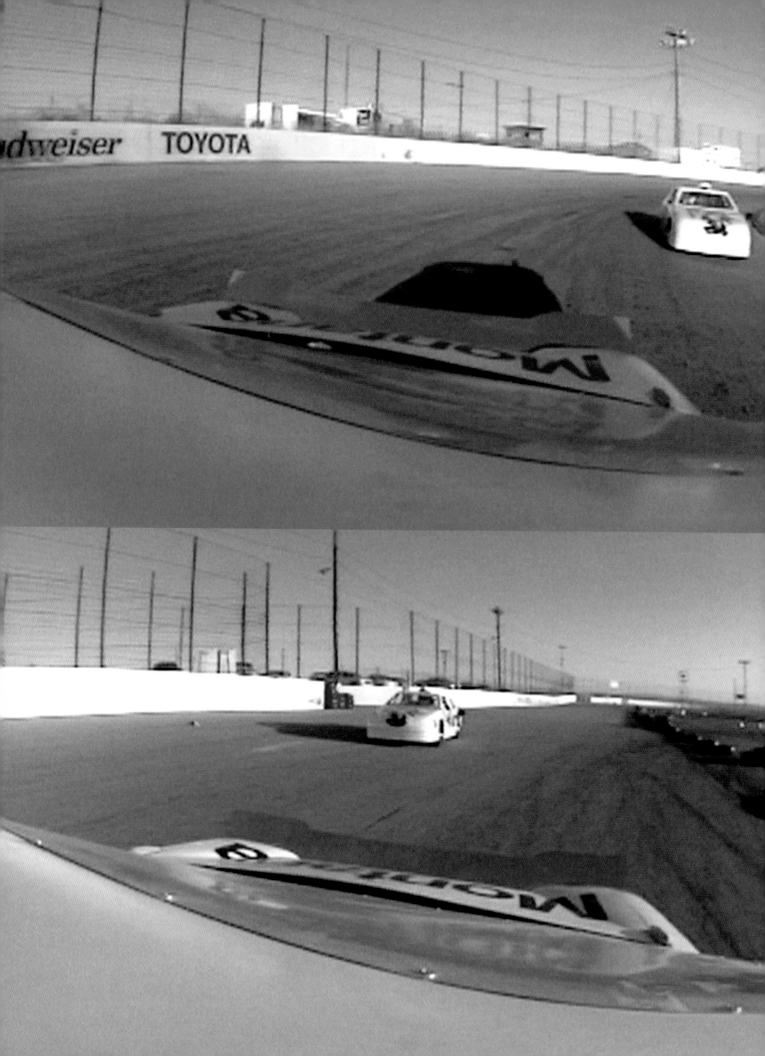

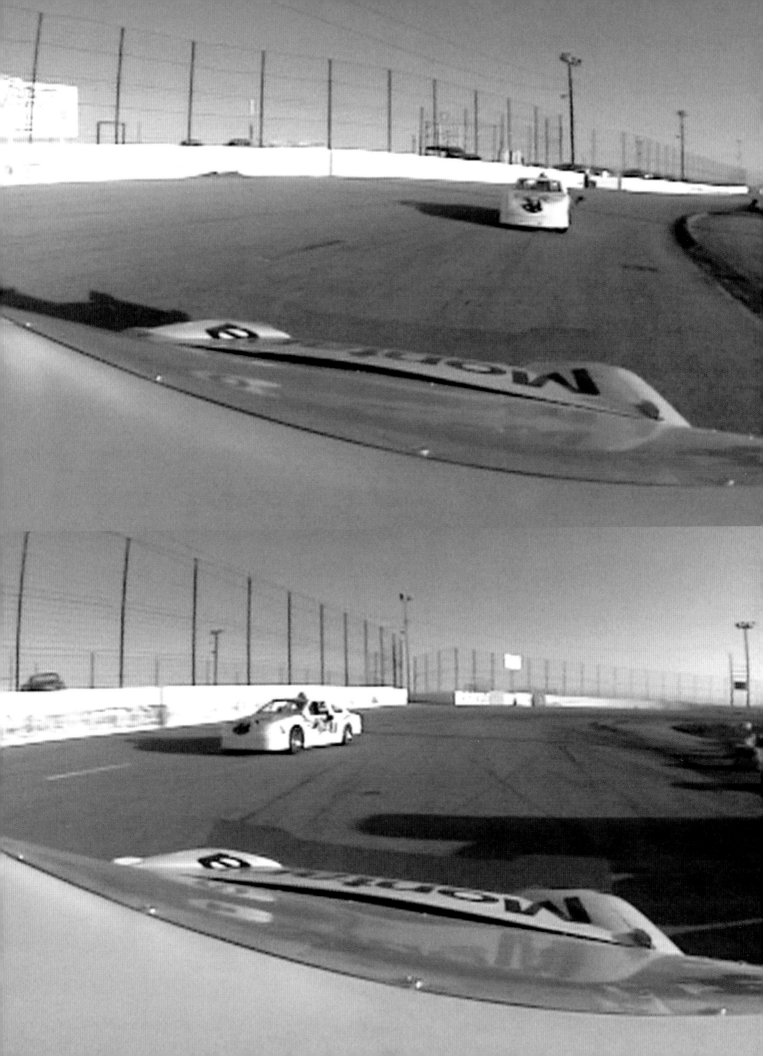

est!

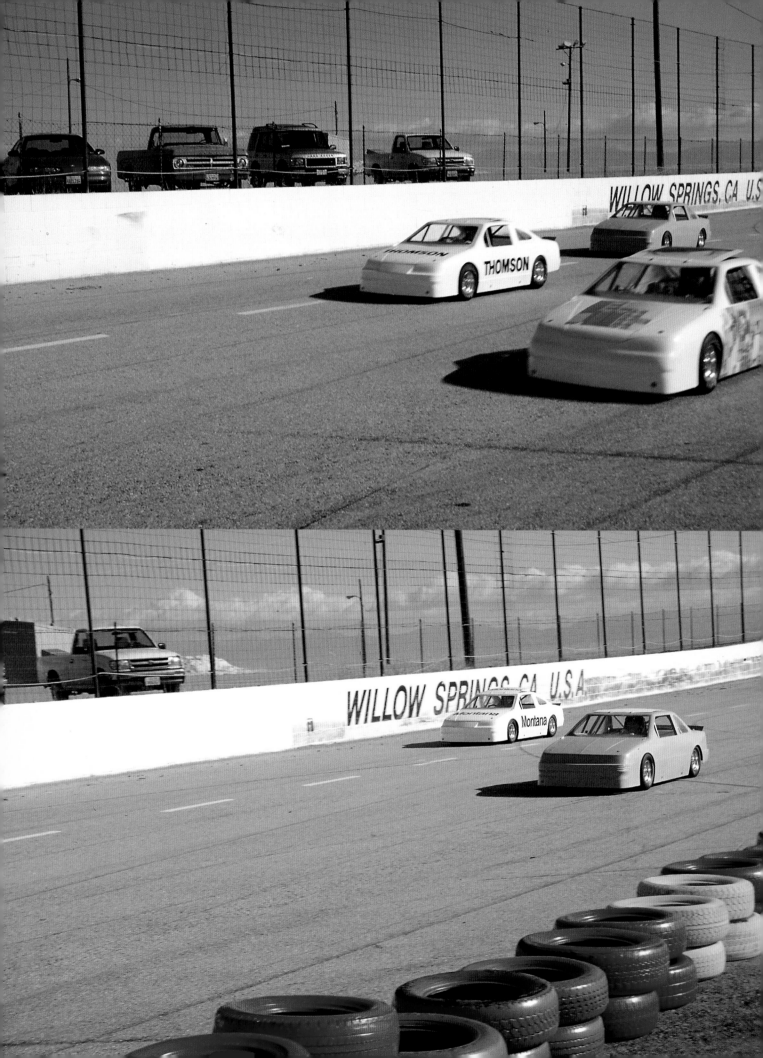

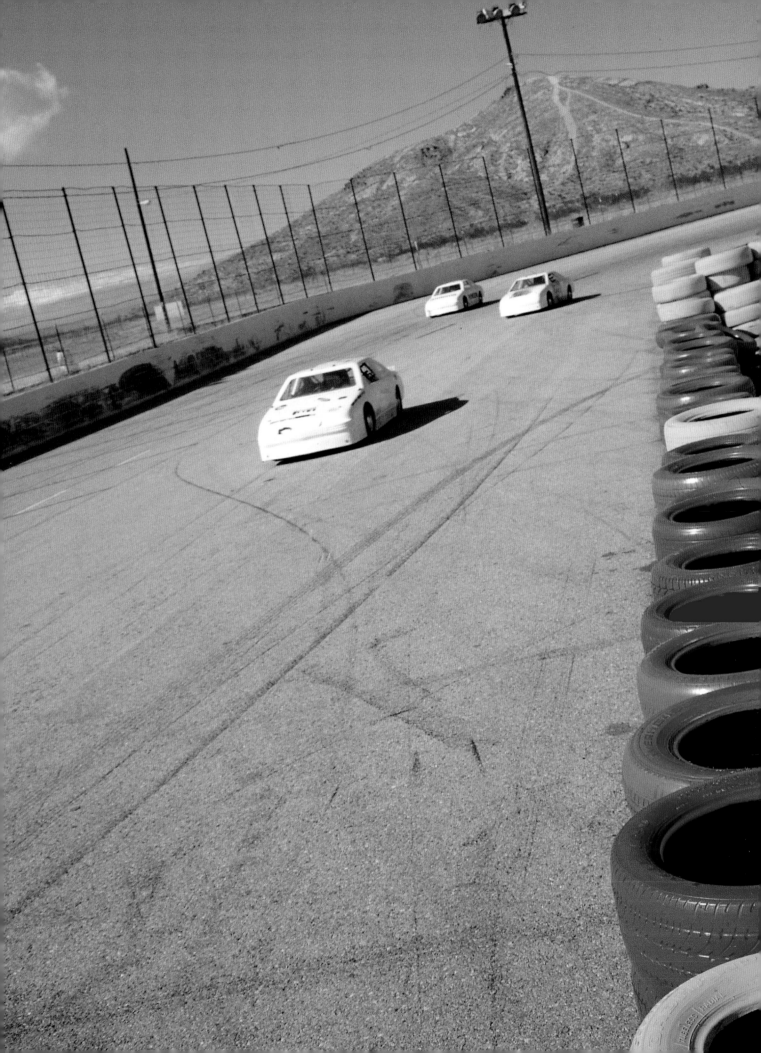

SUPER SLOW MOTION

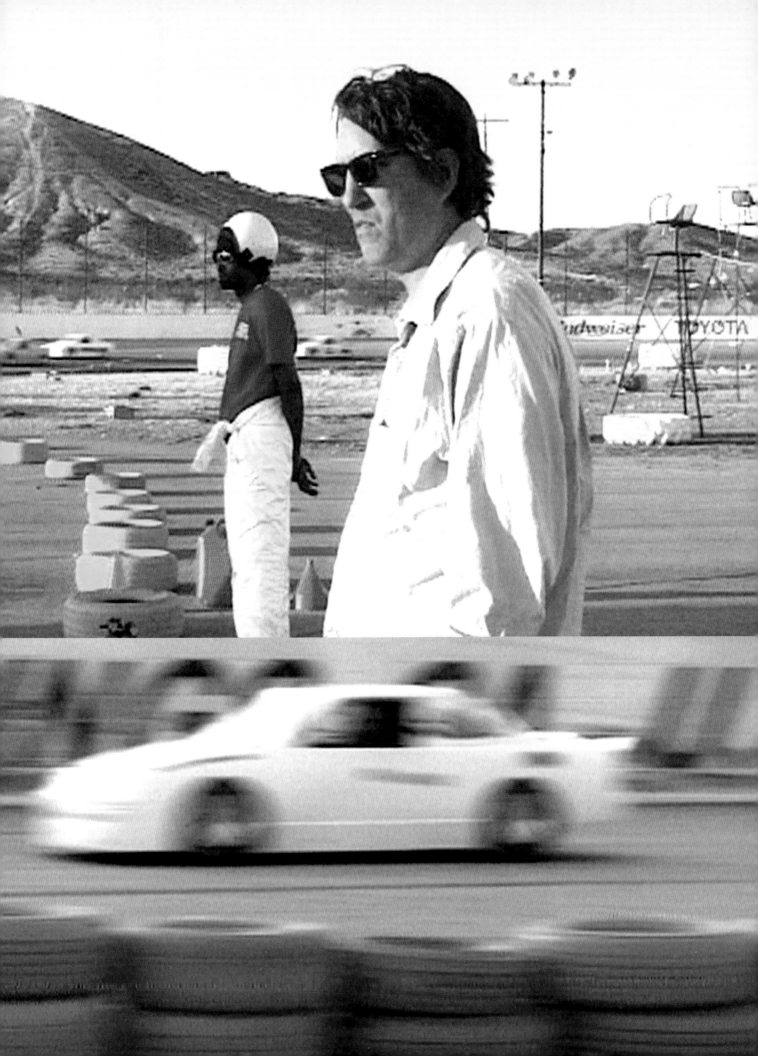

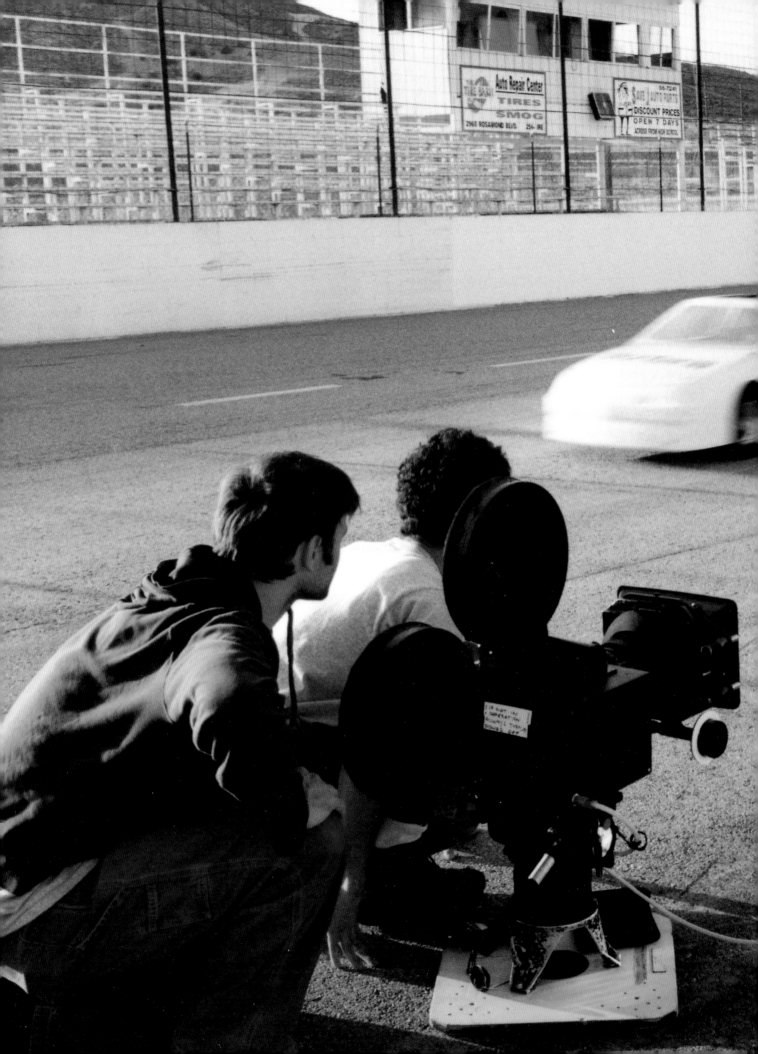

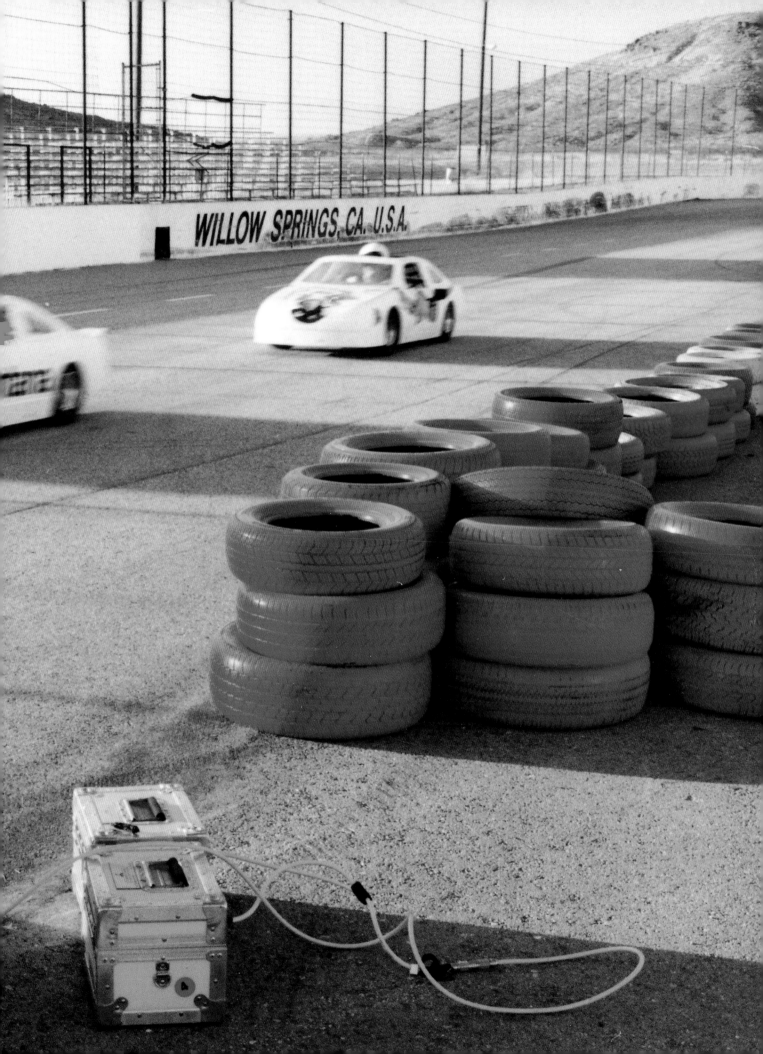

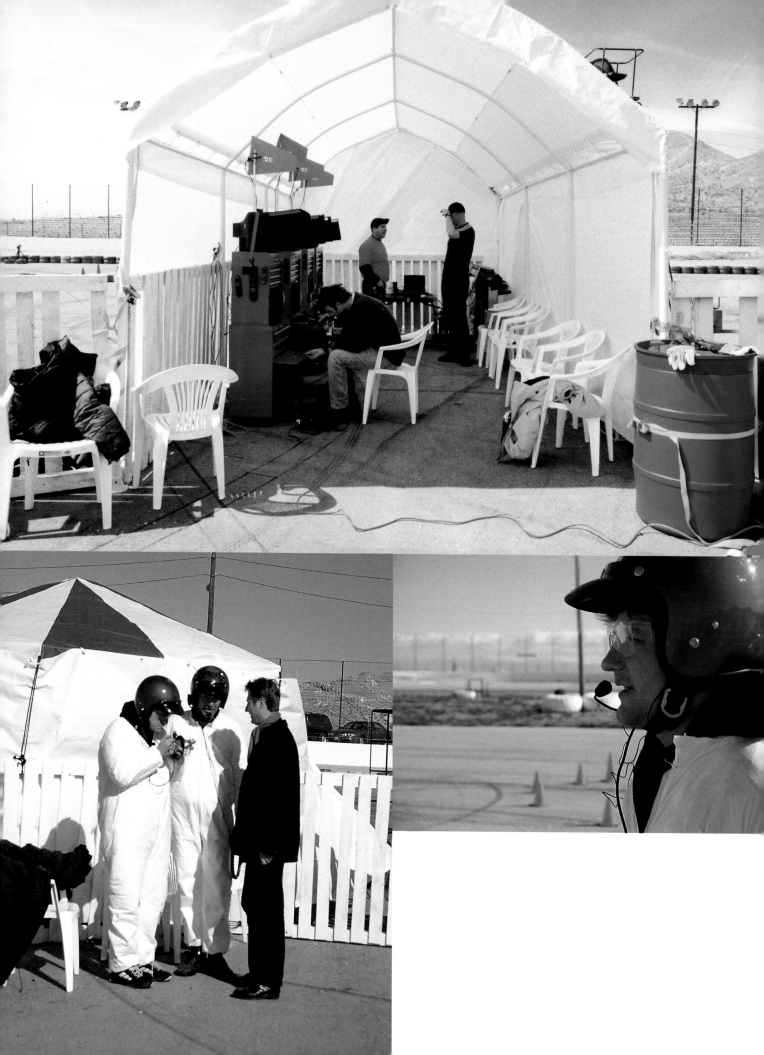

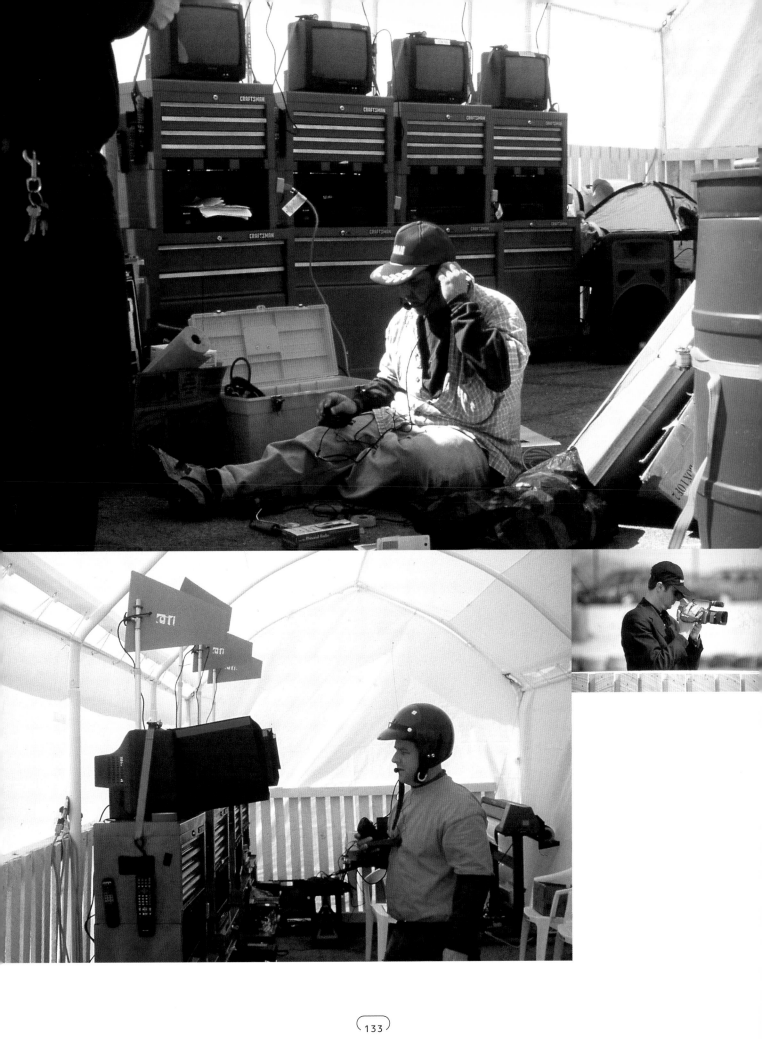

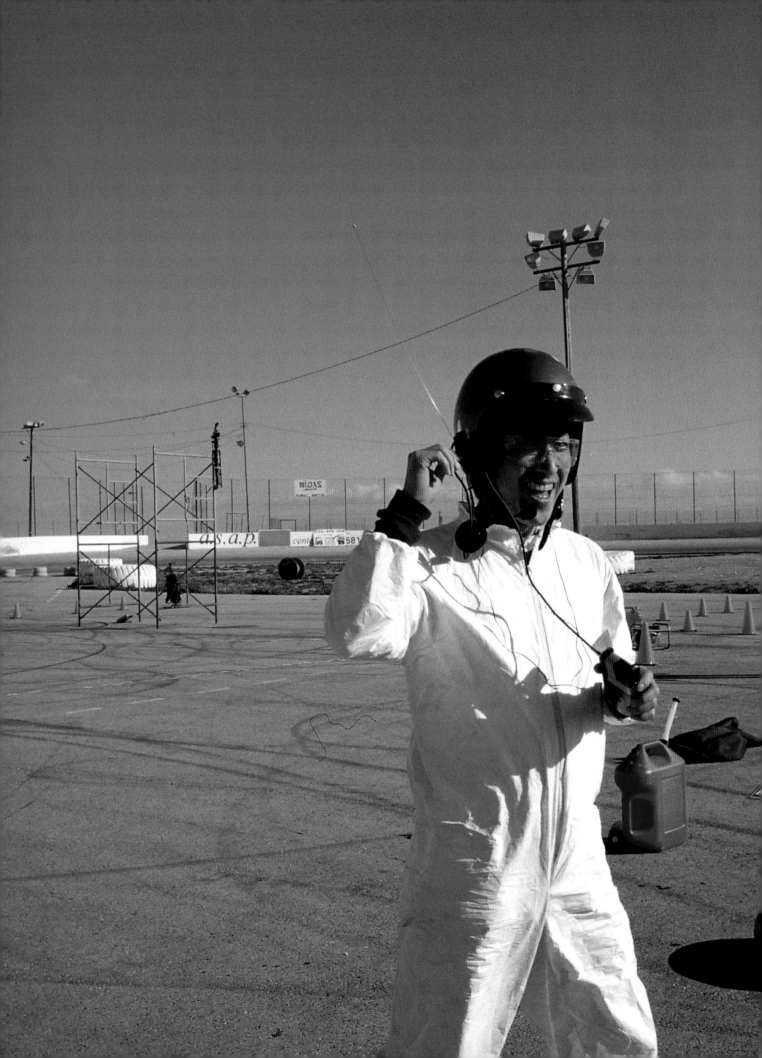

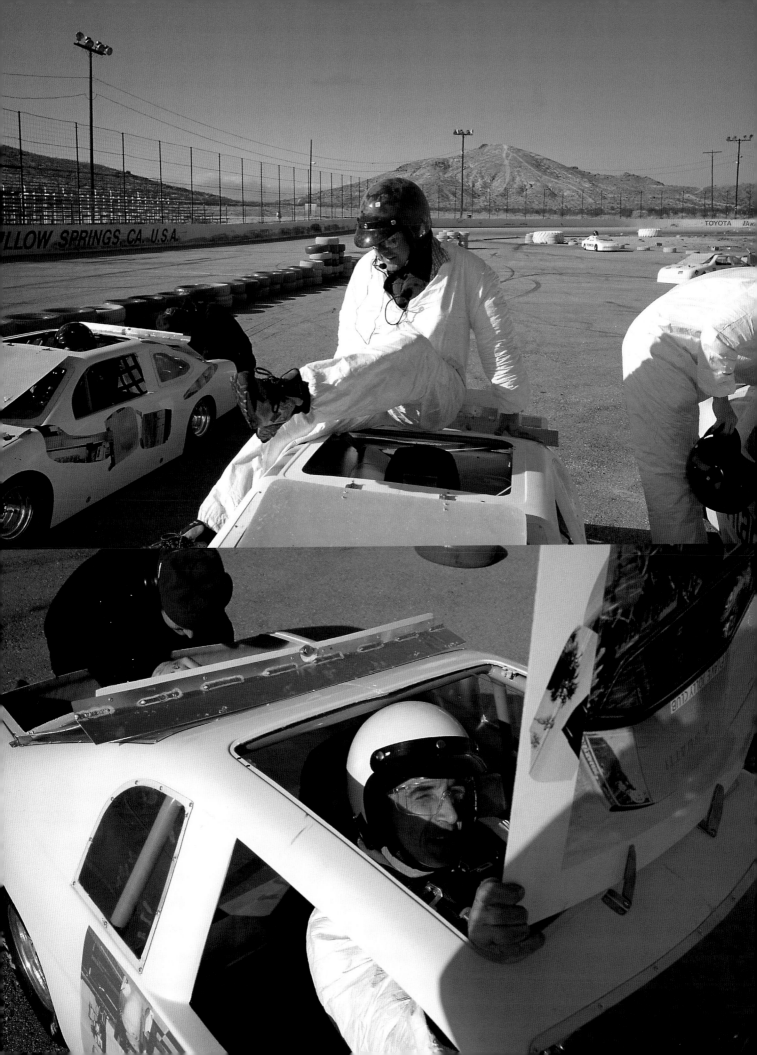

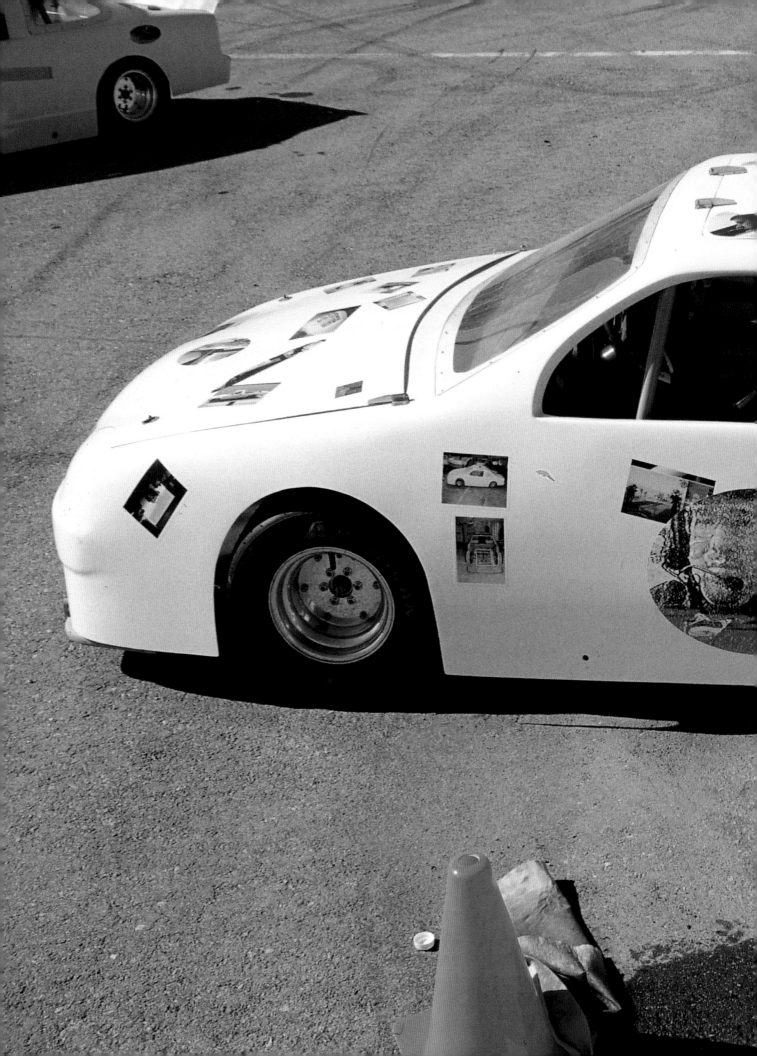

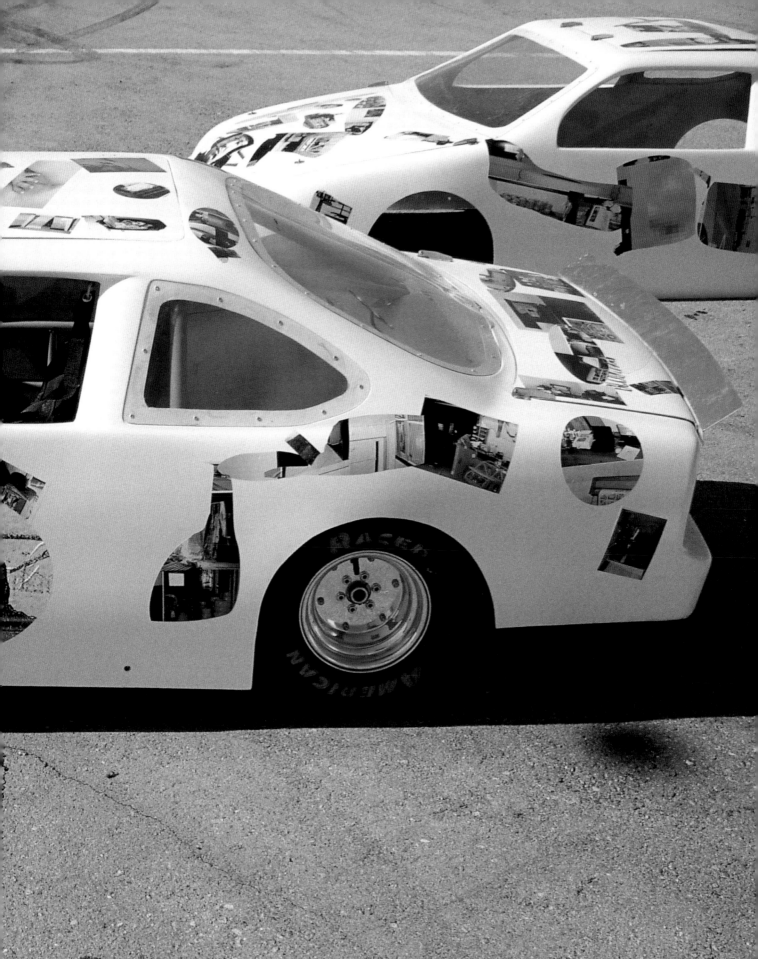

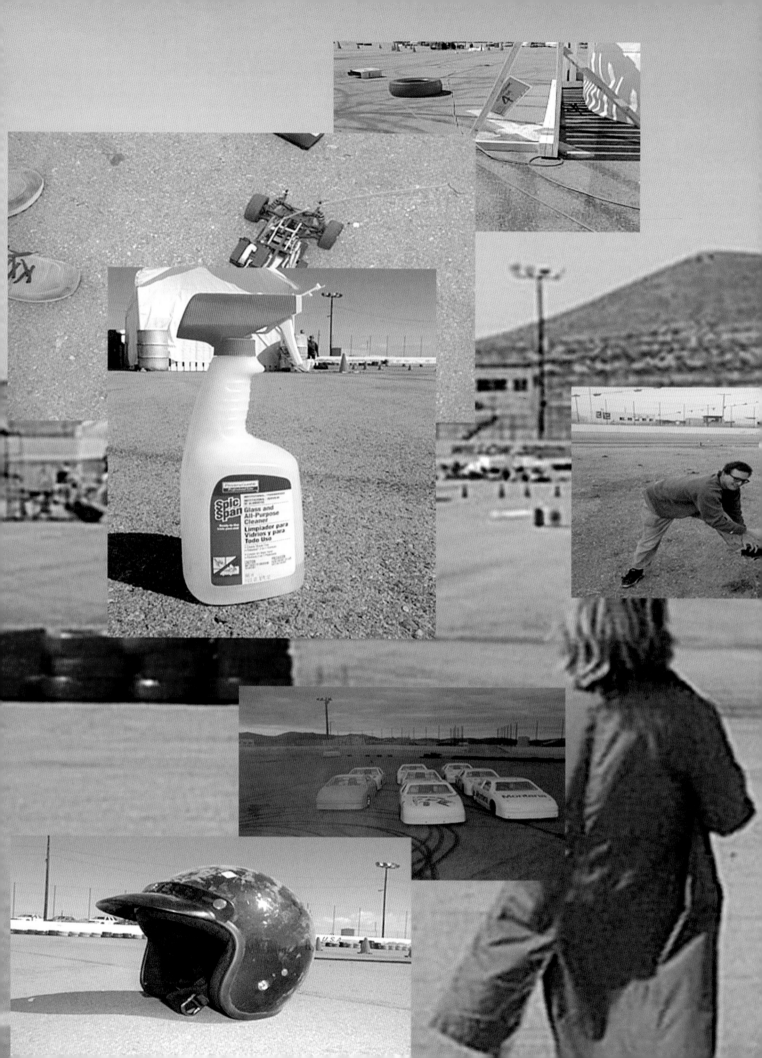

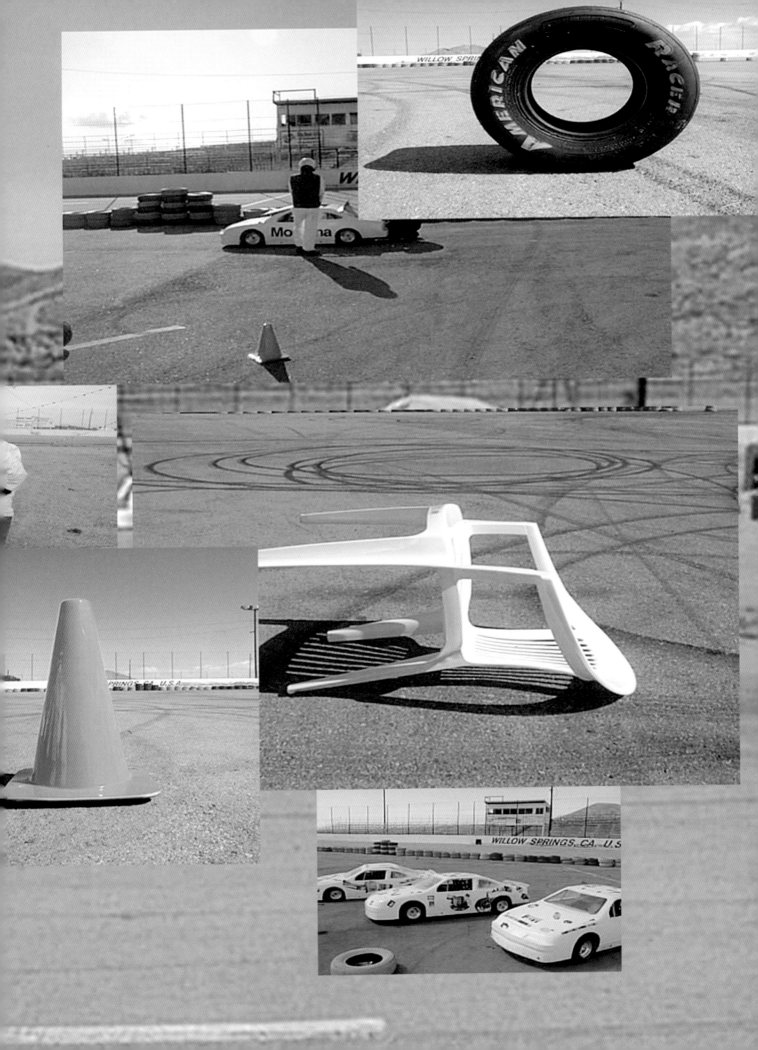

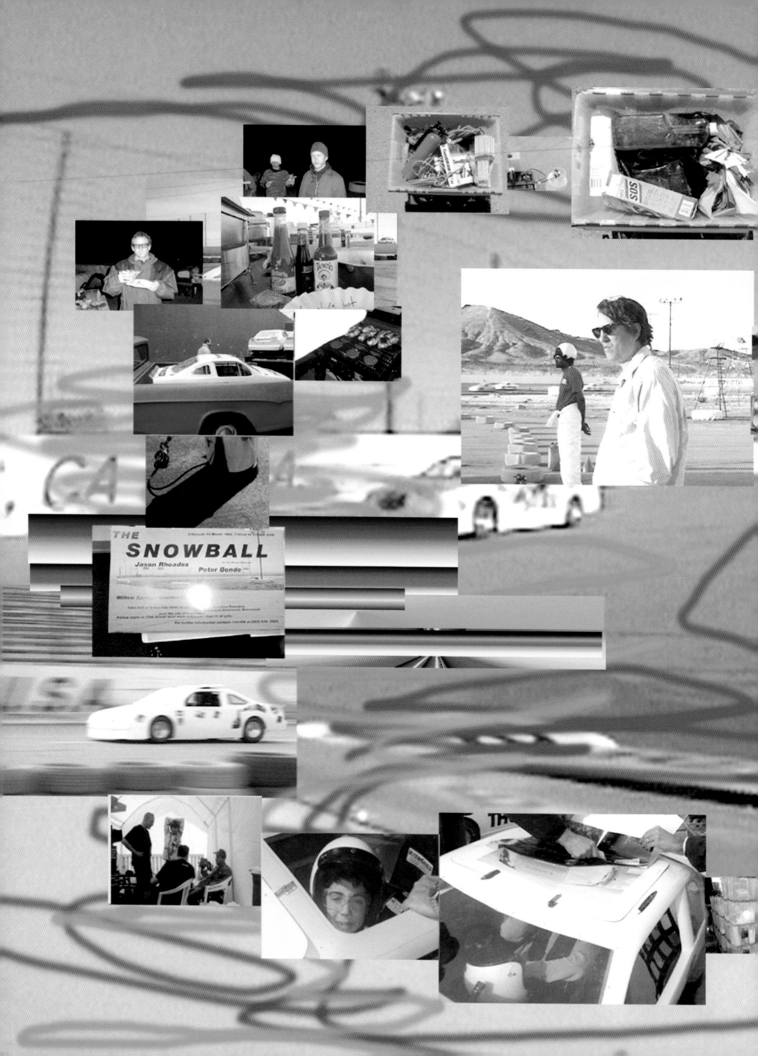

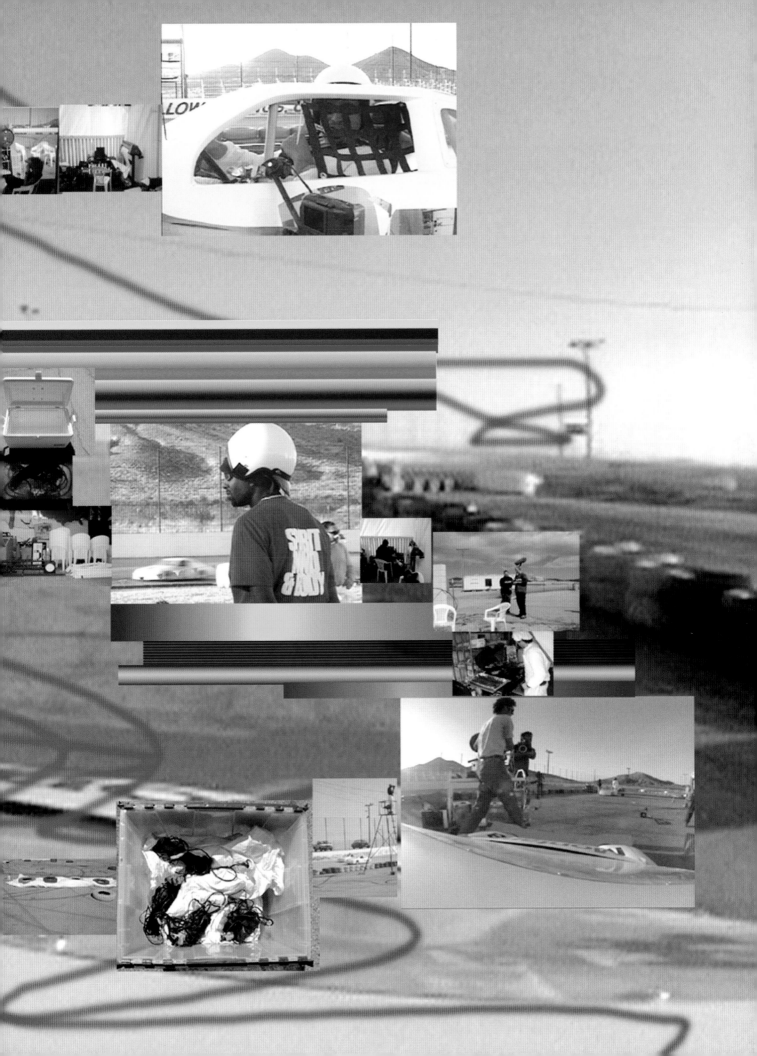

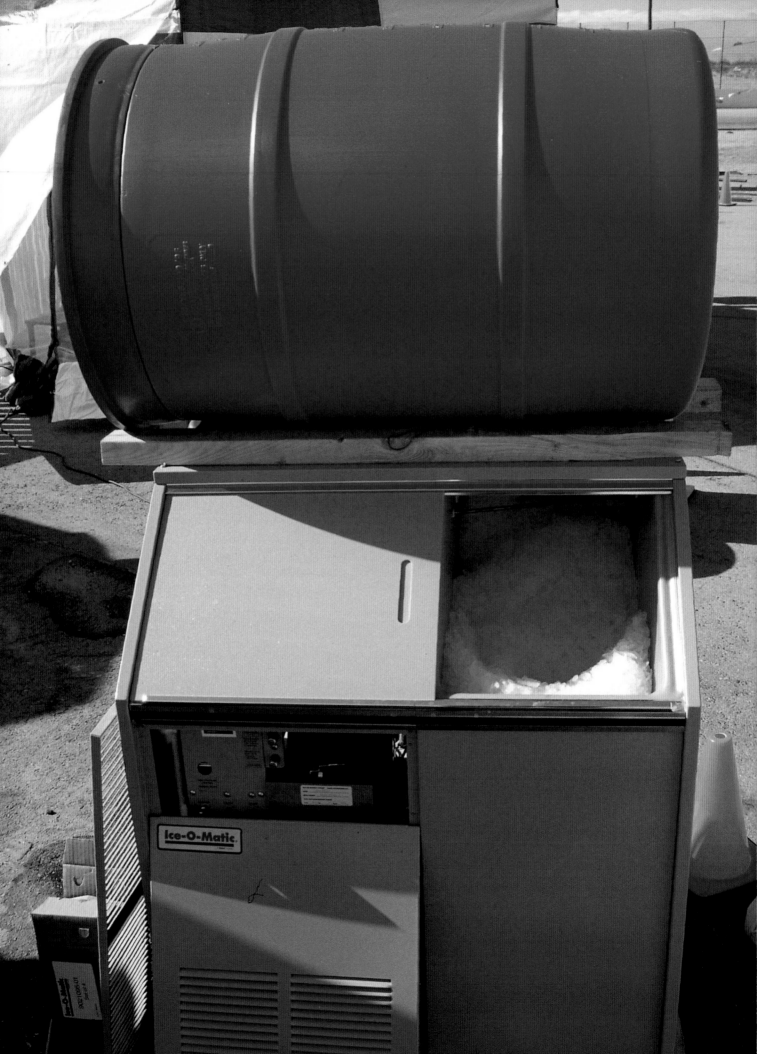

OWBALL

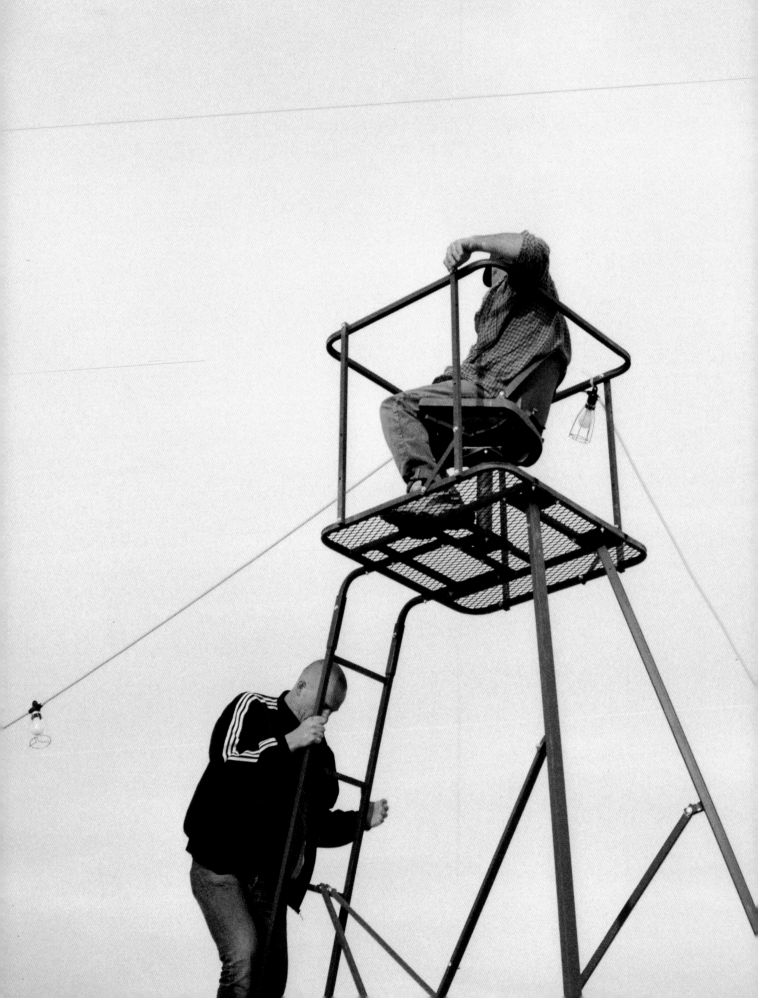

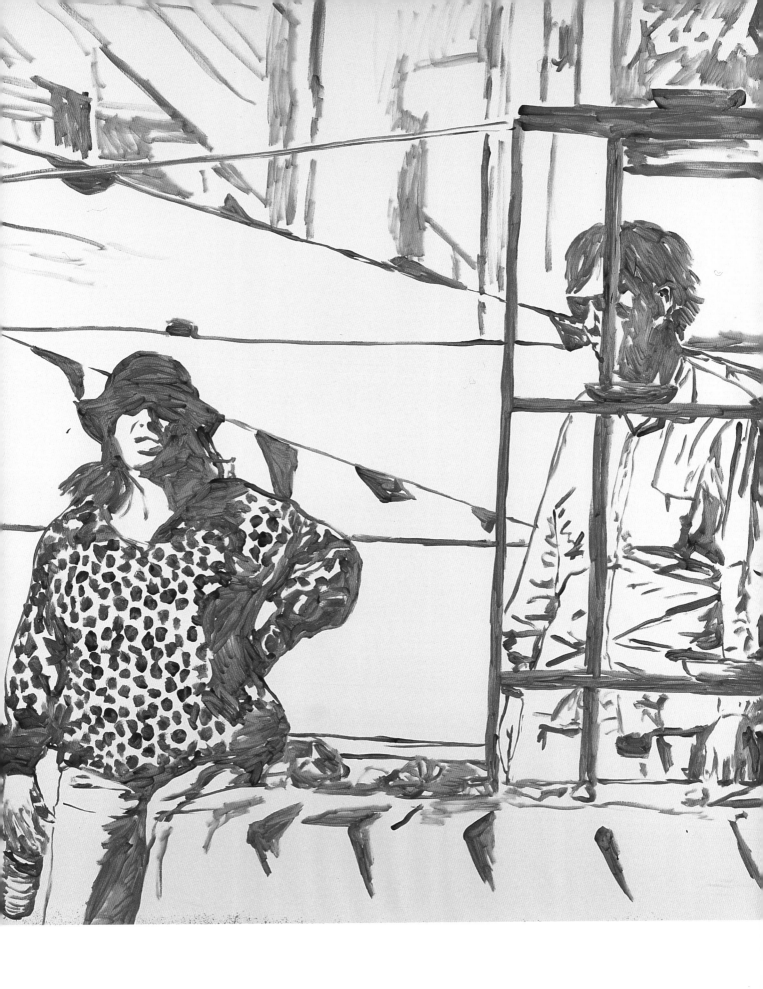

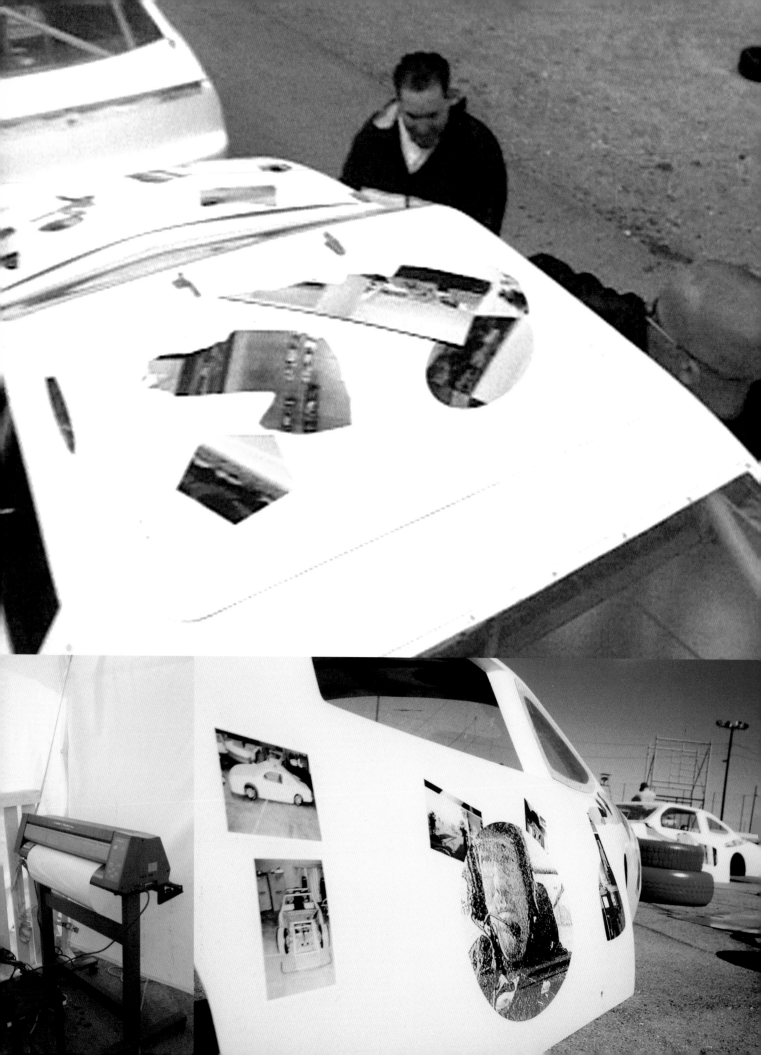

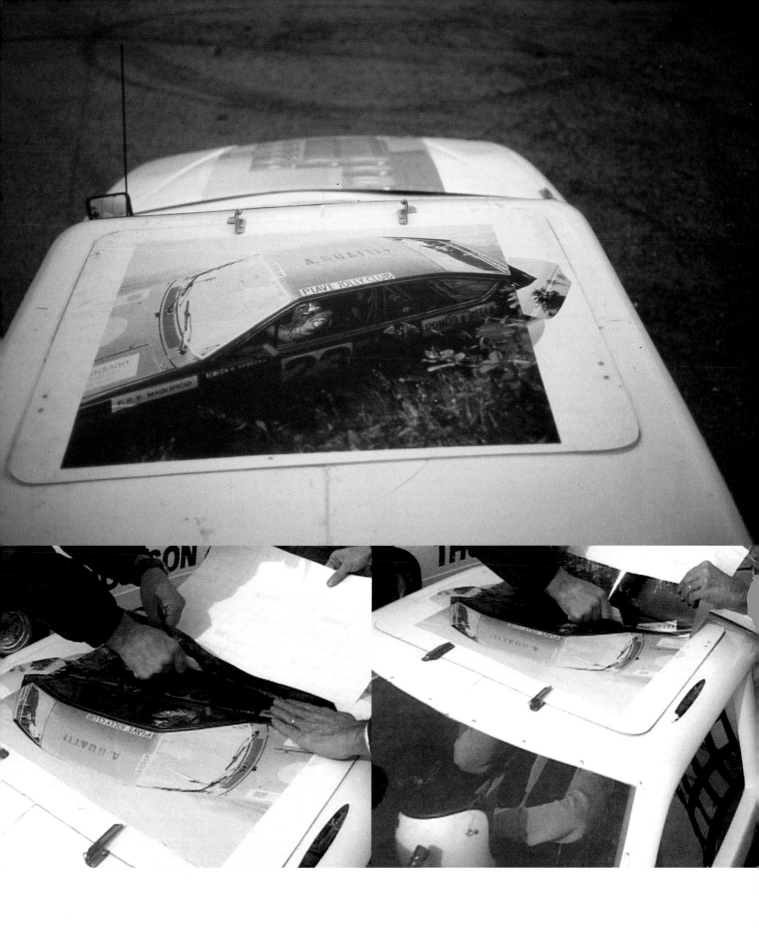

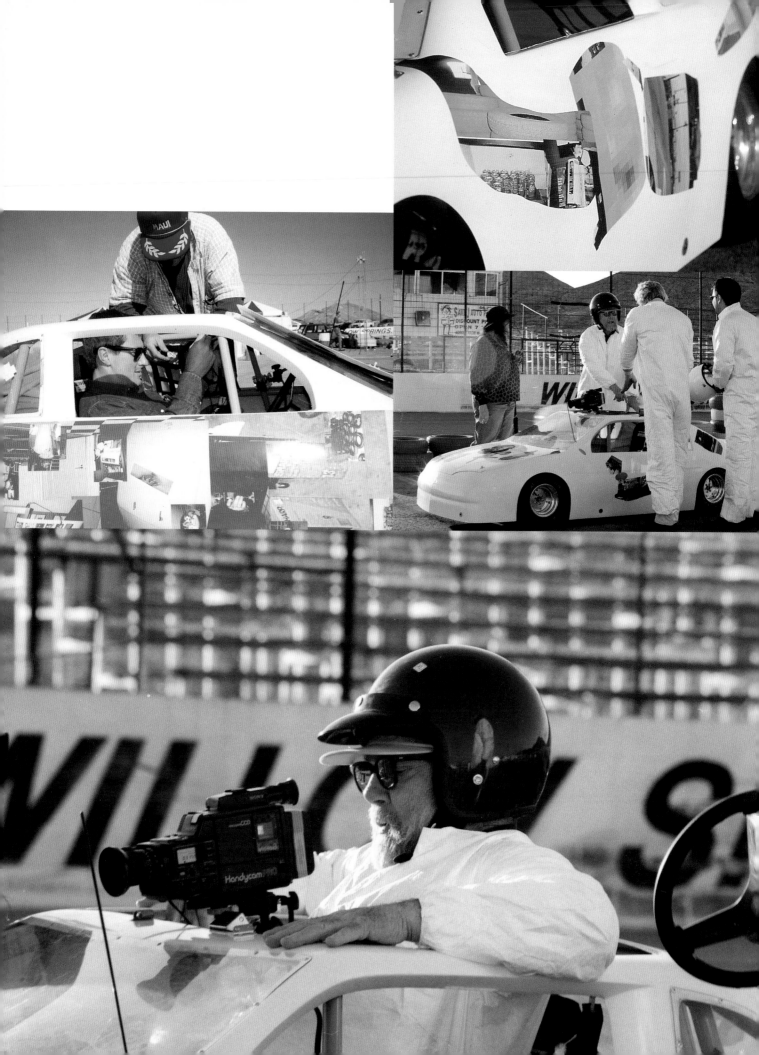

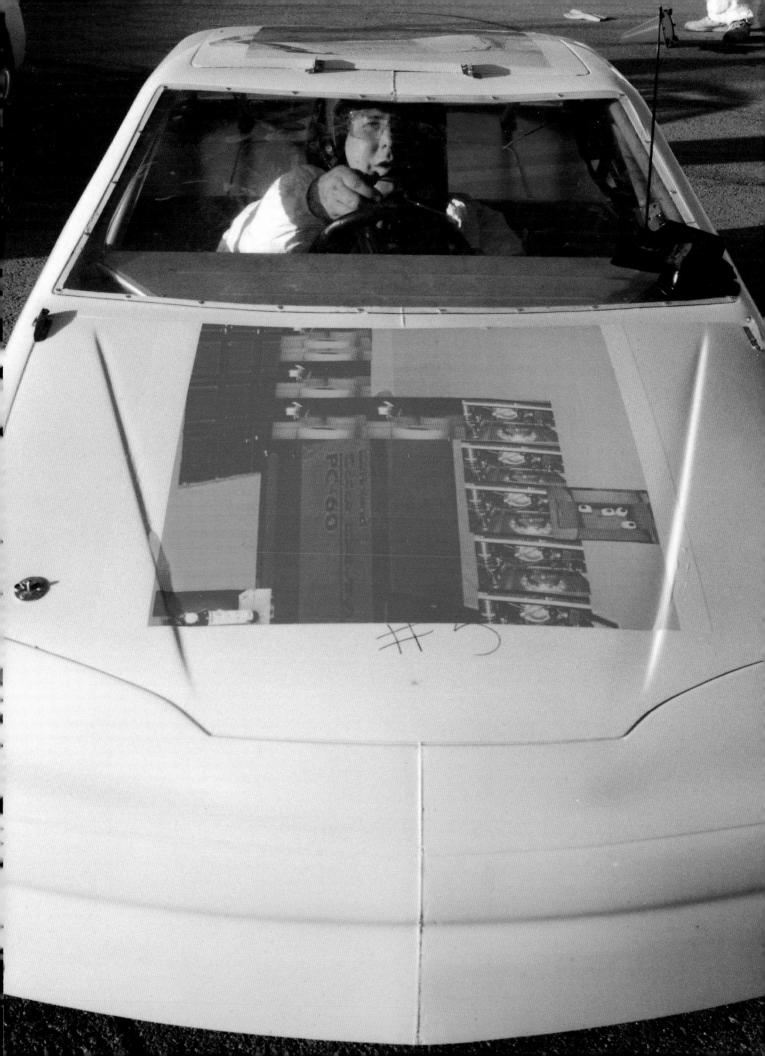

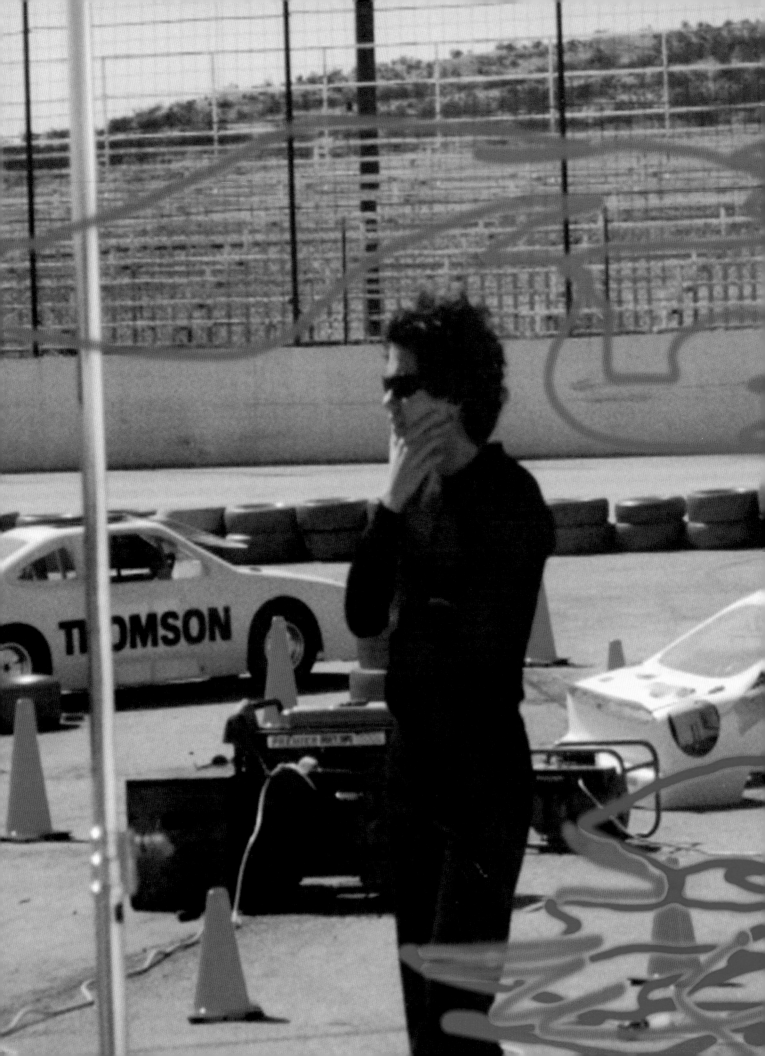

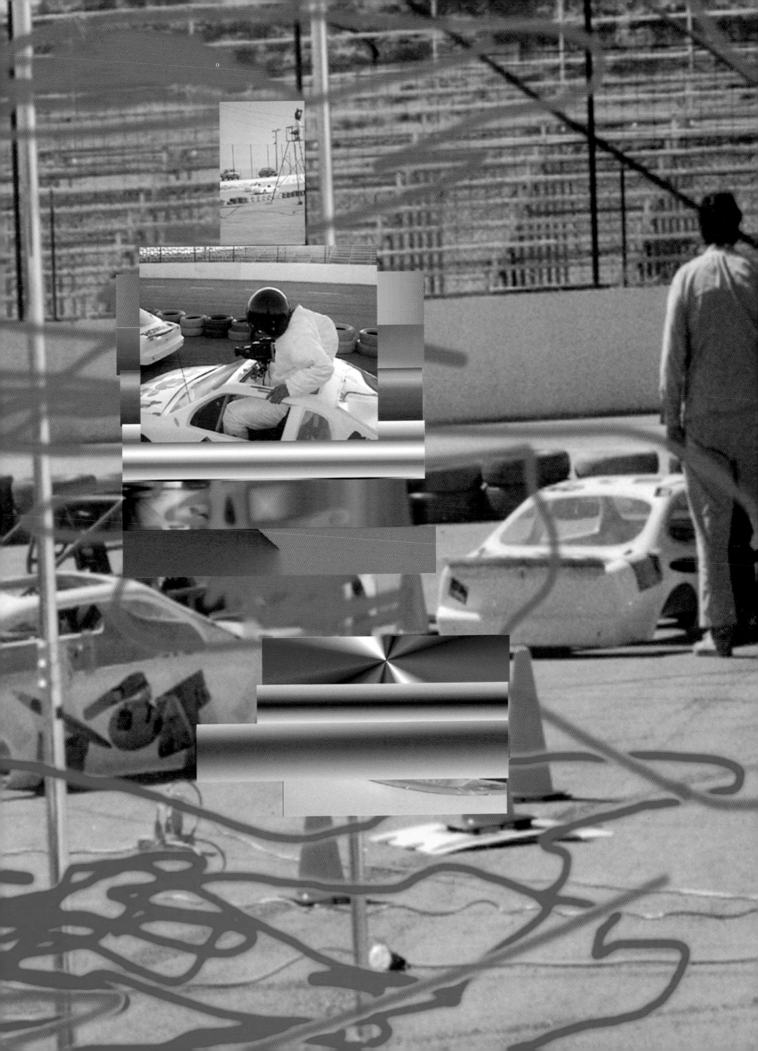

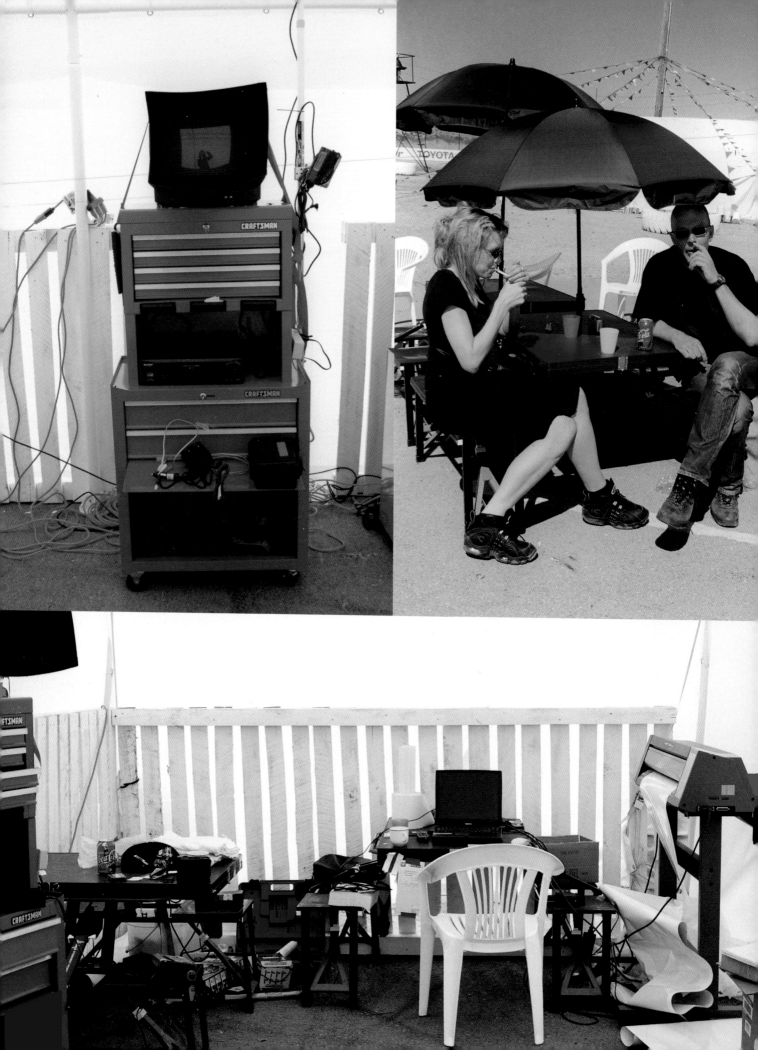

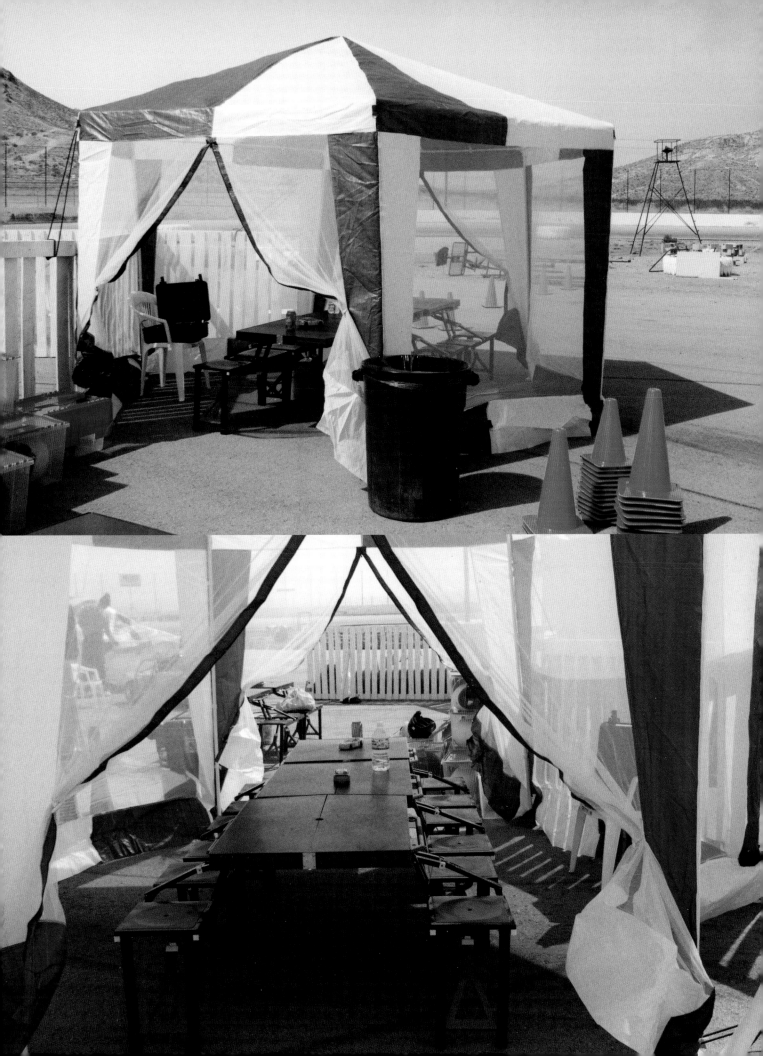

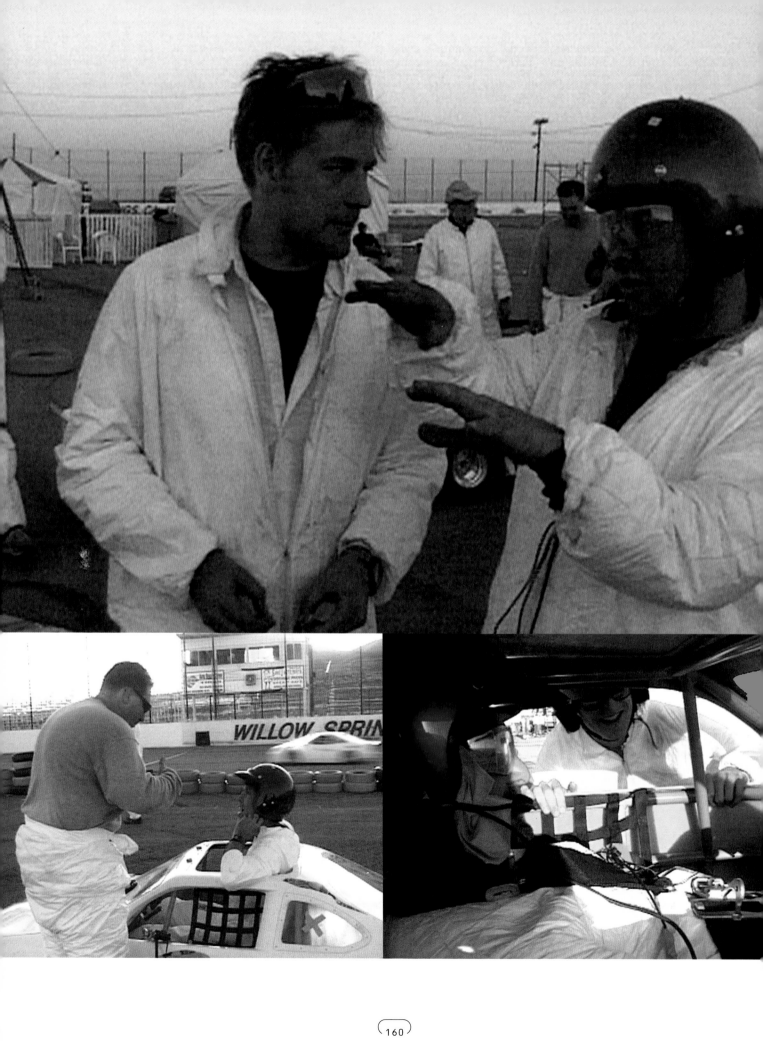

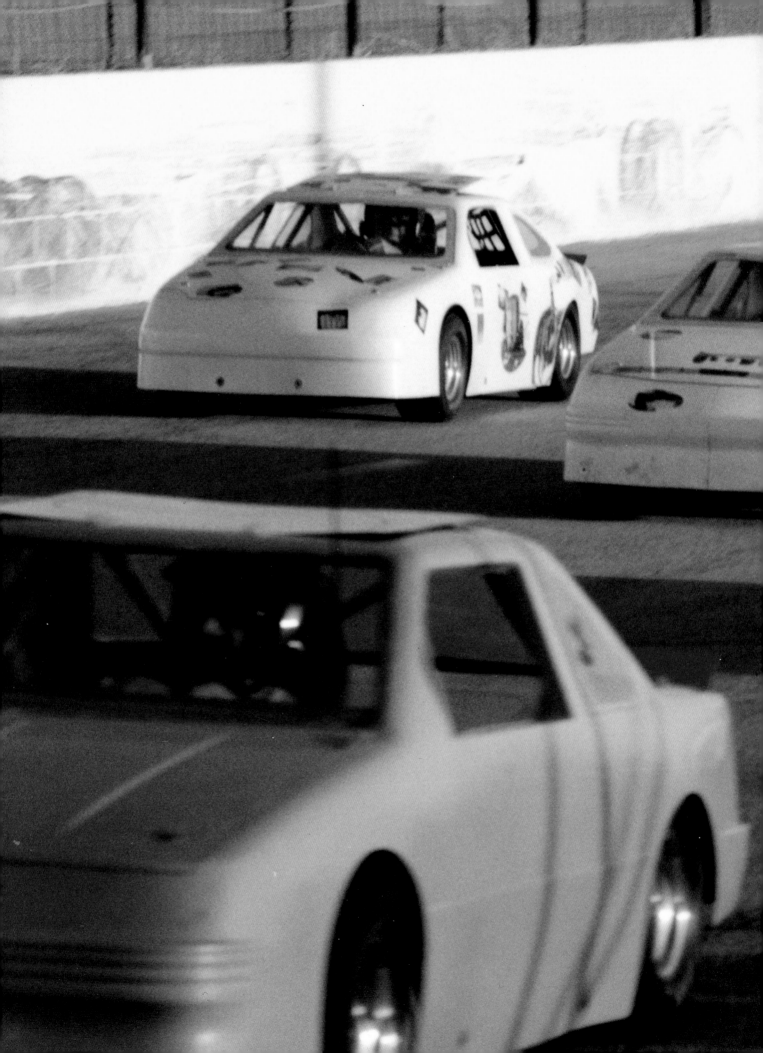

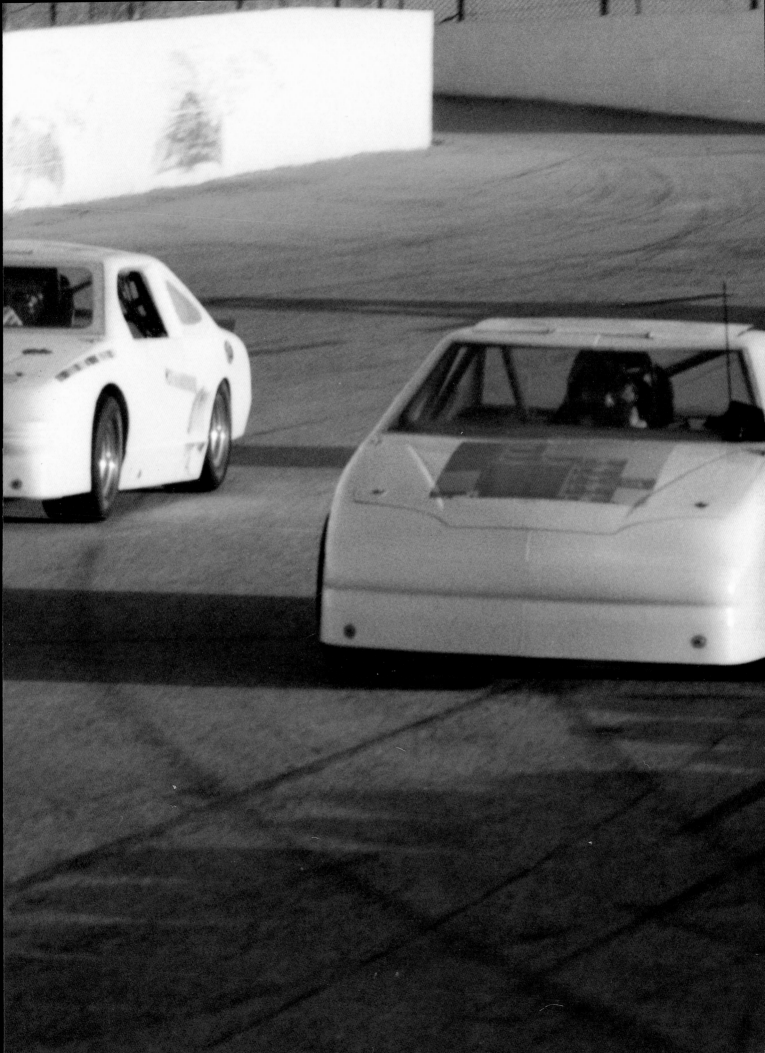

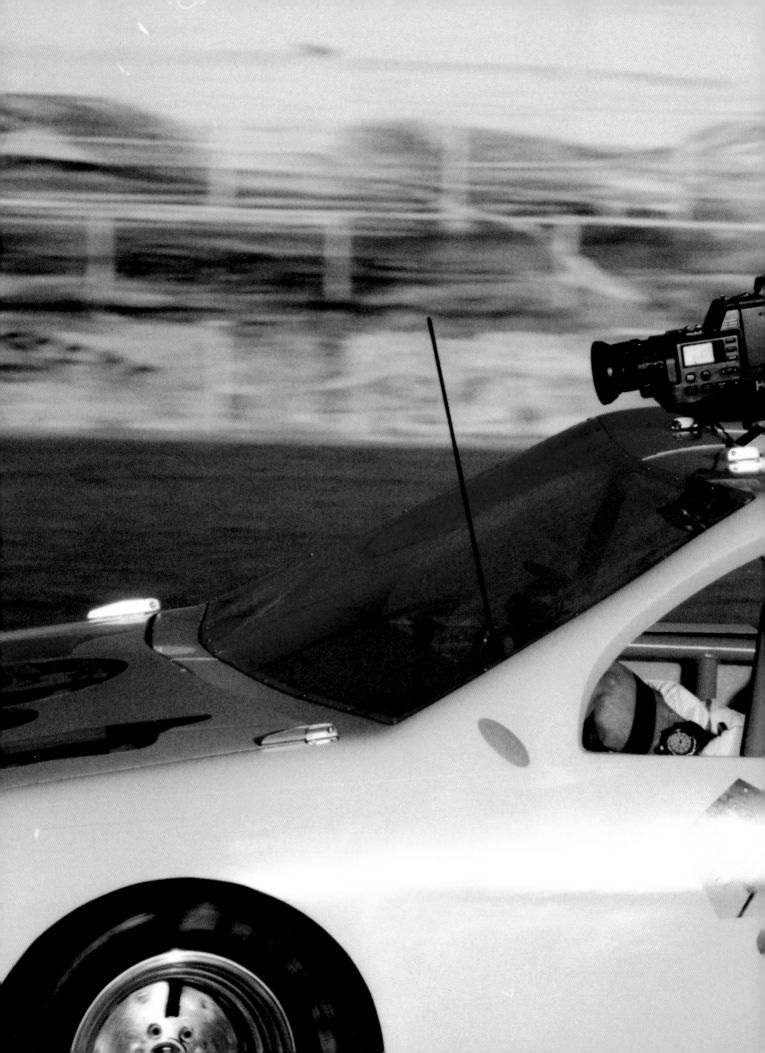

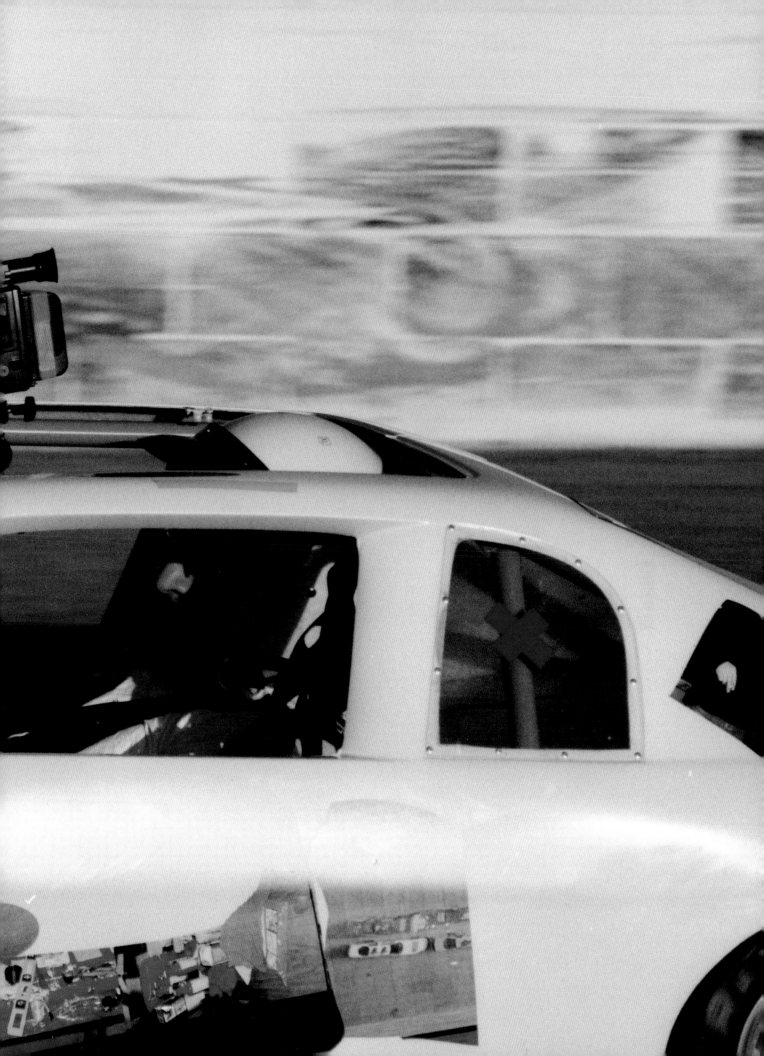

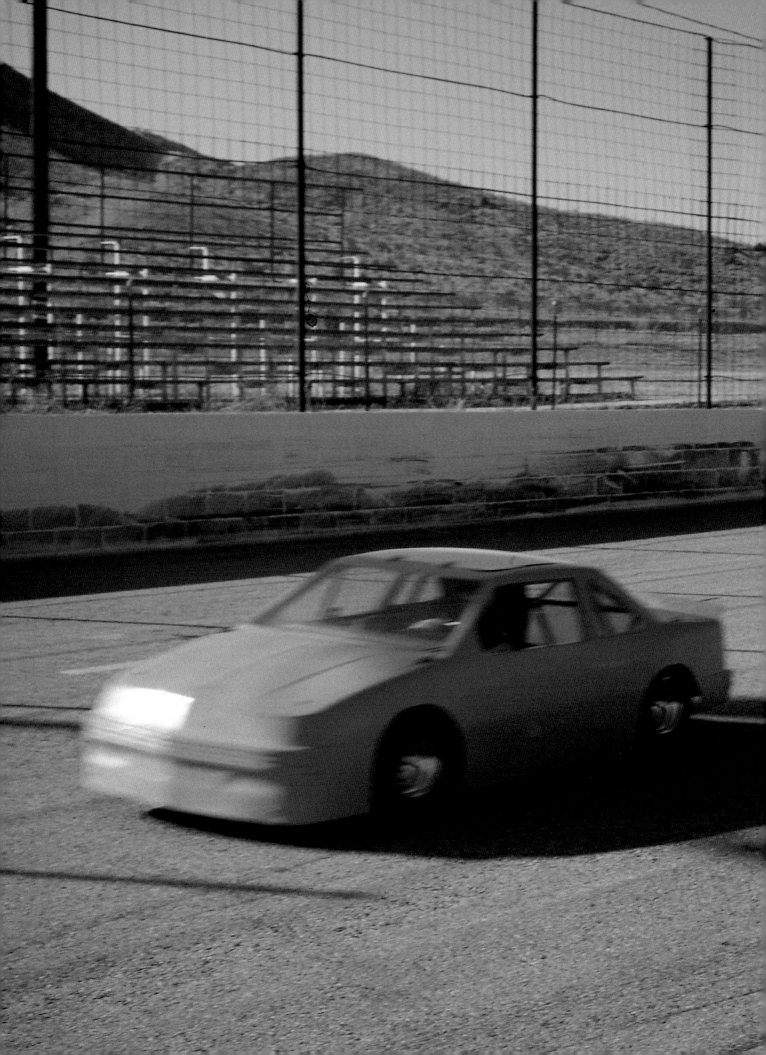

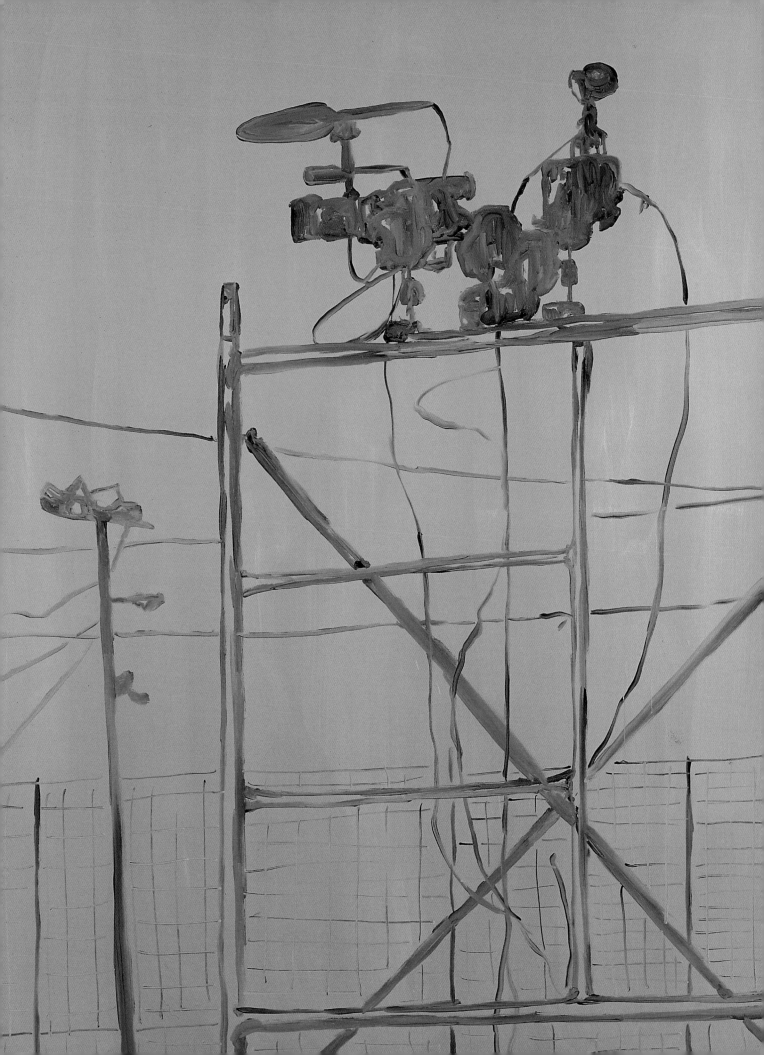

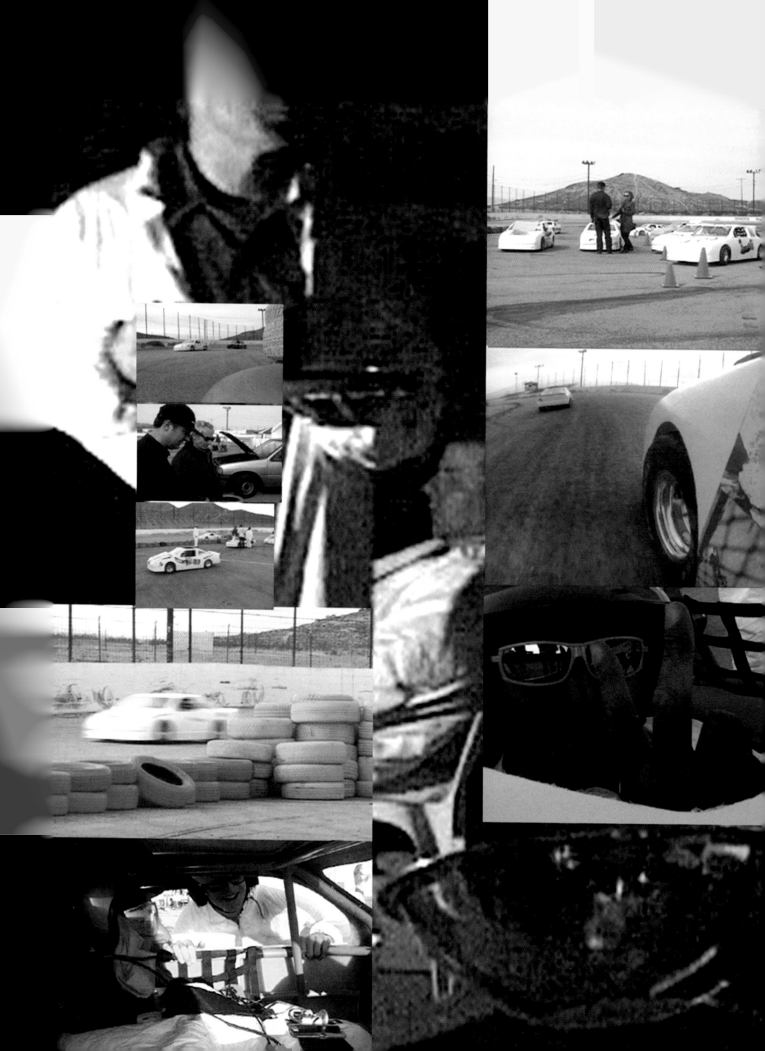

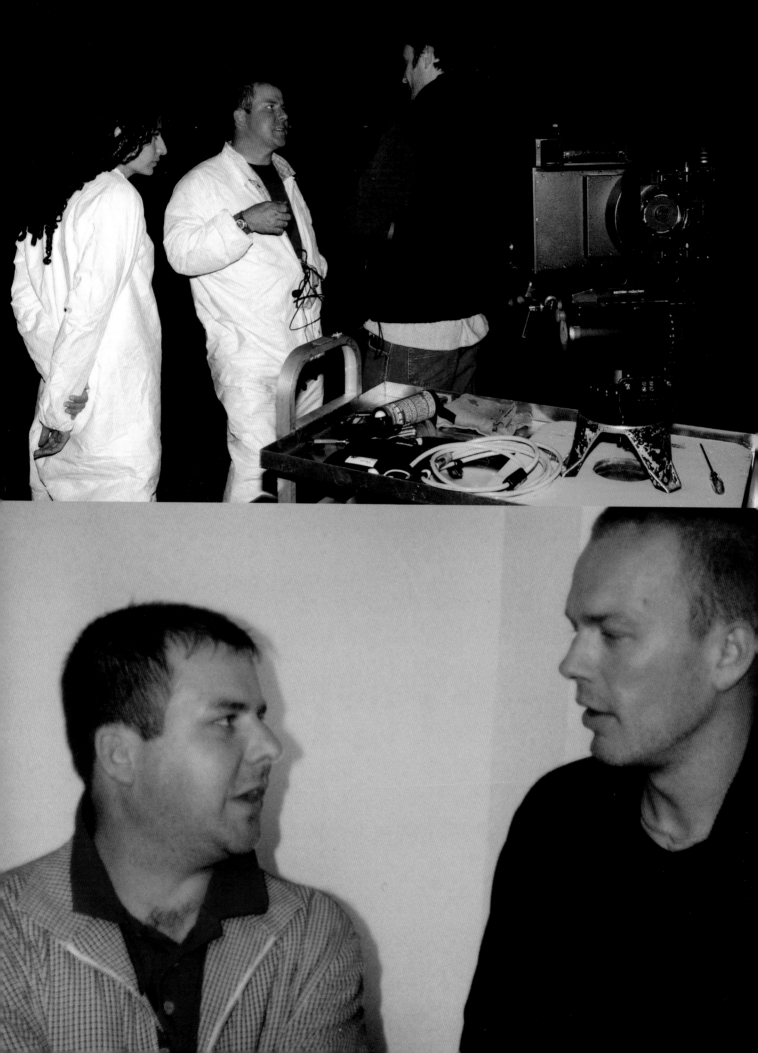

WE SHOULD HAVE SECURITY
GUARDS HERE, CONSTANTLY

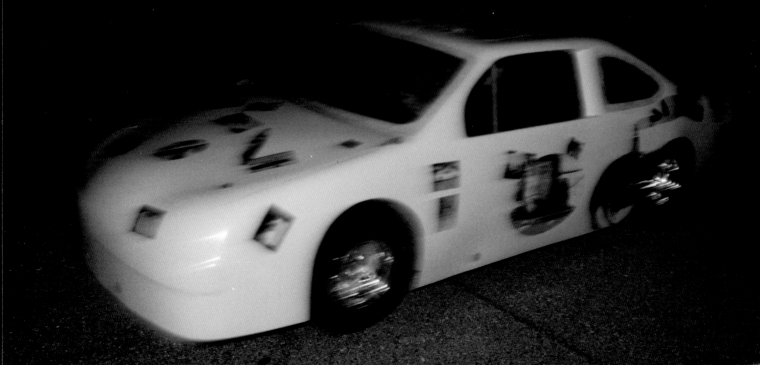

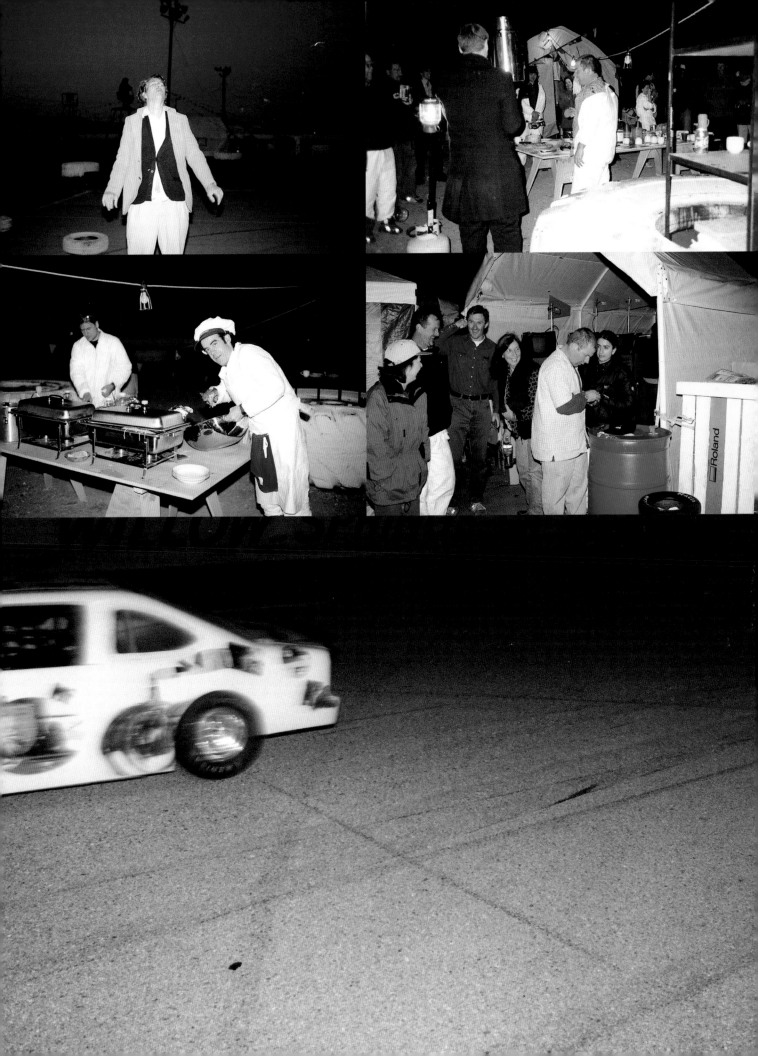

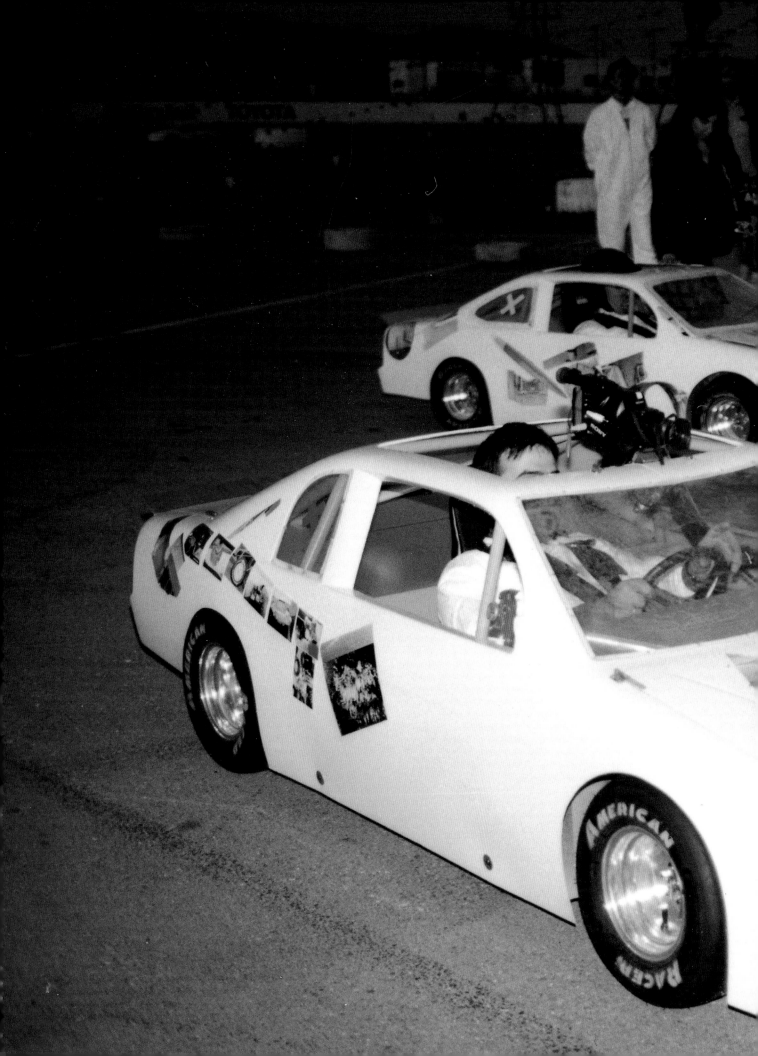

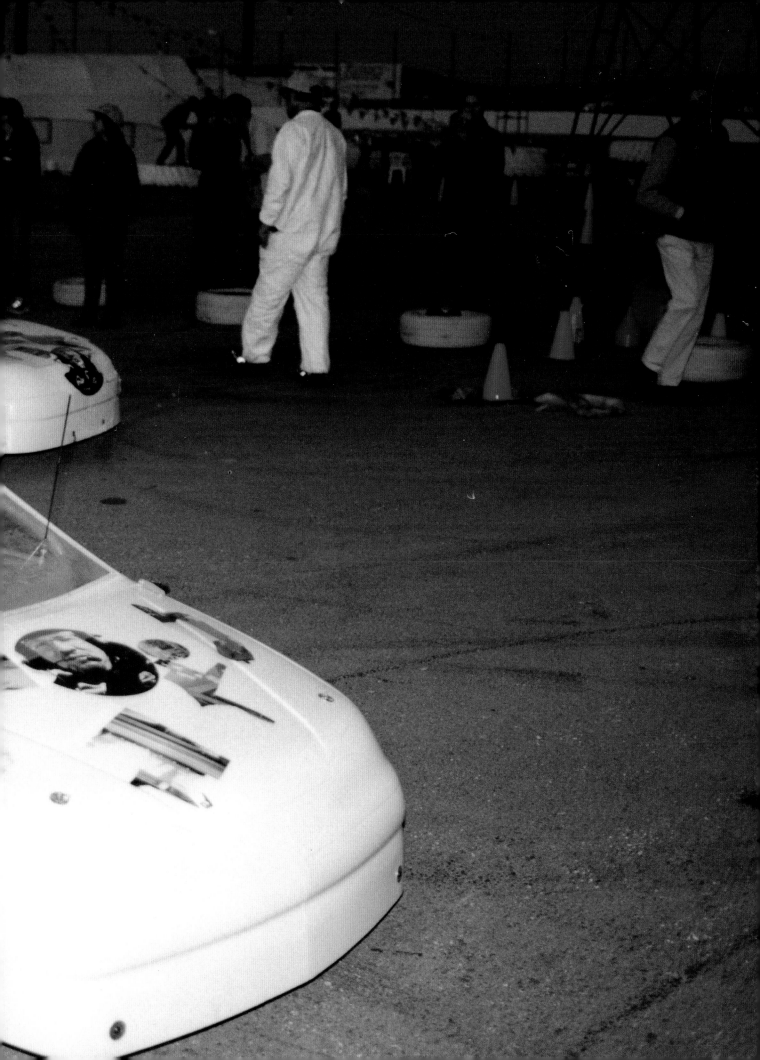

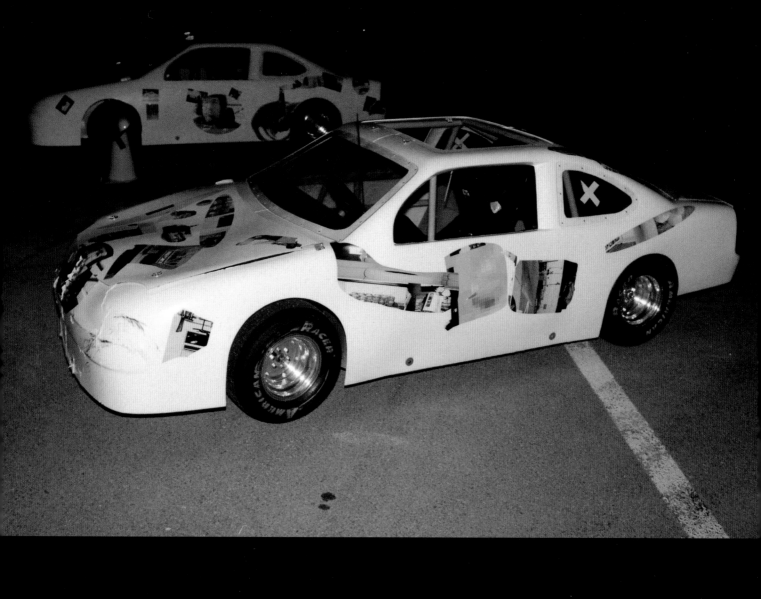

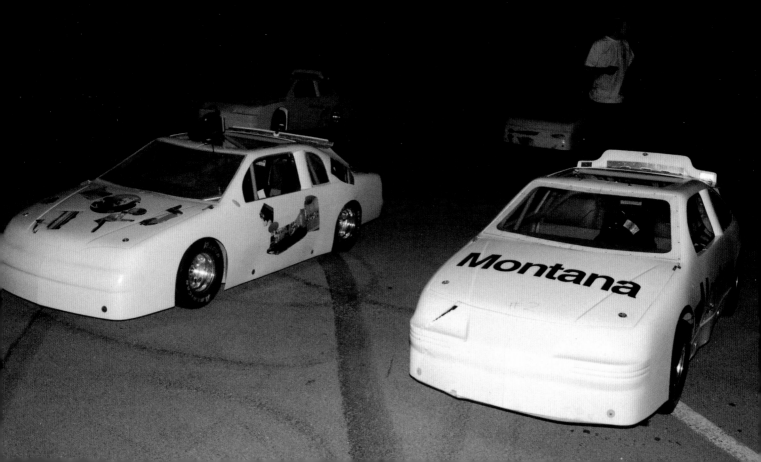

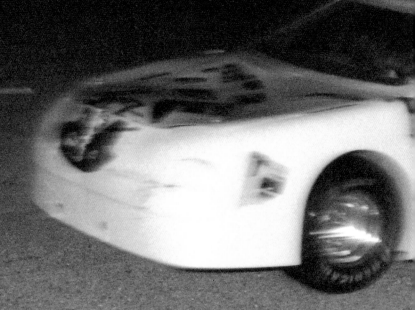

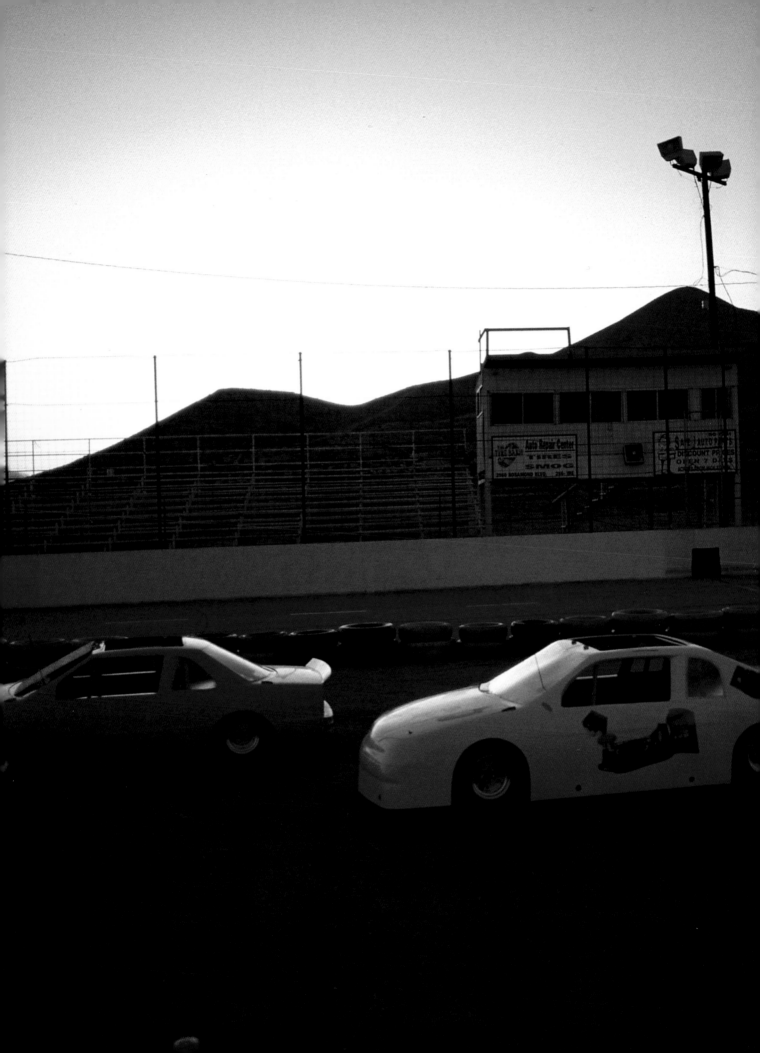

WILLOW SPRINGS RACEWAY

TEAM/COMPANY NAME: _Snow Ball_ _____

PAYMENT:

NUMBER

TYPE OF RENTAL: ☐ OPEN TEST ☐ SEMI-EXCL. ☒ EXCLUSIVE

☐ ROAD COURSE ☐ STREETS OF WILLOW ☒ KCR

☐ DIRT TRACK ☐ OFF ROAD

FUEL:

WILLOW SPRINGS INTERNATIONAL RACEWAY RELE

IN CONSIDERATION of being permitted to enter for any purpose any RESTRICTED AREA (herein defined a including but not limited to the racing surface, pit areas, infield, burn out area, approach area, shut down area, and a walkways, concessions and other areas appurtenant to any area where any activity related to the event shall take place or being permitted to compete, officiate, observe, work for, or for any purpose participate in any way in the even EACH OF THE UNDERSIGNED, for himself, his personal representatives, heirs, and next of kin, acknowledges agrees and represents that he has, or will immediately upon entering any of such restricted areas, and will continuousl thereafter, inspect such restricted areas and all portions thereof which he enters and with which he comes in contac and he does further warrant that his entry upon such restricted area or areas and his participation, if any, in the even constitutes an acknowledgement that he has inspected such restricted area and that he finds and accepts the same a being safe and reasonably suited for the purposes of his use, and he further agrees and warrants that if, at any time he is in or about restricted areas and he feels anything to be unsafe, he will immediately advise the officials of suc and will leave the restricted areas:

1. HEREBY RELEASES, WAIVES, DISCHARGES AND COVENANTS NOT TO SUE the promoter, participant racing association, sanctioning organization or any subdivision thereof, track operator, track owner, officials, c owners, drivers, pit crews, any persons in any restricted area, promoters, sponsors, advertisers, owners and lessee of premises used to conduct the event and each of them, their officers and employees, all for the purposes herei referred to as "releasees," from all liability to the undersigned, his personal representatives, assigns, heirs, and ne of kin for any and all loss or damage, and any claim or demands therefor on account of injury to the person or propert

WSMC CARD #	DRIVER/ CREW	NAME PRINTED	NAME SIGNED
		C. McCAFFREY	I HAVE READ THIS RELE
		ANDREW KRIMELOW	I HAVE READ THIS RELE
		CHARLOTTE Kirkeby	I HAVE READ THIS RELE
		EDVARD FRIIS-MØLLER	I HAVE READ THIS RELE
		Peter Bonde	I HAVE READ THIS RELE
		JASON RHOADES	I HAVE READ THIS RELE
		Damon McCarthy	I HAVE READ THIS RELE
		Heather Mathews	I HAVE READ THIS RELE
		DREW Mathews	I HAVE READ THIS RELE
		JP Flavien	I HAVE READ THIS RELE
		RACHEL KHEDOORI	I HAVE READ THIS RELE
		Rachel Khedoori	

LLED	☐ PAID IN FULL	☐ OWES	OFFICE USE ONLY		DATE 3/9/99		AMOUNT _____
	TYPE OF VEHICLE			_____	Driver/Waiver Card	@ $75. each =	_____
				_____	Driver(s)/Rider(s)	@ $75. each =	_____
				_____	VEHICLE(s)	@ $75. each =	_____
				_____	Crew Person(s)	@ $10. each =	_____

PAID BY SEPARATE CHECK **TOTAL AMOUNT DUE:**

ND WAIVER OF LIABILITY AND INDEMNITY AGREEMENT

or resulting in death of the undersigned, whether caused by the negligence of the releasees or otherwise while the undersigned is in or upon the restricted area, and/or, competing, officiating in, observing, working for, or for any purpose participating in the event;

2. HEREBY AGREES TO INDEMNIFY AND SAVE AND HOLD HARMLESS the releasees and each of them from any loss, liability, damage, or cost they may incur due to the presence of the undersigned in or upon the restricted area or in any way competing, officiating, observing, or working for, or for any purpose participating in the event and whether caused by the negligence of the releasees or otherwise.

3. HEREBY ASSUMES FULL RESPONSIBILITY FOR AND RISK OF BODILY INJURY, DEATH OR PROPERTY DAMAGE due to the negligence of releasees or otherwise while in or upon the restricted area and/or while competing, officiating, observing, or working for or for any purpose participating in the event.

EACH OF THE UNDERSIGNED expressly acknowledges and agrees that the activities of the event are very dangerous and involve the risk of serious injury and/or death and/or property damage. EACH OF THE UNDERSIGNED further expressly agrees that the foregoing release, waiver, and indemnity agreement is intended to be as broad and inclusive as is permitted by the law of the Province or State in which the event is conducted and that if any portion thereof is held invalid, it is agreed that the balance shall, notwithstanding, continue in full legal force and effect.

THE UNDERSIGNED HAS READ AND VOLUNTARILY SIGNS THE RELEASE AND WAIVER OF LIABILITY AND INDEMNITY AGREEMENT, and further agrees that no oral representations, statements or inducements apart from the foregoing written agreement have been made.

WSMC CARD #	DRIVER/ CREW	NAME PRINTED	NAME SIGNED
		V'KETAH	I HAVE READ THIS RELEASE
		E Black	I HAVE READ THIS RELEASE
		Heather Mathews	I HAVE READ THIS RELEASE
		Ase Frid	I HAVE READ THIS RELEASE
		Johan Frid	I HAVE READ THIS RELEASE
		Magdalena Johansson	I HAVE READ THIS RELEASE
		ERIC TREML	I HAVE READ THIS RELEASE
		DAVID AUERBACH	I HAVE READ THIS RELEASE
		MARCUS D Bolton	I HAVE READ THIS RELEASE
		Jason Rhorpe	I HAVE READ THIS RELEASE
			I HAVE READ THIS RELEASE

OFFICE USE ONLY DATE_____ INVOICE #_____

WILLOW SPRINGS RACEWAY

TEAM/COMPANY NAME: _Sinn Ball_

PAYMENT:

NUMBER

FUEL:

TYPE OF RENTAL: ☐ OPEN TEST ☐ SEMI-EXCL. ☒ EXCLUSIVE

☐ ROAD COURSE ☐ STREETS OF WILLOW ☒ KCR

☐ DIRT TRACK ☐ OFF ROAD

WILLOW SPRINGS INTERNATIONAL RACEWAY RELE

IN CONSIDERATION of being permitted to enter for any purpose any RESTRICTED AREA (herein defined a including but not limited to the racing surface, pit areas, infield, burn out area, approach area, shut down area, and a walkways, concessions and other areas appurtenant to any area where any activity related to the event shall take place or being permitted to compete, officiate, observe, work for, or for any purpose participate in any way in the even EACH OF THE UNDERSIGNED, for himself, his personal representatives, heirs, and next of kin, acknowledges agrees and represents that he has, or will immediately upon entering any of such restricted areas, and will continuous thereafter, inspect such restricted areas and all portions thereof which he enters and with which he comes in contact and he does further warrant that his entry upon such restricted area or areas and his participation, if any, in the even constitutes an acknowledgement that he has inspected such restricted area and that he finds and accepts the same a being safe and reasonably suited for the purposes of his use, and he further agrees and warrants that if, at any time he is in or about restricted areas and he feels anything to be unsafe, he will immediately advise the officials of suc and will leave the restricted areas:

1. HEREBY RELEASES, WAIVES, DISCHARGES AND COVENANTS NOT TO SUE the promoter, participants racing association, sanctioning organization or any subdivision thereof, track operator, track owner, officials, ca owners, drivers, pit crews, any persons in any restricted area, promoters, sponsors, advertisers, owners and lessee of premises used to conduct the event and each of them, their officers and employees, all for the purposes herei referred to as "releasees," from all liability to the undersigned, his personal representatives, assigns, heirs, and ne of kin for any and all loss or damage, and any claim or demands therefor on account of injury to the person or propert

WSMC CARD #	DRIVER/ CREW	NAME PRINTED	NAME SIGNED
		EDUARD FRES-MOLLER	I HAVE READ THIS RELEA
		CHARLOTTE KIRKEBY	I HAVE READ THIS RELEA
		JASON RHOARN	I HAVE READ THIS RELEA
		G. MCLAFFREY	I HAVE READ THIS RELEA
		ANDREW KROMELOW	I HAVE READ THIS RELEA
		Drew Mather	I HAVE READ THIS RELEA
		Jérôme Sans	I HAVE READ THIS RELEA
		Peter Lasser	I HAVE READ THIS RELEA
		Arne Steinkopf	I HAVE READ THIS RELEA
		Hanne Odembunt	I HAVE READ THIS RELEA
		Peter Bonde	I HAVE READ THIS RELEA
		RAZHEL KHEDOORI	

LLED	☐ PAID IN FULL	☐ OWES
	TYPE OF VEHICLE	

PAID BY SEPARATE CHECK | **TOTAL AMOUNT DUE:**

ND WAIVER OF LIABILITY AND INDEMNITY AGREEMENT

or resulting in death of the undersigned, whether caused by the negligence of the releasees or otherwise while the undersigned is in or upon the restricted area, and/or, competing, officiating in, observing, working for, or for any purpose participating in the event;

2. HEREBY AGREES TO INDEMNIFY AND SAVE AND HOLD HARMLESS the releasees and each of them from any loss, liability, damage, or cost they may incur due to the presence of the undersigned in or upon the restricted area or in any way competing, officiating, observing, or working for, or for any purpose participating in the event and whether caused by the negligence of the releasees or otherwise.

3. HEREBY ASSUMES FULL RESPONSIBILITY FOR AND RISK OF BODILY INJURY, DEATH OR PROPERTY DAMAGE due to the negligence of releasees or otherwise while in or upon the restricted area and/or while competing, officiating, observing, or working for or for any purpose participating in the event.

EACH OF THE UNDERSIGNED expressly acknowledges and agrees that the activities of the event are very dangerous and involve the risk of serious injury and/or death and/or property damage. EACH OF THE UNDERSIGNED further expressly agrees that the foregoing release, waiver, and indemnity agreement is intended to be as broad and inclusive as is permitted by the law of the Province or State in which the event is conducted and that if any portion thereof is held invalid, it is agreed that the balance shall, notwithstanding, continue in full legal force and effect.

THE UNDERSIGNED HAS READ AND VOLUNTARILY SIGNS THE RELEASE AND WAIVER OF LIABILITY AND INDEMNITY AGREEMENT, and further agrees that no oral representations, statements or inducements apart from the foregoing written agreement have been made.

WSMC CARD #	DRIVER/ CREW	NAME PRINTED	NAME SIGNED
		ERIC TREML	I HAVE READ THIS RELEASE
		DAMON McCARTHY	I HAVE READ THIS RELEASE
		ALBANO GUATTI	I HAVE READ THIS RELEASE
		MARCUS D Bolton	Marcus DBolton
		Yutaka Sone	I HAVE READ THIS RELEASE
		Myle Bouchet	I HAVE READ THIS RELEASE
			I HAVE READ THIS RELEASE
			I HAVE READ THIS RELEASE
		Heather Mathews	I HAVE READ THIS RELEASE
		Lasse Sei Nielsen	I HAVE READ THIS RELEASE
		Lindhard	I HAVE READ THIS RELEASE

WILLOW SPRINGS RACEWAY

TEAM/COMPANY NAME: _Snow Ball_

PAYMENT:

NUMBER

FUEL:

TYPE OF RENTAL: ☐ OPEN TEST ☐ SEMI-EXCL. ☐ EXCLUSIVE

☐ ROAD COURSE ☐ STREETS OF WILLOW ☐ KCR

☐ DIRT TRACK ☐ OFF ROAD

WILLOW SPRINGS INTERNATIONAL RACEWAY RELE

IN CONSIDERATION of being permitted to enter for any purpose any RESTRICTED AREA (herein defined as including but not limited to the racing surface, pit areas, infield, burn out area, approach area, shut down area, and al walkways, concessions and other areas appurtenant to any area where any activity related to the event shall take place) or being permitted to compete, officiate, observe, work for, or for any purpose participate in any way in the event EACH OF THE UNDERSIGNED, for himself, his personal representatives, heirs, and next of kin, acknowledges, agrees and represents that he has, or will immediately upon entering any of such restricted areas, and will continuously thereafter, inspect such restricted areas and all portions thereof which he enters and with which he comes in contact, and he does further warrant that his entry upon such restricted area or areas and his participation, if any, in the event constitutes an acknowledgement that he has inspected such restricted area and that he finds and accepts the same as being safe and reasonably suited for the purposes of his use, and he further agrees and warrants that if, at any time, he is in or about restricted areas and he feels anything to be unsafe, he will immediately advise the officials of such and will leave the restricted areas:

1. HEREBY RELEASES, WAIVES, DISCHARGES AND COVENANTS NOT TO SUE the promoter, participants, racing association, sanctioning organization or any subdivision thereof, track operator, track owner, officials, ca owners, drivers, pit crews, any persons in any restricted area, promoters, sponsors, advertisers, owners and lessees of premises used to conduct the event and each of them, their officers and employees, all for the purposes herein referred to as "releasees," from all liability to the undersigned, his personal representatives, assigns, heirs, and next of kin for any and all loss or damage, and any claim or demands therefor on account of injury to the person or property

WSMC CARD #	DRIVER/ CREW	NAME PRINTED	NAME SIGNED
	MECH	SANDY RAINEY	I HAVE READ THIS RELEA
	MECH	Bob Saunders	I HAVE READ THIS RELEA
	Rider?	EDDIE LAWSON	I HAVE READ THIS RELEA
	Rider?	Justin Gurney	I HAVE READ THIS RELEA
	Mech.	Joe Palomba	I HAVE READ THIS RELEA
	DRIVER	HENRIK JAKOBSEN	I HAVE READ THIS RELEA
	Driver	Mike Bouchet	I HAVE READ THIS RELEA
		Byron Payne	I HAVE READ THIS RELEA
		BOB ARMSTRONG	I HAVE READ THIS RELEA
		CHRIS B48	I HAVE READ THIS RELEA
		Gerry Glenn	I HAVE READ THIS RELEA

	☐ PAID IN FULL	☐ OWES	OFFICE USE ONLY	DATE 3/10/99	AMOUNT

LLED ☐ PAID IN FULL ☐ OWES

TYPE OF VEHICLE

AID BY SEPARATE CHECK **TOTAL AMOUNT DUE:**

ND WAIVER OF LIABILITY AND INDEMNITY AGREEMENT

or resulting in death of the undersigned, whether caused by the negligence of the releasees or otherwise while the undersigned is in or upon the restricted area, and/or, competing, officiating in, observing, working for, or for any purpose participating in the event;

2. HEREBY AGREES TO INDEMNIFY AND SAVE AND HOLD HARMLESS the releasees and each of them from any loss, liability, damage, or cost they may incur due to the presence of the undersigned in or upon the restricted area or in any way competing, officiating, observing, or working for, or for any purpose participating in the event and whether caused by the negligence of the releasees or otherwise.

3. HEREBY ASSUMES FULL RESPONSIBILITY FOR AND RISK OF BODILY INJURY, DEATH OR PROPERTY DAMAGE due to the negligence of releasees or otherwise while in or upon the restricted area and/or while competing, officiating, observing, or working for or for any purpose participating in the event.

EACH OF THE UNDERSIGNED expressly acknowledges and agrees that the activities of the event are very dangerous and involve the risk of serious injury and/or death and/or property damage. EACH OF THE UNDERSIGNED further expressly agrees that the foregoing release, waiver, and indemnity agreement is intended to be as broad and inclusive as is permitted by the law of the Province or State in which the event is conducted and that if any portion thereof is held invalid, it is agreed that the balance shall, notwithstanding, continue in full legal force and effect.

THE UNDERSIGNED HAS READ AND VOLUNTARILY SIGNS THE RELEASE AND WAIVER OF LIABILITY AND INDEMNITY AGREEMENT, and further agrees that no oral representations, statements or inducements apart from the foregoing written agreement have been made.

WSMC CARD #	DRIVER/ CREW	NAME PRINTED 3-11-99	NAME SIGNED
		Robert Foss	I HAVE READ THIS RELEASE
		Surges	I HAVE READ THIS RELEASE
		P FLAVIEN	I HAVE READ THIS RELEASE
		J. Rhoades	I HAVE READ THIS RELEASE
		ANDREW KROMELOW	I HAVE READ THIS RELEASE
		ERIC TREML	I HAVE READ THIS RELEASE
		Peter Bonde	I HAVE READ THIS RELEASE
		Marianne Ockenholt	I HAVE READ THIS RELEASE
		Jérôme Sans	I HAVE READ THIS RELEASE
		C. McCAFFREY	I HAVE READ THIS RELEASE
		Mathews	I HAVE READ THIS RELEASE

OFFICE USE ONLY DATE_____ INVOICE #_____

WILLOW SPRINGS RACEWAY

TEAM/COMPANY NAME: Snow Ball

PAYMENT: NUMBER

TYPE OF RENTAL: ☐ OPEN TEST ☐ SEMI-EXCL. ☑ EXCLUSIVE

☐ ROAD COURSE ☐ STREETS OF WILLOW ☑ KCR

☐ DIRT TRACK ☐ OFF ROAD

FUEL:

WILLOW SPRINGS INTERNATIONAL RACEWAY REL

IN CONSIDERATION of being permitted to enter for any purpose any RESTRICTED AREA (herein defined including but not limited to the racing surface, pit areas, infield, burn out area, approach area, shut down area, and walkways, concessions and other areas appurtenant to any area where any activity related to the event shall take plac or being permitted to compete, officiate, observe, work for, or for any purpose participate in any way in the even EACH OF THE UNDERSIGNED, for himself, his personal representatives, heirs, and next of kin, acknowledge agrees and represents that he has, or will immediately upon entering any of such restricted areas, and will continuou thereafter, inspect such restricted areas and all portions thereof which he enters and with which he comes in conta and he does further warrant that his entry upon such restricted area or areas and his participation, if any, in the eve constitutes an acknowledgement that he has inspected such restricted area and that he finds and accepts the same being safe and reasonably suited for the purposes of his use, and he further agrees and warrants that if, at any tim he is in or about restricted areas and he feels anything to be unsafe, he will immediately advise the officials of su and will leave the restricted areas:

1. HEREBY RELEASES, WAIVES, DISCHARGES AND COVENANTS NOT TO SUE the promoter, participan racing association, sanctioning organization or any subdivision thereof, track operator, track owner, officials, owners, drivers, pit crews, any persons in any restricted area, promoters, sponsors, advertisers, owners and lesse of premises used to conduct the event and each of them, their officers and employees, all for the purposes here referred to as "releasees," from all liability to the undersigned, his personal representatives, assigns, heirs, and ne of kin for any and all loss or damage, and any claim or demands therefor on account of injury to the person or proper

WSMC CARD #	DRIVER/ CREW	NAME PRINTED	NAME SIGNED
		DREW MATHEWS	I HAVE READ THIS RELE
		Jonathan Williams	I HAVE READ THIS RELE
		JASON Rhodes	I HAVE READ THIS RELE
		ANDREW Kromerow	I HAVE READ THIS RELE
		OLIVER CAFFREY	I HAVE READ THIS RELE
		Olia Koii R	I HAVE READ THIS RELE
		Akoll Hachisuka	I HAVE READ THIS RELE
		Peter Broade	I HAVE READ THIS RELE
		JEVENT Flavian	I HAVE READ THIS RELE
		Dimitre Glick	I HAVE READ THIS RELE
		Yutaka Sone	I HAVE READ THIS RELE
		EDUARD Feis-Moeller + CHARLOTTE Everest	

BILLED	☐ PAID IN FULL	☐ OWES	OFFICE USE ONLY	DATE 3-12-44	AMOUNT _____

TYPE OF VEHICLE

	Driver/Waiver Card	@ $75. each =
_____	Driver(s)/Rider(s)	@ $75. each = _____
_____	VEHICLE(s)	@ $75. each = _____
_____	Crew Person(s)	@ $10. each = _____

PAID BY SEPARATE CHECK

TOTAL AMOUNT DUE:

AND WAIVER OF LIABILITY AND INDEMNITY AGREEMENT

or resulting in death of the undersigned, whether caused by the negligence of the releasees or otherwise while the undersigned is in or upon the restricted area, and/or, competing, officiating in, observing, working for, or for any purpose participating in the event;

2. HEREBY AGREES TO INDEMNIFY AND SAVE AND HOLD HARMLESS the releasees and each of them from any loss, liability, damage, or cost they may incur due to the presence of the undersigned in or upon the restricted area or in any way competing, officiating, observing, or working for, or for any purpose participating in the event and whether caused by the negligence of the releasees or otherwise.

3. HEREBY ASSUMES FULL RESPONSIBILITY FOR AND RISK OF BODILY INJURY, DEATH OR PROPERTY DAMAGE due to the negligence of releasees or otherwise while in or upon the restricted area and/or while competing, officiating, observing, or working for or for any purpose participating in the event.

EACH OF THE UNDERSIGNED expressly acknowledges and agrees that the activities of the event are very dangerous and involve the risk of serious injury and/or death and/or property damage. EACH OF THE UNDERSIGNED further expressly agrees that the foregoing release, waiver, and indemnity agreement is intended to be as broad and inclusive as is permitted by the law of the Province or State in which the event is conducted and that if any portion thereof is held invalid, it is agreed that the balance shall, notwithstanding, continue in full legal force and effect.

THE UNDERSIGNED HAS READ AND VOLUNTARILY SIGNS THE RELEASE AND WAIVER OF LIABILITY AND INDEMNITY AGREEMENT, and further agrees that no oral representations, statements or inducements apart from the foregoing written agreement have been made.

WSMC CARD #	DRIVER/ CREW	NAME PRINTED	NAME SIGNED
		Brian Butler	I HAVE READ THIS RELEASE
		Bella Hubert	I HAVE READ THIS RELEASE
		Arcola J. Kraup	I HAVE READ THIS RELEASE
		Toba Khedoori	I HAVE READ THIS RELEASE
		F Raymond Pettibon	I HAVE READ THIS RELEASE Raymond Pettibon
		Mitchell Kane	I HAVE READ THIS RELEASE
		Irene Tsatsos	I HAVE READ THIS RELEASE
		John Millei	I HAVE READ THIS RELEASE
		Richard Neelsen	I HAVE READ THIS RELEASE
		DAVID AVERBACH	I HAVE READ THIS RELEASE
			I HAVE READ THIS RELEASE

OFFICE USE ONLY	DATE_____	INVOICE #_____

WILLOW SPRINGS RACEWAY

TEAM/COMPANY NAME: Snow Ball

TYPE OF RENTAL: ☐ OPEN TEST ☐ SEMI-EXCL. ☒ EXCLUSIVE

☐ ROAD COURSE ☐ STREETS OF WILLOW ☒ KCR
☐ DIRT TRACK ☐ OFF ROAD

PAYMENT: ☐
NUMBER
FUEL:

WILLOW SPRINGS INTERNATIONAL RACEWAY RELE

IN CONSIDERATION of being permitted to enter for any purpose any RESTRICTED AREA (herein defined a
including but not limited to the racing surface, pit areas, infield, burn out area, approach area, shut down area, and a
walkways, concessions and other areas appurtenant to any area where any activity related to the event shall take place)
or being permitted to compete, officiate, observe, work for, or for any purpose participate in any way in the event
EACH OF THE UNDERSIGNED, for himself, his personal representatives, heirs, and next of kin, acknowledges
agrees and represents that he has, or will immediately upon entering any of such restricted areas, and will continuousl
thereafter, inspect such restricted areas and all portions thereof which he enters and with which he comes in contact
and he does further warrant that his entry upon such restricted area or areas and his participation, if any, in the even
constitutes an acknowledgement that he has inspected such restricted area and that he finds and accepts the same a
being safe and reasonably suited for the purposes of his use, and he further agrees and warrants that if, at any time
he is in or about restricted areas and he feels anything to be unsafe, he will immediately advise the officials of suc
and will leave the restricted areas:

1. HEREBY RELEASES, WAIVES, DISCHARGES AND COVENANTS NOT TO SUE the promoter, participants
racing association, sanctioning organization or any subdivision thereof, track operator, track owner, officials, ca
owners, drivers, pit crews, any persons in any restricted area, promoters, sponsors, advertisers, owners and lessee
of premises used to conduct the event and each of them, their officers and employees, all for the purposes herei
referred to as "releasees," from all liability to the undersigned, his personal representatives, assigns, heirs, and nex
of kin for any and all loss or damage, and any claim or demands therefor on account of injury to the person or property

WSMC CARD #	DRIVER/ CREW	NAME PRINTED	NAME SIGNED
		Konstantin Bojanov	I HAVE READ THIS RELEA
		Linda Nishio	I HAVE READ THIS RELEA
		Karen McCarthy	Karen McCarthy I HAVE READ THIS RELEA
		Eva Meyer-Hermann	I HAVE READ THIS RELEA
		Max Kuo	I HAVE READ THIS RELEA
		Katiana Rush	I HAVE READ THIS RELEA
		Luciano Perna	I HAVE READ THIS RELEA
		Darcy Huebler	I HAVE READ THIS RELEA
		Paul McCarthy	I HAVE READ THIS RELEA
		Mike Boudet	I HAVE READ THIS RELEA
		Chris Beas	I HAVE READ THIS RELEA

TYPE OF VEHICLE

OFFICE USE ONLY	DATE 3-13-99	AMOUNT _____
_____	Driver/Waiver Card	@ $75. each = _____
_____	Driver(s)/Rider(s)	@ $75. each = _____
_____	VEHICLE(s)	@ $75. each = _____
_____	Crew Person(s)	@ $10. each = _____

AID BY SEPARATE CHECK

TOTAL AMOUNT DUE:

ND WAIVER OF LIABILITY AND INDEMNITY AGREEMENT

or resulting in death of the undersigned, whether caused by the negligence of the releasees or otherwise while the undersigned is in or upon the restricted area, and/or, competing, officiating in, observing, working for, or for any purpose participating in the event;

2. HEREBY AGREES TO INDEMNIFY AND SAVE AND HOLD HARMLESS the releasees and each of them from any loss, liability, damage, or cost they may incur due to the presence of the undersigned in or upon the restricted area or in any way competing, officiating, observing, or working for, or for any purpose participating in the event and whether caused by the negligence of the releasees or otherwise.

3. HEREBY ASSUMES FULL RESPONSIBILITY FOR AND RISK OF BODILY INJURY, DEATH OR PROPERTY DAMAGE due to the negligence of releasees or otherwise while in or upon the restricted area and/or while competing, officiating, observing, or working for or for any purpose participating in the event.

EACH OF THE UNDERSIGNED expressly acknowledges and agrees that the activities of the event are very dangerous and involve the risk of serious injury and/or death and/or property damage. EACH OF THE UNDERSIGNED further expressly agrees that the foregoing release, waiver, and indemnity agreement is intended to be as broad and inclusive as is permitted by the law of the Province or State in which the event is conducted and that if any portion thereof is held invalid, it is agreed that the balance shall, notwithstanding, continue in full legal force and effect.

THE UNDERSIGNED HAS READ AND VOLUNTARILY SIGNS THE RELEASE AND WAIVER OF LIABILITY AND INDEMNITY AGREEMENT, and further agrees that no oral representations, statements or inducements apart from the foregoing written agreement have been made.

WSMC CARD #	DRIVER/ CREW	NAME PRINTED	NAME SIGNED
			I HAVE READ THIS RELEASE
			I HAVE READ THIS RELEASE
			I HAVE READ THIS RELEASE
			I HAVE READ THIS RELEASE
			I HAVE READ THIS RELEASE
			I HAVE READ THIS RELEASE
			I HAVE READ THIS RELEASE
			I HAVE READ THIS RELEASE
			I HAVE READ THIS RELEASE
			I HAVE READ THIS RELEASE
			I HAVE READ THIS RELEASE

OFFICE USE ONLY DATE_____ INVOICE #_____

WILLOW SPRINGS RACEWAY

TEAM/COMPANY NAME: _Snow Ball_

PAYMENT:

NUMBER

FUEL:

TYPE OF RENTAL: ☐ OPEN TEST ☐ SEMI-EXCL. ☑ EXCLUSIVE

☐ ROAD COURSE ☐ STREETS OF WILLOW ☑ KCR

☐ DIRT TRACK ☐ OFF ROAD

WILLOW SPRINGS INTERNATIONAL RACEWAY RELE

IN CONSIDERATION of being permitted to enter for any purpose any RESTRICTED AREA (herein defined a including but not limited to the racing surface, pit areas, infield, burn out area, approach area, shut down area, and a walkways, concessions and other areas appurtenant to any area where any activity related to the event shall take place or being permitted to compete, officiate, observe, work for, or for any purpose participate in any way in the even EACH OF THE UNDERSIGNED, for himself, his personal representatives, heirs, and next of kin, acknowledge agrees and represents that he has, or will immediately upon entering any of such restricted areas, and will continuous thereafter, inspect such restricted areas and all portions thereof which he enters and with which he comes in contac and he does further warrant that his entry upon such restricted area or areas and his participation, if any, in the even constitutes an acknowledgement that he has inspected such restricted area and that he finds and accepts the same a being safe and reasonably suited for the purposes of his use, and he further agrees and warrants that if, at any time he is in or about restricted areas and he feels anything to be unsafe, he will immediately advise the officials of suc and will leave the restricted areas:

1. HEREBY RELEASES, WAIVES, DISCHARGES AND COVENANTS NOT TO SUE the promoter, participant racing association, sanctioning organization or any subdivision thereof, track operator, track owner, officials, c owners, drivers, pit crews, any persons in any restricted area, promoters, sponsors, advertisers, owners and lesse of premises used to conduct the event and each of them, their officers and employees, all for the purposes here referred to as "releasees," from all liability to the undersigned, his personal representatives, assigns, heirs, and ne of kin for any and all loss or damage, and any claim or demands therefor on account of injury to the person or propert

WSMC CARD #	DRIVER/ CREW	NAME PRINTED	NAME SIGNED
		doReen MorrisSey	I HAVE READ THIS RELEA
	D	Sebastian Clough	I HAVE READ THIS RELE
	D	Michele Maccarone	I HAVE READ THIS RELE
		Andrea Zittel	I HAVE READ THIS RELE
		Mike Bouchet	I HAVE READ THIS RELEA
		CHRIS BEAS	I HAVE READ THIS RELE
		JULIEN BISMUTH	I HAVE READ THIS RELE
		KATE YANCEY	I HAVE READ THIS RELEA
		ERIK BLACK	I HAVE READ THIS RELEA
		DREW MATHEIS	I HAVE READ THIS RELEA
		ANDREW Kromelw	I HAVE READ THIS RELEA

	OFFICE USE ONLY	DATE 3-13-99	AMOUNT _____
TYPE OF VEHICLE	_____ Driver/Waiver Card	@ $75. each =	_____
	_____ Driver(s)/Rider(s)	@ $75. each =	_____
	_____ VEHICLE(s)	@ $75. each =	_____
	_____ Crew Person(s)	@ $10. each =	_____

AID BY SEPARATE CHECK **TOTAL AMOUNT DUE:**

ND WAIVER OF LIABILITY AND INDEMNITY AGREEMENT

or resulting in death of the undersigned, whether caused by the negligence of the releasees or otherwise while the undersigned is in or upon the restricted area, and/or, competing, officiating in, observing, working for, or for any purpose participating in the event;

2. HEREBY AGREES TO INDEMNIFY AND SAVE AND HOLD HARMLESS the releasees and each of them from any loss, liability, damage, or cost they may incur due to the presence of the undersigned in or upon the restricted area or in any way competing, officiating, observing, or working for, or for any purpose participating in the event and whether caused by the negligence of the releasees or otherwise.

3. HEREBY ASSUMES FULL RESPONSIBILITY FOR AND RISK OF BODILY INJURY, DEATH OR PROPERTY DAMAGE due to the negligence of releasees or otherwise while in or upon the restricted area and/or while competing, officiating, observing, or working for or for any purpose participating in the event.

EACH OF THE UNDERSIGNED expressly acknowledges and agrees that the activities of the event are very dangerous and involve the risk of serious injury and/or death and/or property damage. EACH OF THE UNDERSIGNED further expressly agrees that the foregoing release, waiver, and indemnity agreement is intended to be as broad and inclusive as is permitted by the law of the Province or State in which the event is conducted and that if any portion thereof is held invalid, it is agreed that the balance shall, notwithstanding, continue in full legal force and effect.

THE UNDERSIGNED HAS READ AND VOLUNTARILY SIGNS THE RELEASE AND WAIVER OF LIABILITY AND INDEMNITY AGREEMENT, and further agrees that no oral representations, statements or inducements apart from the foregoing written agreement have been made.

WSMC CARD #	DRIVER/ CREW	NAME PRINTED	NAME SIGNED
		CAITLIN McCAFFREY	I HAVE READ THIS RELEASE
		Eileen Teavell	I HAVE READ THIS RELEASE
		PAUL SCHIMMEL.	I HAVE READ THIS RELEASE
		MAX DEAN.	I HAVE READ THIS RELEASE
		DAMON McCARTHY	I HAVE READ THIS RELEASE
		Peter Bond	I HAVE READ THIS RELEASE
		Mette Grostøl	I HAVE READ THIS RELEASE
		J. P. Flanigan	I HAVE READ THIS RELEASE
		MARCUS D Bolton	Marcus D Bolton / I HAVE READ THIS RELEASE
			I HAVE READ THIS RELEASE
			I HAVE READ THIS RELEASE

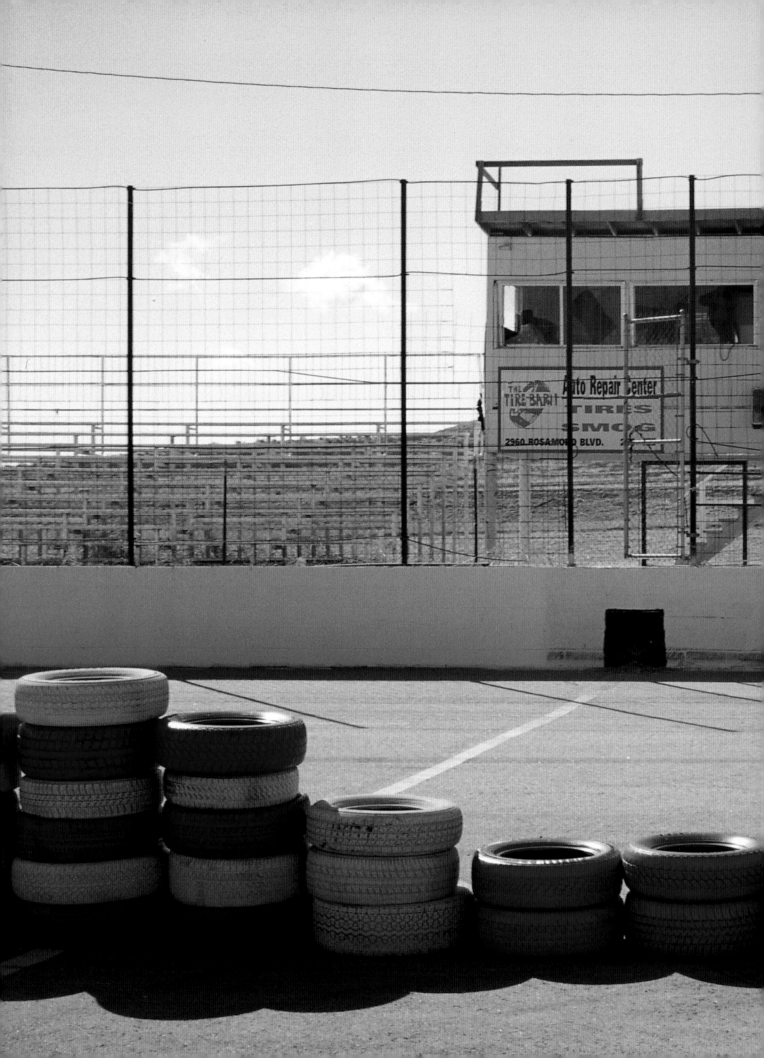

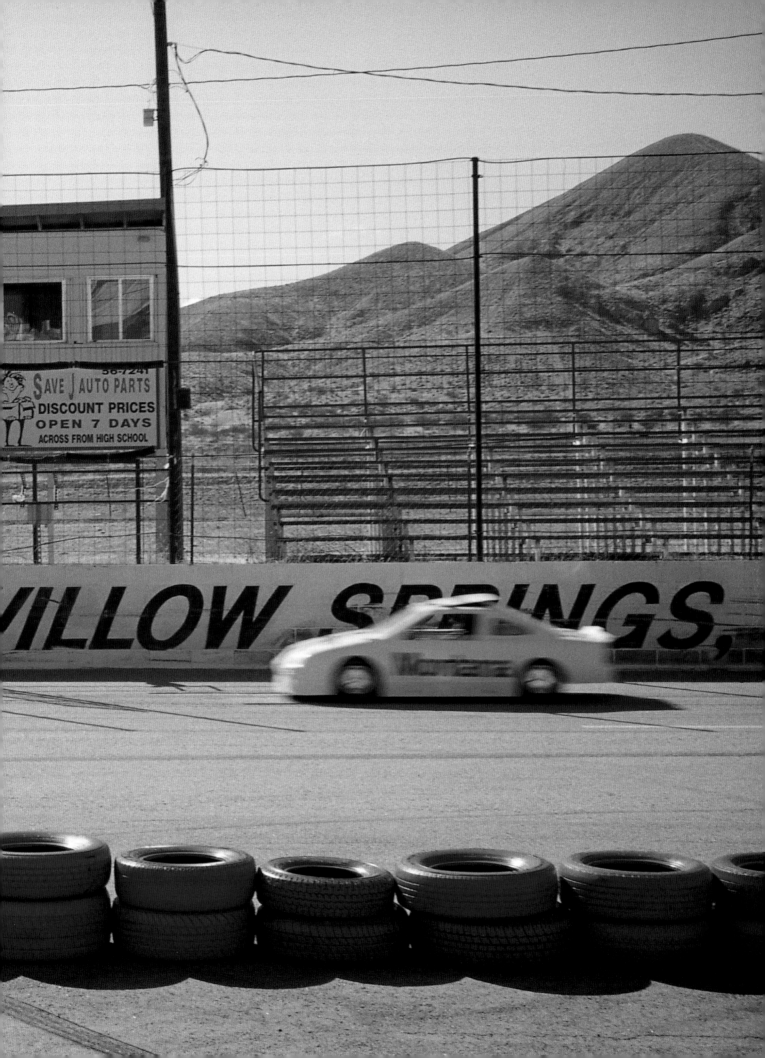

SPECIAL THANKS

LOS ANGELES

Chris Beas
Julien Bismuth
Marcus Bolton
Mike Bouchet
Brian D. Butler
Sebastian Clough
Mike Cram
Flavian
Henrik Grundsted
Albano Guatti
Jennifer Lane Hollander
Rachel Khedoori
Toba Khedoori
Andrew Kromelow
Drew Mathews
Damon McCarthy
Paul McCarthy
George Nava
Luciano Perna
Raymond Pettibon
Henrik Plenge Jakobsen
Paw Rytter
Paul Schimmel
Yukata Sone
Eric Treml
V'ketah
Jeff Wisniewski
David Zwirner
WILLOW SPRINGS RACE TRACK

VENICE

Troels Bruun
Agnes Kohlmeyer
Daniela Murgia
Dario Ventimiglia
Anna Barbagallo

COPENHAGEN

DANISH CONTEMPORARY ART FOUNDATION
Lars Grambye
Marianne Krogh Jensen
Sanne Kofod Olsen
Lars Bang Larsen
Karin Francke
Cathrine Lefebvre
Dorthe Abildgaard

STATENS MUSEUM FOR KUNST
Allis Helleland
Vibeke Petersen

DANISH CULTURAL MINISTRY
Helvinn Høst

ZENTROPA PRODUCTIONS
Carsten Holst
Charlotte Kirkeby
Molly Malene Stensgaard
Edvard Friis-Møller

Galerie Asbæk
Patricia and Jacob Asbaek
Anders Kold
Anne Meisner
Lars Krogh
Liselotte Birkmose
Mette Grostøl
Erik Øckenholt
John Körner
Kristian West
Charlotte Schmidt

PARIS

agnès b.
Pietro Delfondo
Anne de Vandière
Mary Deschamps
Edith Bizot
Virginie Gudmundsson
Laurent Pinon
Claire Staebler
Aïcha Anfif

NEW YORK

David Zwirner Gallery

MILWAUKEE

INSTITUTE OF VISUAL ARTS
Peter Doroshenko
Marilu Knode
Pedro Alonzo

ZURICH

Hauser & Wirth Gallery

ROME

Ellen Margrethe Andersen

AND

DANISH CONTEMPORARY ART FOUNDATION
Christian Collin, THOMSON MULTIMEDIA
Peter Lassen, Lone Stentoft, MONTANA
THE DEVELOPMENT FOUNDATION OF THE DANISH CULTURAL MINISTRY
agnès b.
THE BECKETT FOUNDATION
CONSUL GEORGE JORK AND EMMA JORK'S FOUNDATION
ATTORNEY L. ZEUTHEN'S MEMORIAL AWARD

Montana

Montana

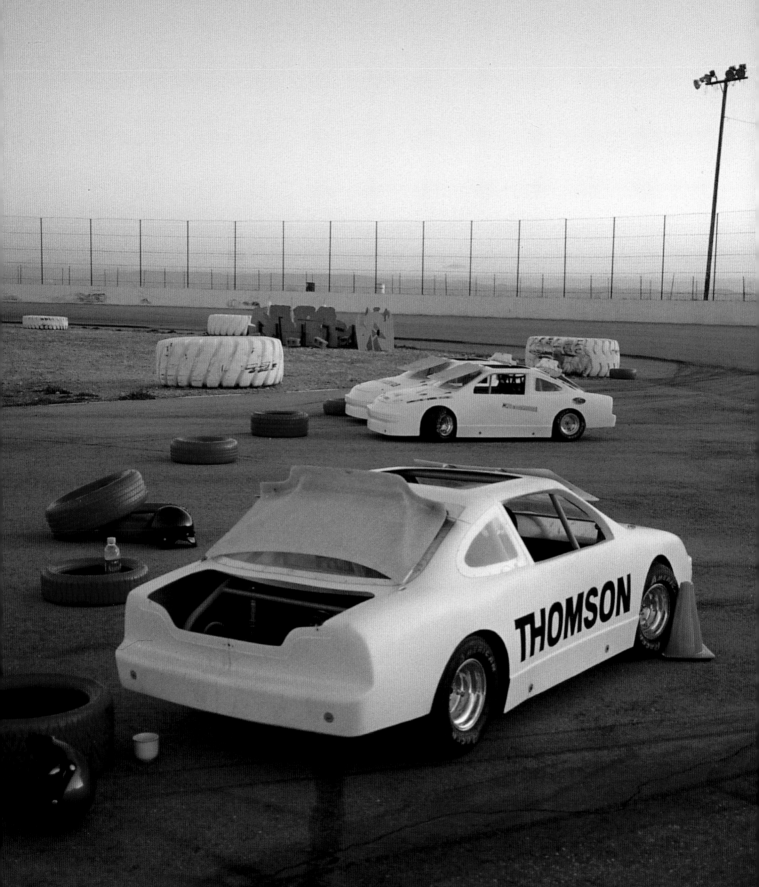

THOMSON

agnès b.

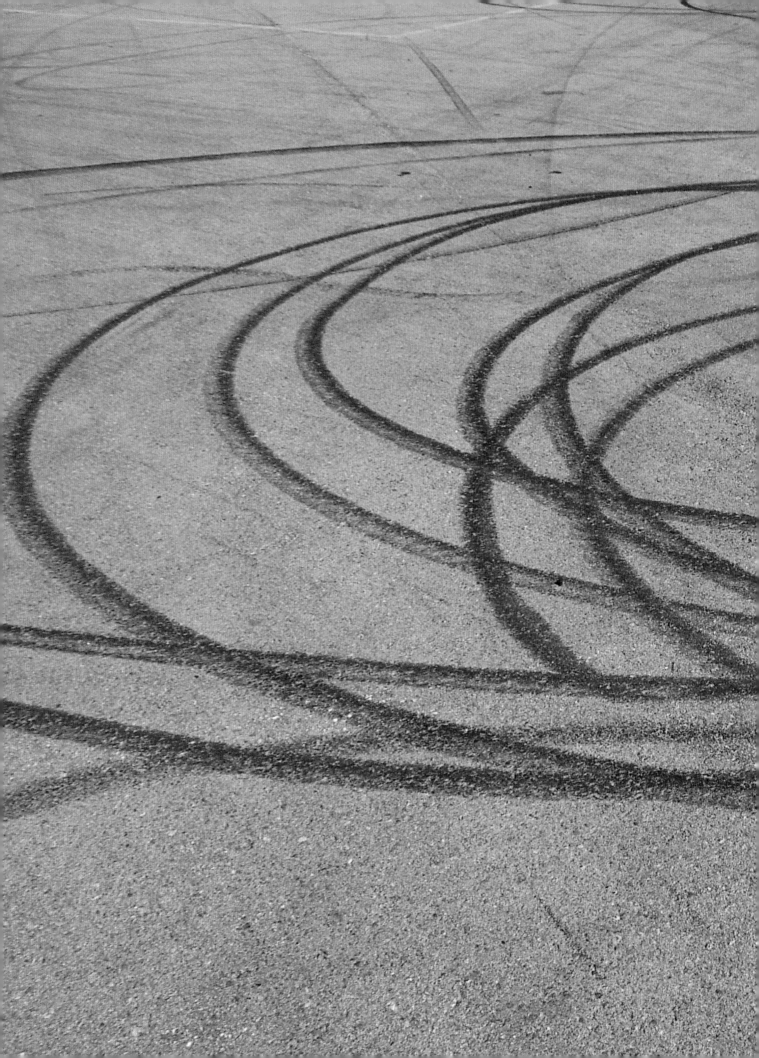

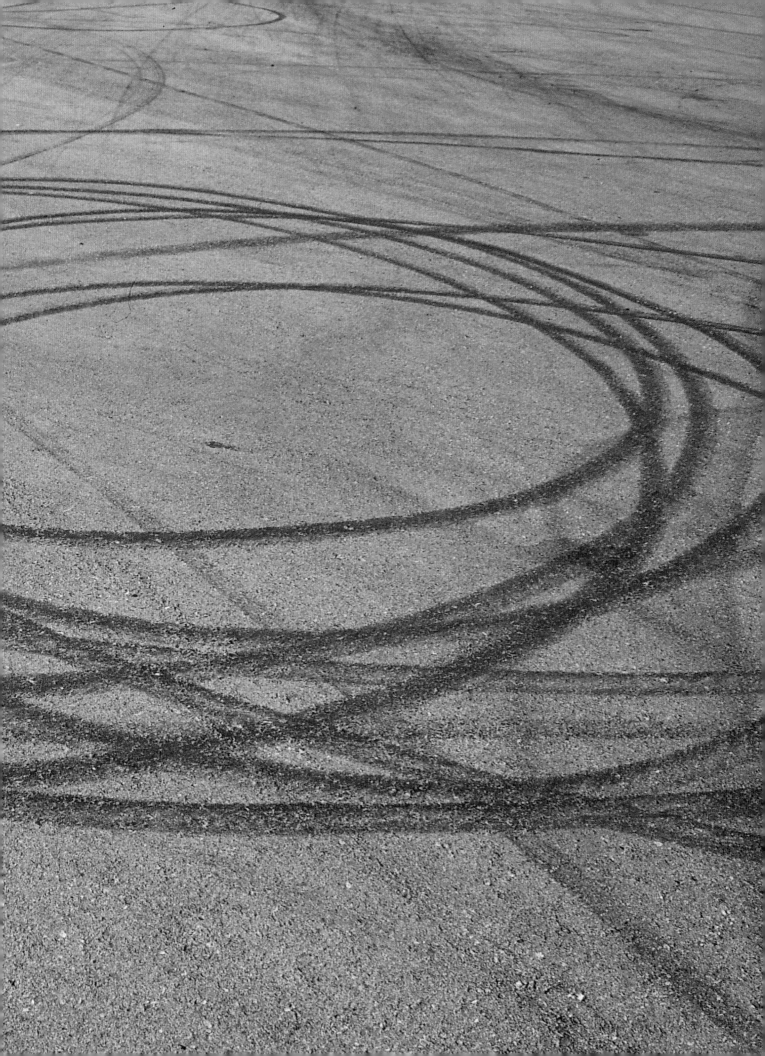

Colophon

Editors — Jérôme Sans & Marianne Øckenholt
Editing — Mary Deschamps
Graphic Design — Laurent ◖ Pinon
Photo Credits — Peter Bonde, Mike Cram, Albano Guatti,
Rachel Khedoori, Eva Meyer Herman,
Bellatrix Hubert, Marianne Øckenholt,
Luciano Perna, Henrik Plenge Jakobsen,
Jason Rhoades, Bent Ryberg, Jérôme Sans,
V'ketah, Paw Rytter, Edvard Friis-Møller,
Zentropa, David Zwirner
Typesetting — Helvetica Neue & Eurostile
Printed by — Dr. Cantz' sche Druckerei
Ostfildern-Ruit

©1999 — The authors & The artists,
The Danish Contemporary Art Foundation
& Hatje Cantz Publishers

©1999 — For all artwork by the artists
& their legal successors

Published by — Hatje Cantz Publishers
Senefelderstraße 12
D-73760 Ostfildern-Ruit
Tel. 0049 / 711 / 440 50
Fax. 0049 / 711 / 440 52 20
www.hatjecantz.de

Distribution in the USA — D.A.P., Distributed Art Publishers, Inc.
155 Avenue of the Americas, Second Floor
USA – New York, N.Y. 10013-1507
Tel. 001 / 212 / 627 1999
Fax. 001 / 212 / 627 9484

ISBN — 3-7757-0969-8

Printed in Germany

Front & Back Cover photos — Peter Bonde & Jérôme Sans

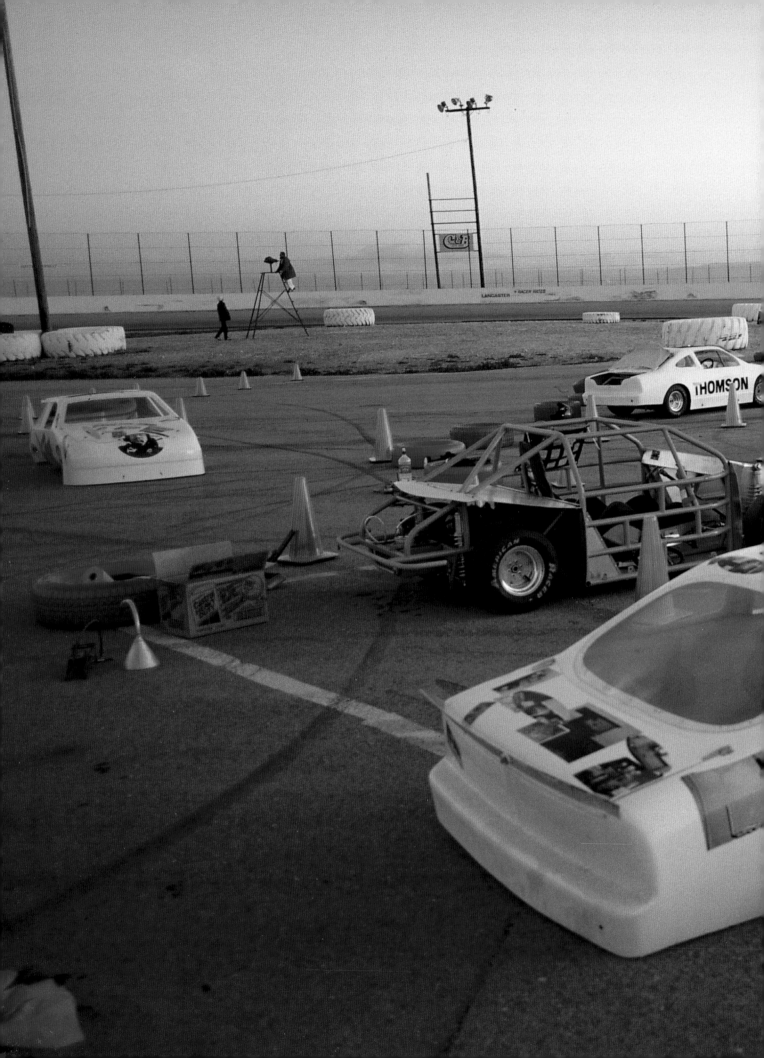

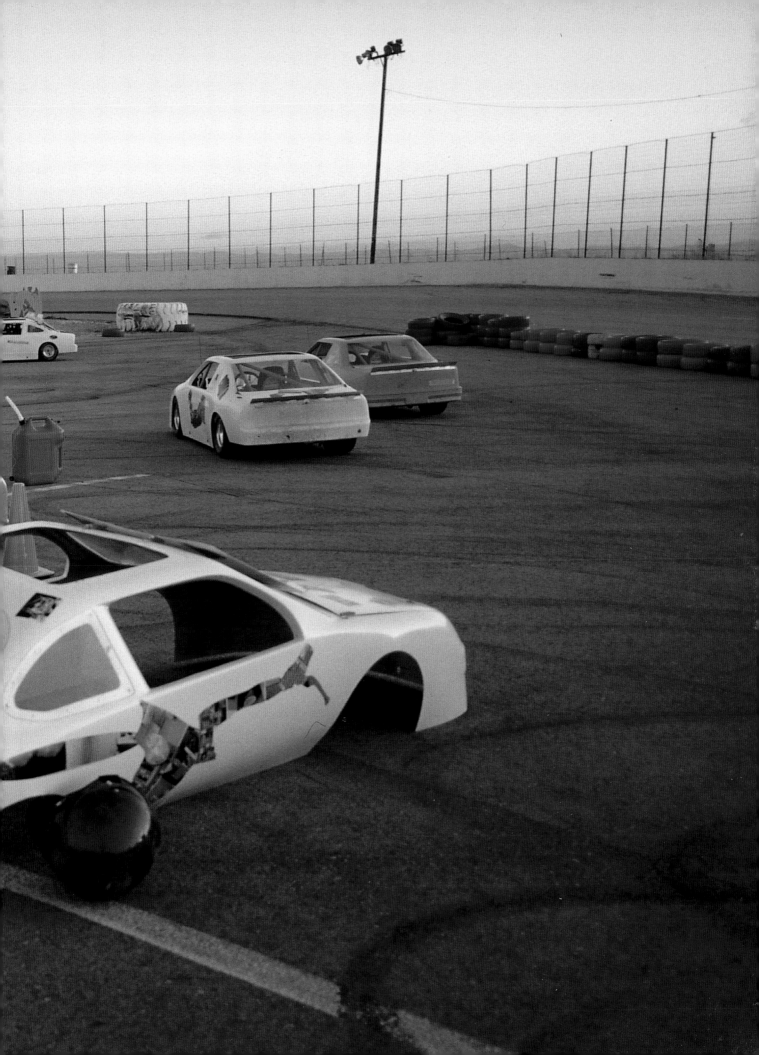